# Paris
## A Photographic Journey

Sandra Forty

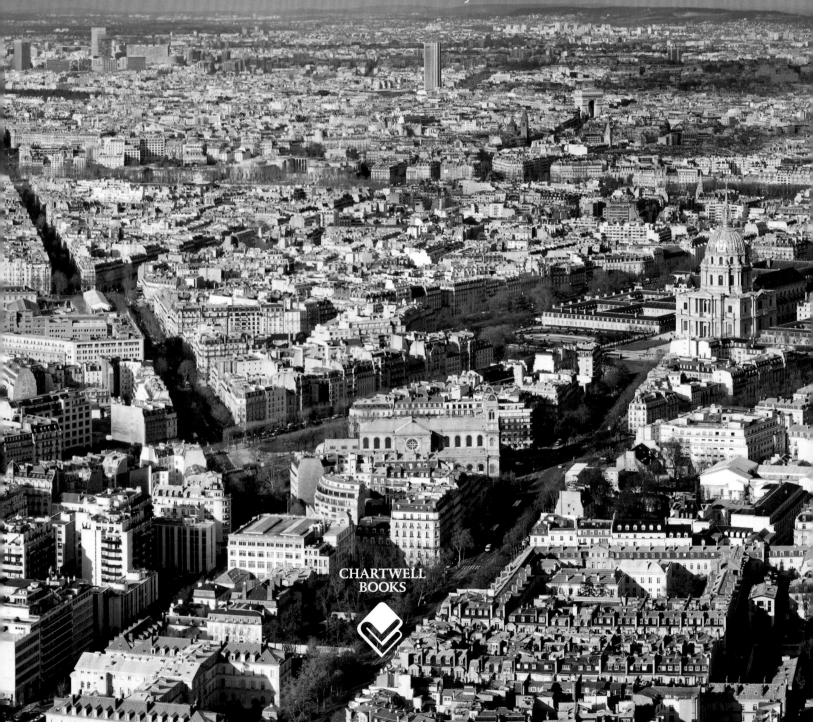

CHARTWELL
BOOKS

Brimming with creative inspiration, how-to projects, and useful information to enrich your everyday life, Quarto Knows is a favorite destination for those pursuing their interests and passions. Visit our site and dig deeper with our books into your area of interest: Quarto Creates, Quarto Cooks, Quarto Homes, Quarto Lives, Quarto Drives, Quarto Explores, Quarto Gifts, or Quarto Kids.

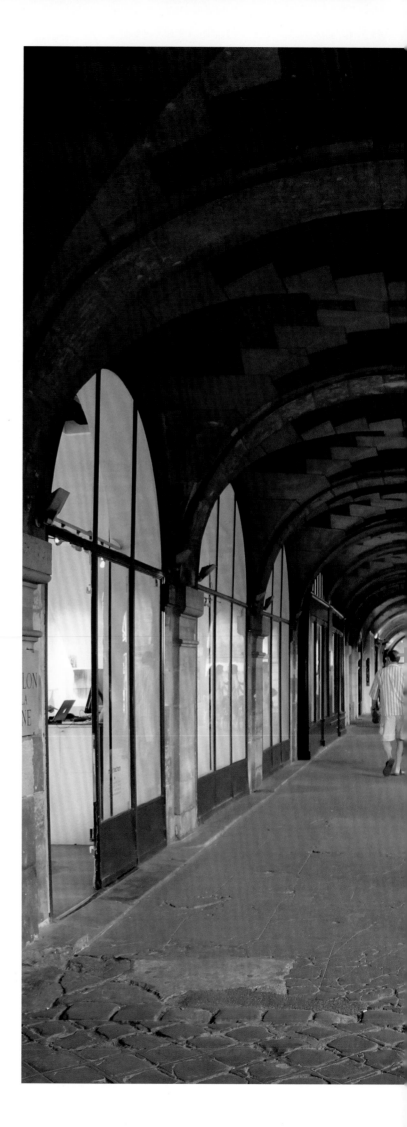

This edition published in 2019 by Chartwell Books,
an imprint of The Quarto Group,
142 West 36th Street, 4th Floor
New York, NY 10018 USA
T (212) 779-4972 F (212) 779-6058
www.QuartoKnows.com

Chartwell Books titles are also available at discount for retail, wholesale, promotional, and bulk purchase. For details, contact the Special Sales Manager by email at specialsales@quarto.com or by mail at The Quarto Group, Attn: Special Sales Manager, 100 Cummings Center, Suite 265-D, Beverly, MA 01915, USA.

ISBN: 978-0-7858-3774-9

10 9 8 7 6 5 4 3 2 1

Design: Greene Media Ltd/Eleanor Forty Design

Printed and bound in China

MIX
Paper from responsible sources
FSC® C008047
FSC www.fsc.org

**PAGE 1:** The Eiffel Tower—unmistakable, the quintessential monument of Paris.

**PAGES 2–3:** Paris from the Montparnasse Tower—a vantage point that affords superb views of the city.

**RIGHT:** All around the center of Paris are intriguing covered walkways leading off to further shops, markets, cafés, museums, and adventures. This is Place des Vosges (see pages 90–91).

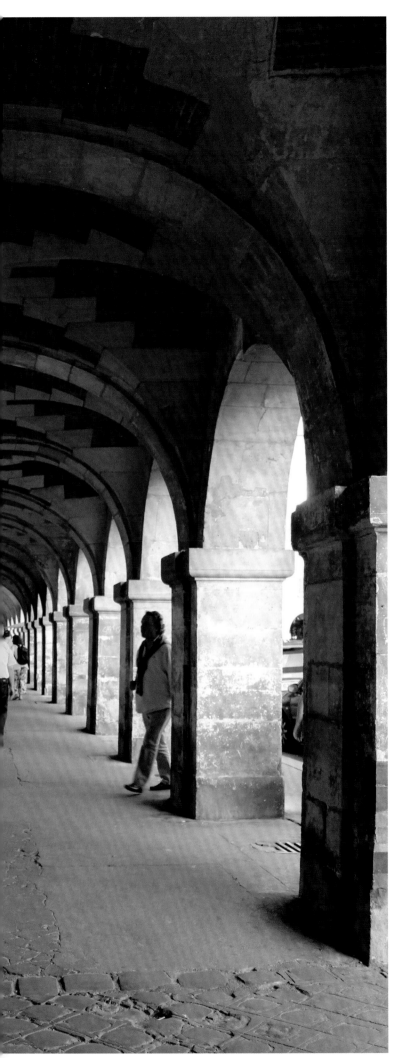

# Contents

# Introduction

The history of the city of Paris is also very much the history of France. Few other capital cities are as integral to the workings of their countries as is Paris. This hegemony started in medieval times but really became consolidated during the autocratic reign of King Louis XIV. He centralized all administration and culture in Paris, poured the vast wealth of his conquests into the city, and embellished the cityscape with monuments to his and France's magnificence. As if this were not enough, any prevailing provincial attempts to reassert their independence were squashed by Napoleon Bonaparte's even greater centralization of state business and commerce and embellishments of victory and pride. Look at a road map of France and all the roads and railway lines converge on Paris in a way that no other country has even attempted. Such historical antecedents are ingrained in Frenchmen who look to Paris as the very heartbeat of their country. Inevitably, such a stranglehold on all French life and culture is a massive cause of resentment among the greater population of France. However, Paris as a place is justifiably loved to an equally unreserved extent—it is a truly wonderful city as well as the historical roadmap of France.

Paris has long been popularly known as the "City of Light" for its architectural beauty and tradition of intellectualism. It is the royal city of the Sun King and Napoleon; of Enlightenment thinkers such as Rousseau and Voltaire who, literally, changed the world; of bloody revolution and the dream of liberty; of magnificent Gothic cathedrals, the grand avenues of Baron Haussmann, and cutting-edge contemporary buildings. Artists, writers, and poets have flocked here through the years and all attempted to capture something of its complexity and verve— such renowned names as Lautrec, Seurat, Picasso, Dumas, Hugo, and Rimbaud among them. Paris is the city of elegant Belle Époque designs and the risqué dancers of the Moulin Rouge. It is redolent of music and high fashion, of opulence and decadence, of culture and rigorous philosophy. Above all though, it is a city of enchantment. Paris has been seducing visitors for countless centuries.

Today, the city is the commercial center and the cultural heart of France, and still a seat of learning and creative endeavor envied throughout the world. Paris teems year round with tourists who come to sample fine cuisine, gaze upon artistic treasures, and take in the indefinable but heady atmosphere of this most romantic of cities. They find a metropolis with a past as rich as any sauce served up by an *haute*

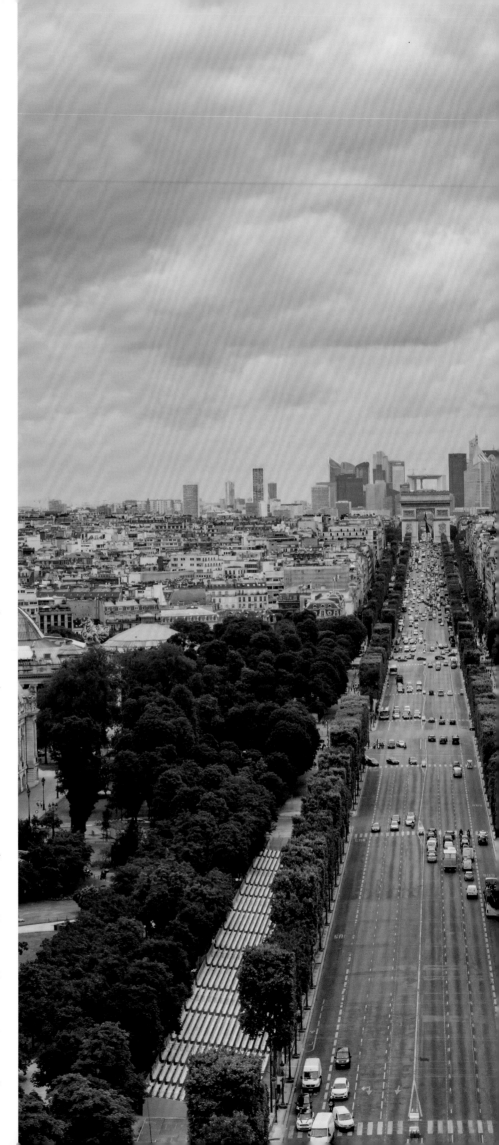

*cuisine* chef, a proud and dynamic modern city where intimate nooks and crannies remain unchanged from decade to decade. The City of Light is well named. Paris is much, much more than the sum of its parts, but an understanding of its history offers an insight into its unique and brilliant personality.

## Early Paris

Like many cities around the world, Paris owes its existence to the presence of an easily navigable river. The Seine and its tributaries would have allowed the people who settled here around 4500 B.C. to travel and hunt widely around the area. Over the millennia, most remnants of the area's earliest inhabitants have been lost—we do not know who these people were or what they called themselves. However, archaeologists have unearthed canoes dating back to this time as well as evidence that hunters were at work in the vicinity at an even earlier date. The tombs of Neolithic peoples (4000–2000 B.C.) have been discovered under the courtyard of the Louvre and

**LEFT:** Paris is a city of wide boulevards and there is no better example than the Champs-Elysées and its continuation after the Arc de Triomphe (toward which this photograph is taken), the Avenue de la Grande Armée. The skyscrapers of La Défense can be seen in the distance.

**BELOW:** A typical Paris Métro sign as seen all over central Paris. The sign is illuminated at night to indicate the entrance to the underground station. The first line opened in July 1900 and has since expanded to 16 lines, the third longest in western Europe. There is now a total of 300 stations and 132 miles of track.

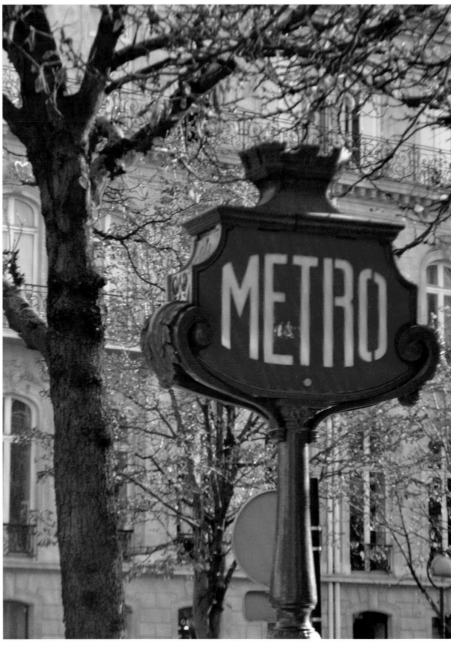

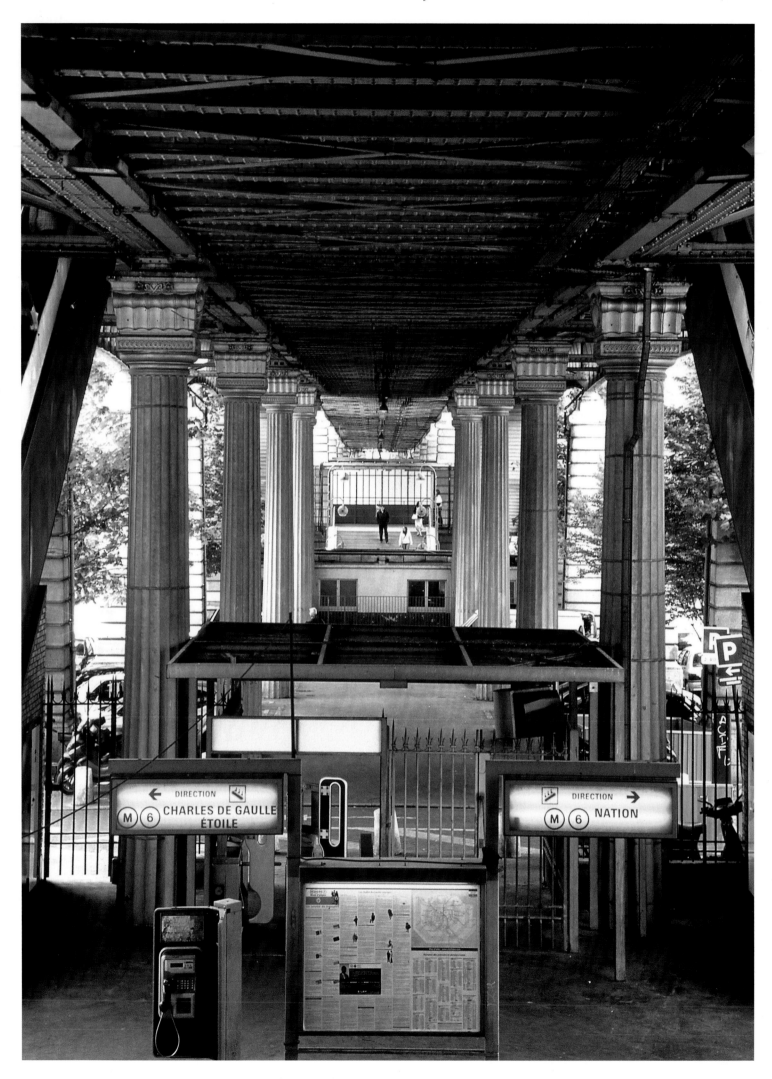

SAINT-DENIS

St. Denis (or Denys) is the patron saint of Paris and France. Nothing is really known about his early years, although he is thought to have been born in Rome. He gained a reputation there for his piety, virtue, and knowledge of the holy scriptures. He was ordered to Gaul in about A.D. 250 by Pope Fabian to convert the pagan Parisii. Denis, accompanied for his mission by a priest named Rusticus and a deacon named Eleutherius, settled on the Île de la Cité in the middle of the Seine, where they built a small church and Denis became the first Bishop of Paris. Later accounts say that Denis was successful in converting many Parisii and this aroused hatred from the pagan priests who did their best to whip up hostility against the Christians. To stop the trouble, Emperor Valerian (A.D. 253–260) ordered governor Fescenninus Sisinnius to stop Denis. The three companions were seized but refused to recant. In A.D. 258, they were beheaded in the area now known as Montmartre—the "mountain of the martyr." Legend has it that after Denis was beheaded he picked up his severed head and walked through Paris for two miles preaching as he went. A shrine was built over their graves by Ste. Geneviève. This grew over the years to become an abbey founded by Dagobert I, king of the Franks (A.D. 628–637). Used for royal ceremonies, in 1122 King Louis VI declared Saint-Denis the official burial place for the kings of France. In 1136 construction on a basilica started, Paris's first great Gothic building. The Rue St. Denis was for centuries the ceremonial holy route taken by kings of France for their second and public coronation in front of the people. St. Denis's feast day is October 9.

**LEFT:** Much of the Métro is elevated on metal bridges which make a clattering noise when a train passes. This is the overpass at Passy.

abundant worked flints have been found at Place du Châtelet, indicating the presence of artisans who would have supplied weapons and tools to their neighbors. A recent excavation, at Bercy in the southwest of the city, also uncovered the remains of very early buildings as well as pottery and bone tools.

But while ancient Parisians may have been living in the area for more than six thousand years, the city's story really begins with the arrival of a Celtic tribe known as the Parisii in the third century B.C. These folk may have eventually bequeathed the city their name, but the settlement they founded was known as "Lutetia." Most history books agree that the community was sited on the Île de la Cité, as described—albeit vaguely—in Caesar's *Gallic Wars*. Indeed, many traces of Parisii occupation, such as iron daggers, fired clay pots, coins, armor, and beads have been found on the island. Despite this, a 2004 excavation suggests that the main settlement of the Parisii was, in fact, six miles to the west of the island in the present day suburb of Nanterre.

The Nanterre excavation has revealed a much larger town than was previously thought existed on the Île de la Cité, comprising a market square and cobbled streets. The houses would have been framed in wood with clay walls and straw roofs, and the village also boasted drainage ditches and stone-lined wells for each house. Sited on a peninsula created by a loop in the Seine, the site would have been easily defended, and in a siege would have provided its population with forests for hunting as well as cultivated fields.

Wherever Lutetia lay, and the argument is not likely to be resolved in the near future, the Seine would, again, have played a vital role in the prosperity of its inhabitants. The town that began as a simple fishing village developed into an increasingly wealthy center for trade, with goods passing through from northern and southern France and from as far away as the Mediterranean. The town minted its own coins and all who passed through it would have been taxed. All this did not go unnoticed by the Julius Caesar who set out to conquer Gaul, as France was then known, in 59 B.C.

By 53 B.C., the country was almost entirely Caesar's and representatives of all the tribes were ordered to the Assembly of Gaul at Amiens. When no one from the Celtic Carnute and Senone tribes deigned to appear. The following year the Celt leader Vercingétorix began a full revolt. He was joined by fellow Celt Camulogenus, who occupied Lutetia, stationing his troops where the Panthéon now stands. The Roman pro-consul Labienus defeated the main rebel army at Melun with typical Roman dispatch and arrived at Lutetia soon after. His army met with the Camulogenus's warriors near the Champs de Mars (close by the Eiffel Tower) and again the Romans slaughtered the Celts, and with them Camulogenus himself. They then sacked what was left of Lutetia after the defeated Gauls attempted to destroy their own town. The conquerors then built (or rebuilt depending on which side of the dispute you favor) their own fortified town on the Île de la Cité. The Roman invader now ruled the Parisii tribe, along with the rest of Gaul.

**The Roman City**

Despite the revolt, the Romans and the indigenous population slowly came to coexist in comparative harmony, and the city thrived and grew once more. Over the following two and a half centuries Lutetia became a vital trading center for the empire and spread over the Left Bank. The town and its people little by little assimilated the Roman way of life. By the second century A.D. Lutetia was unrecognizable—a city of mosaic and fresco-ornamented, masonry villas with its own Forum (on the present day Rue Soufflot). An arena had also been built for the gladiatorial and circus spectacles so beloved by Romans (the Arènes de Lutèce, on the rue de Navarre), as well as baths, which can now be seen at the Musée de Cluny, and extensive catacombs beneath Montparnasse. On the site over which Notre-Dame was built was a temple to Jupiter.

By the early third century A.D., Lutetia had been renamed "Paris" after the tribe that founded the original town. Its native people became full Roman citizens under the Edict of Caracella (A.D. 212) when the name Paris seems to have been formalized. The disparity between Gaul and Roman was now almost imperceptible. The power of the empire was, however, decaying everywhere, and over the next century the city was more and more frequently assailed by barbarian hordes from the outer Rhine area. The five thousand or so inhabitants sought shelter and protection on the increasingly fortified Île de la Cité. Around this period the area became more commonly referred to as Paris. It was during this time that Christianity came to Paris in the person of St. Denis.

According to legend, this evangelical bishop and two of his flock chose to demonstrate their faith by vandalizing statues of Gaulish and Roman gods. For this crime the three men were taken to Mount Mercury to the north of the city, and beheaded. Miraculously, Denis did not die, but walked away clutching his own head and reciting psalms. He was buried where he eventually fell, now the site of the Basilique St. Denis. The hill where he and his companions were decapitated became known as Mons Martis (the Mount of Martyrs), then, eventually, Montmartre.

Christianity finally displaced the Roman and Gaulish pantheons in Paris—as throughout the Empire—in 313 under the rule of Emperor Constantine, but by this time Parisians had other things to think about. The security of the city was increasingly threatened. Indeed, the population of the Left Bank dwindled as more and more people sought safety behind the walls that had been raised against invaders around the Île de la Cité.

The increasing prosperity and fame of Paris inevitably attracted the ravening hordes who were intent on murder and mayhem as a way of life. As the Roman armies gradually relinquished their hold over Gaul the barbarians became bolder. Repeated raids were made against Paris but the raiders never managed to breech the island's defenses. As a consequence, the outer areas of Paris were abandoned, particularly the Left Bank, for the safety and security of the island. As buildings were abandoned the Roman governor of Paris ordered their demolition and used the recovered stone for building the first inner defensive wall.

In about 451 Attila the Hun brought his horde of around 500,000 towards Paris. With his reputation preceding him, many city dwellers started packing their belongings to flee. According to legend a young girl named Geneviève beseeched the terrified Parisians not to run away but to pray, repent their sins, and stand firm and fight. They listened to her and Attila's hordes instead swung south and were at last defeated in 451 by the Roman general Actius at Châlons. For her vital part in saving the city Geneviève was later made the patron saint of Paris.

**The Merovingian Dynasty**

A period of relative peace ensued until 486 when the Franks, a Germanic tribe originally from the Rhine estuary and led by Clovis I, defeated the last Roman army in Gaul and overwhelmed Paris. Geneviève managed to convert Clovis to Christianity in 496 and although he was baptized at Rheims he made Paris his capital in about 508. Clovis was the founder of the Merovingian Dynasty, which lasted from 448–751. Under his rule most of Gaul north of the Loire was united as he defeated many chieftains, kings, and minor princes. When he died he partitioned his kingdom into four pieces for each of his sons. Over the following century Paris became the virtually

**RIGHT:** The three-mile long St. Martin canal in the northeast of Paris was constructed 1822–1825 to supply drinking water.

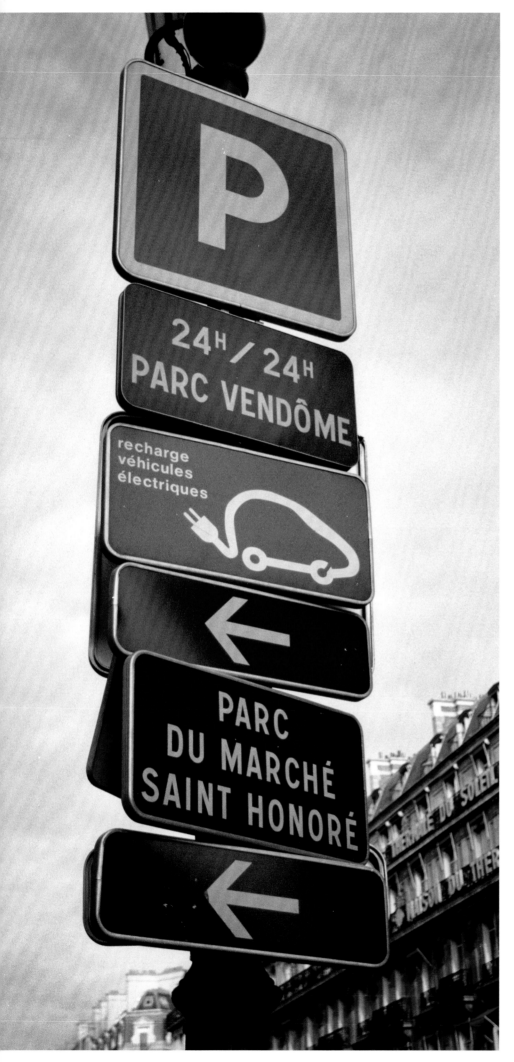

undisputed capital of France/Gaul, with its political rivals such as Rheims, Laon, Chartres, Tours, Soissons, and Orléans left to fight for second-city status.

With more peaceful times the city inhabitants were able to spill out of the confines of the island and the population also increased. The marshes started to be drained and more land was used for building, much of these new grounds were acquired by the church and most of the new dwellings tended to cluster around the newly founded monastic institutions either side of the Seine. By 700 the different areas started to merge and Paris and St. Denis became linked by the St. Denis fairground.

In 768 Charlemagne was crowned king of the Franks and moved his royal court and capital to Aix-la-Chapelle (now Aachen in Germany). From there he was better able to oversee his lands in Germany and Italy. However Paris had by then become self-sustaining as a vital trading center and crossroads, and the population had grown to between 20,000 and 30,000 making it one of the largest cities in Europe. Nevertheless with the removal of royal patronage, Paris went into a slow decline—although it was still a rich prize for adventurous and ambitious tribesmen. In 885 30,000 Viking pirates sailed up the Seine and laid siege to the Cité for about a year, but without success thanks in large part to the organizational and leadership abilities of Comte Eudes. The Normans left their mark by extensively looting all the surrounding area, in particular the south bank, which was reduced to rubble. Eudes was crowned king of the western Franks in 888 at Compiègne partly in thanks for his bravery while defending Paris. The Vikings instead moved south to settle around Rouen, in what would become Normandy.

### Capetian Capital of France

In 987 Eudes's grandnephew, Huguès Capet, was crowned by his peers as king of France (such as it was) and Paris became his official, although still transient, capital. The city of Orléans was also a candidate until Louis VI the Fat (1108–37) finally settled the honor for Paris for good. Huguès was the founder of the Capetian dynasty which lasted from 987 until 1328. He settled his Palais de la Cité on the Île de la Cité as the royal bastion. Under the ambitious Capetians the primacy of Paris grew as they used the commerce and wealth of the city to bolster and glorify their own importance. However the cities of Laon and Chartres in the Champagne region remained the most prosperous in France. Paris was still what we would today recognize as an agricultural city; even within the protection of the city walls large areas were still cultivated—12 areas on the right bank and 30 on the left. King Philippe I returned the monarchy to

Paris when the threat of Norman aggression revived Paris's strategic importance. This, in turn, revived commerce and wealth in Paris, and also in the surrounding but still separate villages of St. Marcel and St. Germain.

The River Seine proved not only an important highway for commerce of all sorts it also provided wealth in the form of taxes imposed on all goods transported by water. Paris grew rapidly in both important buildings and population: in 1140 the great Gothic cathedral of St. Denis was started and then in 1163 the first stones of Notre-Dame cathedral were laid beginning with the choir under the direction of Maurice de Sully, bishop of Paris.

The reign of Philippe-Auguste (who ruled 1180–1223) changed Paris even further and started the building of a truly defensive city. The lurking presence of the Anglo-Normans only 40 miles away made Paris even more strategically important as the guardian of the Seine and the commercial heartlands of Champagne—it also meant that Paris was vulnerable to sudden attack. Philippe-Auguste started a huge program of building, fortification, and development. This started with building a strong, fortified 3.3-mile-long wall to protect his city and a huge fortified castle, which later became the Louvre. It was designed to provide plenty of

room for expansion but the area rapidly filled up with the influx of builders and tradesmen needed to expand the city. Also a coordinated program to drain the marshes that surrounded Paris was started so that they could be turned over to grain production for the inhabitants of the city and secure the food supply.

The wall enclosed an area of 700 arpens (four-fifths of an acre) or about 620 acres. It was organized into four districts and to facilitate access around the city more bridges were built and a number of muddy streets around the area of Les Halles were paved. The street cries of traders filled the air and animals such as pigs blocked easy movement as they were allowed to wander freely around the muddy lanes in search of food. Philippe-Auguste worked hard and successfully to establish his authority. By the time he died it was customary to appeal to the king for ultimate justice and he had made Paris the European center for diplomatic activity and, as a direct by-product, French became the language of diplomacy for many centuries. Paris had become not only the center of France but also in many ways—cultural, economic, and social—the center of Europe.

During Philippe-Auguste's reign the first foundations of the University of Paris were started when Pope Innocent III granted letters uniting the

**LEFT:** Parking in Paris is as much a nightmare as in any big city. But, typically, the signs are as confusing as they are helpful. However, Parisians seem to be able to squeeze their cars into the most unlikely spaces that foreigners can only marvel at.

**BELOW:** Dogs—even really big ones—are a common sight in Paris, especially in the mornings and early evenings when their owners take them for a walk. Some, however, like this chow, accompany their owner to the vintner as well.

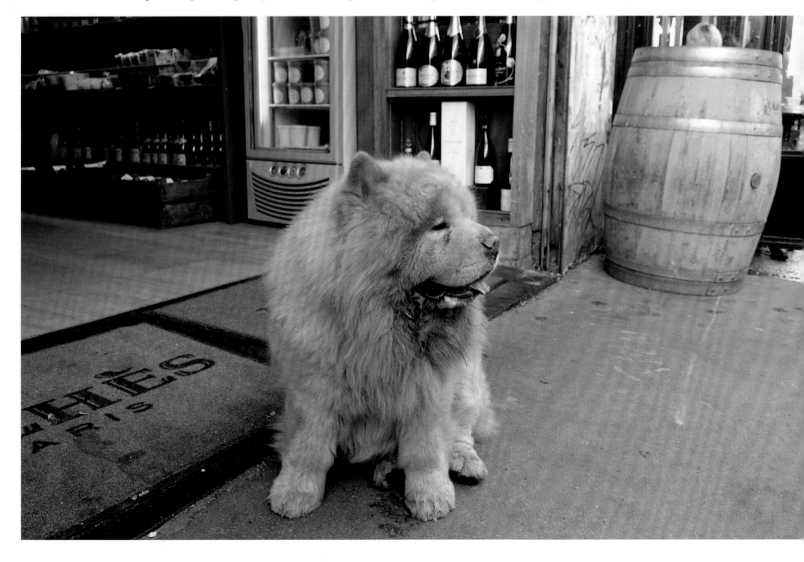

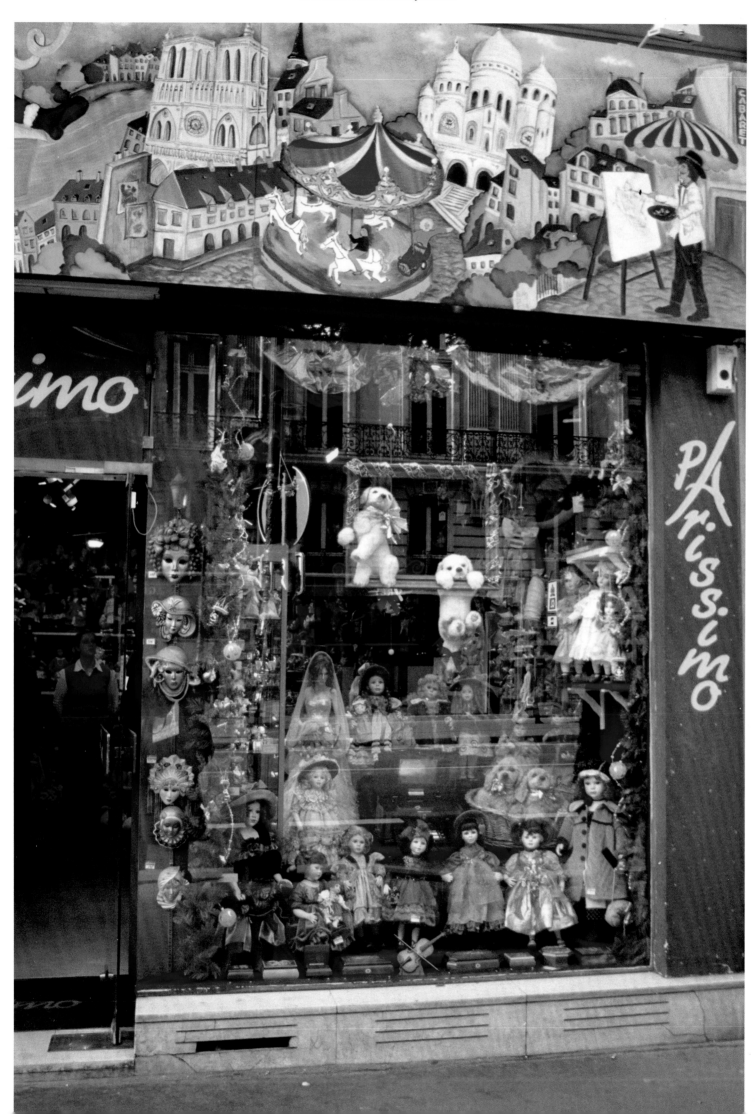

existing schools there. The Latin Quarter began to emerge on the Left Bank. Furthermore, numerous wealthy Parisians were building private houses for themselves.

As a great trading crossroads and market, Paris was second only to Rouen. To improve their economic strength, Parisian merchants gathered together to form the Hanse Parisienne and quickly grew in importance to the benefit of themselves and the city. This structure is credited with sounding the beginnings of the Parisian municipality. The city was growing fast and soon literally bursting at the seams; in 1240 Louis VIII reluctantly granted permission to build outside the protective city walls. In addition the great theological College de Sorbonne was founded in 1257 by Robert de Sorbon—a chaplain and confessor to King Louis IX—initially serving 20 theology students in the Notre-Dame area. The Sorbonne (along with Bologna University) became the model for all later medieval universities. Paris was very soon the indisputable cultural capital of Europe.

In 1260 Paris faced up to what was one of its perennial problems until the late 19th century— what to do with the vast amounts of human and animal sewerage. The Fossés-le-Roi became the first formal sewer in Paris and was cut through the swamps to take the waste out of the city.

Paris was by now a big and thriving city and thanks to the work of successive kings was by now the undisputed center of France. The network of roads across the country shifted from the old trading center of Lyon to converge on Paris. This centralization only reinforced the power, wealth, and prestige of her merchants, traders, judiciary, politics, fashion, and culture. The city required formal administration; accordingly the provost of Paris office was reorganized in 1261 so that the merchants oversaw everything concerning local matters, leaving the king free to attend to matters of state.

By then Paris was—if fiscal records are accurate—the third largest city in Europe after Venice and Milan, which were both more important strategically for trade. The population of Paris is calculated to have risen to about 80,000, but packed in at a density of 74 per acre—the highest in Europe. The city population was expanding not just because of Parisians, but also because of the influx of young men from the provinces seeking their fortune in the big city. Also, increasing numbers of foreigners were coming to learn at the university, ply the diplomatic trade, or buy and sell with the great merchant houses.

The once-independent villages surrounding Paris were being submerged by infill. Houses for the wealthy were being built around the Louvre, at Mont Ste. Geneviève, St. Germain-l'Auxerrois, Greve, and in the Marais.

## The House of Valois

Medieval Europe was continually in conflict but matters got much worse in 1328 when Charles IV of France (and last of the Capetians) died. The French throne hit a crisis—the English king Edward III as Charles' nephew (through his mother, Charles' sister), thought he should have the French crown; however, the French barons preferred Philip the IIIs (1268–1314) grandson, Philip de Valois, who they crowned Philipe VI. The scene was set for the conflict that in time became known as the Hundred Years War, a long drawn out range of arguments centering around control of France that were fuelled by increasingly complicated feudal contracts between the various participants.

The Hundred Years War was actually a prolonged on and off series of battles and encounters between England and France which started in 1337 and continued until 1453 when the English were finally thrown out of France. During this period Paris and Parisians had a particularly hard time as the different political and royal factions each in turn dominated the city.

At the same time the most devastating natural event in medieval Europe was the arrival of the Black Death in about 1346 that lasted in virulent mode until around 1351. This is a form of bubonic plague that first appears by giving its victim a high sweating fever, splitting headache, vomiting, delirium, pain in the back and legs, and discolored skin; on the second day huge black swellings appeared in the groin and armpits. Typically within three days 99 percent of the victims were dead. The carriers of the plague were the millions of rats that infested the medieval countryside and cities. People caught the plague via bites from rat-carried fleas.

The plague probably originated in the Middle East and arrived in Europe via southern Russia along the great trade routes where it was caught by Venetian and Genoese traders. It swept westwards through Europe at an alarming rate. Plague was in the Crimea in 1346, Pisa, Italy, in early 1348 and had reached Paris by early June 1348; by late June it was in England. It has been estimated that 25–30 percent of the population of Europe—or 25 million people—died during this epidemic. Across France the population halved. Records have not survived for Paris, but it is reasonable to assume that given the overpopulation and cramped living conditions, the city suffered even greater losses.

Paris declared itself an independent commune for the first time in 1356; this lasted for three years. The leader of the movement was Etienne Marcel, the provost of Paris in 1356, a time when the young and inexperienced King Charles was harassed by ambitious and angry noblemen. Marcel, a Parisian

**LEFT:** A shop specializing in puppets. There are many such niche retailers in Paris, a city that revels in its huge retail diversity.

and wealthy clothier by trade, took it upon himself to defend the city from the machinations of the dauphin and the noblemen. The power struggle grew increasingly violent between the nobility and crown, who wanted to control Paris, and the townspeople who wanted to be their own masters.

Marcel was supported by Parisians who wore a red-and-blue hood as a sign of their allegiance. As matters became increasingly uncontrollable Charles fled Paris and started a blockade of the city to starve it into submission. Desperate for support Marcel appealed to the king of Navarre who arrived in Paris

**BELOW:** Detail of a street lamp near Les Invalides. Paris is known as the City of Lights and it certainly lives up to its name at night when the entire place is illuminated with light and color.

with English troops in tow. Parisians turned against Marcel and he was assassinated at the Porte Saint-Martin on July 31, 1358. Paris again came under the strict control of the crown.

Because of the general unrest and uncertain times, the city merchants decided to protect their interests by building a new city wall. This was started in 1356 on the Right Bank by the provost of merchants, Etienne Marcel, and was finished by Charles V (1364–1380). When it was finished it had enclosed 430 more acres outside Philippe-Auguste's wall, stood between 26 and 33 feet high, included six small fortresses (called bastilles), and was surrounded by a double moat. Meanwhile Philippe-Auguste's original wall on the Left Bank was reinforced and modernized. Paris now enclosed 1,084 acres.

Around 1370 work on the Bastille (Bastille Saint-Antoine) was started as part of the defenses on the Right Bank, with construction of eight massive towers. Elsewhere the Louvre was again remodeled by being enlarged and modernized. To pay for all this work and the continuing wars, Charles V increased taxes on his citizens and became even more unpopular in the process. Fearing for his life he fled Paris for the relative safety of the Château at Vincennes, which he hastily fortified. The French monarchy never returned to live in Paris, deeming it too dangerous. When Charles V died in 1380, rioters thronged the streets to protest their increasing tax burden.

Paris had grown enormously in the last few decades and had now emerged as three distinct districts: the original Île de la Cité had become the area of government and administrators for both France and Paris; the Left Bank was the area for students and intellectuals; and around the Place de Greve lived the merchants and their businesses. The poor lived wherever they could find space—rents and taxes escalated regularly and revolt was never very far away. Money lenders were blamed, in particular the Jews, and they were expelled from Paris and France in September 1394. (They were not officially permitted to return to Paris until 1789.)

In 1418 Paris became the battleground between the Burgundians and the Armagnacs—with fortunes fluctuating between the factions. The king, Charles VI, was caught between the two sides—both of which claimed to be his allies, but actually wanted to control him. The two sides eventually fought it out at the Bastille and on the night of June 12–13 all Armagnacs found in the city were slaughtered by the mob. The fighting carried on through July. Paris was a Burgundian city. The fallout of all the plots and murders was that the Burgundians entered into an alliance with the English in 1419 and Paris was turned over to King Henry V and his English forces. They stayed until 1436.

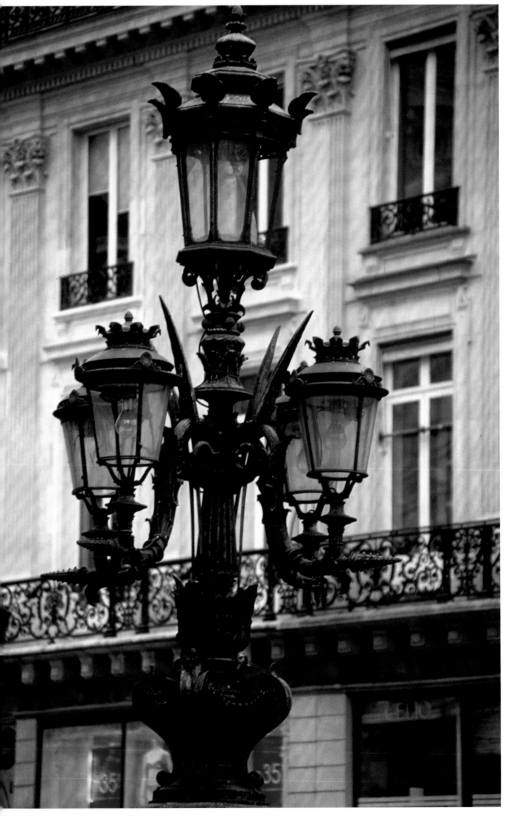

In 1429, after the coronation of Charles VII at Rheims, Joan of Arc led the French army to Paris in an attempt to take the city back. On September 8 they stormed the walls between Porte St. Denis and Porte St. Honore. In the course of the battle Joan is wounded by an arrow and then to her dismay her troops are ordered by others to withdraw, which they do in disarray. The following May Joan of Arc was captured by the Burgundians who handed her over to the English who tried her, found her guilty of being a heretic, and sent her to the stake at Rouen in 1430.

The inevitable companion of such turmoil and insurrection was famine. Many people in Paris found themselves on the edge of starvation as armed gangs and deserting soldiers rampaged the countryside and food failed to get through to the city. Many people fled. English control of Paris was emphasized in 1431 when nine-year old Henry V was crowned in Notre-Dame as Henry II of France.

Despite this seeming triumph the English were gradually losing ground in northern France: their one-time allies the Burgundians made peace at the Treaty of Arras with the French king Charles VII. Paris remained English—it seems with the support of much of the population—until 1436 when it was besieged again by the French troops. The city was soon starving and Parisians loyal to Charles gave the troops entry on April 13. The English retreated to the stronghold of the Bastille; negotiations were held and a general amnesty was declared and the English allowed to withdraw from Paris.

Paris was French again and it took a couple of decades for the economy to recover, but prosperity returned—as did the plague in 1466 when an estimated 40,000 people died in Paris alone. Thousands more died out in the countryside. Despite this, indication of the improving economy was evident when work started in 1506 on the Notre-Dame bridge.

Francis I (1494–1547) was crowned in 1515 by which time Paris had grown as far as it was possible: undrainable swamps to the east and north prevented further expansion. The population of Paris was a teeming 200,000 mostly crammed into medieval streets and unsanitary and overcrowded tenement houses. Traffic and trade routinely ground to a halt as narrow streets were blocked by everyday incidents. Sanitation was a huge problem, causing untold diseases and foul-smelling air. The River Seine was polluted with numerous chemicals spilling out from local industries and human waste. There was no clean water for the majority of the population; the administration of water belonged to the king—it was exclusively his to give out. By 1533 Paris had grown to about 260,000 people.

The lack of room for further expansion called for

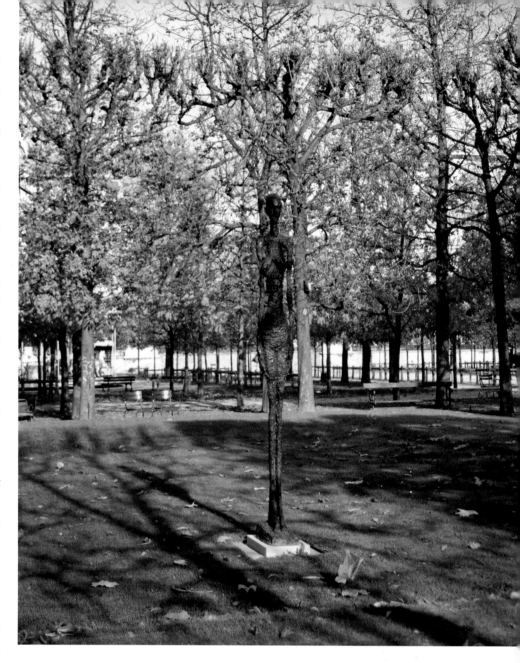

drastic measures. Francis I was anxious not to allow the suburbs to grow further because it made Paris difficult to defend from attack. Instead he ordered the clearing of the city dumps and personally provided a number of his residences for housing development. Despite this Paris continued to expand westwards due to population pressure. Rents continued going up and accommodation continued getting smaller as buildings and rooms were subdivided to make more of the limited space.

Yet Francis rebuilt the Louvre in the latest Renaissance style. Just two years later Leonardo da Vinci arrived in Paris, bringing with him his favorite painting—the *Mona Lisa* (aka La Gioconda)—which he carried wherever he went. Somehow he was eventually persuaded to sell it to Francis I.

Politically and economically Paris was in crisis. The huge population was stifling the city, trade had ground to a near halt. Private carriages were banned altogether in 1563 in an attempt to reduce the traffic on the streets and allow everyday commerce to flow. The city imported goods but exported nothing and even redistribution of goods was almost nonexistent.

**ABOVE:** Sculpture and art can be found in many public places around Paris, especially in the parks. The city has been famous for attracting artists since the Impressionists made starving in a Parisian garret fashionable.

LEFT: Graceful bronze figures stand at regular intervals across the front of the Palais de Chaillot. Other decorations include bas reliefs and monumental groups of bronze figures.

Yet Paris remained an important cultural and economic center.

## Religious Persecution

A new element had been introduced to the already-volatile Parisian mix—Protestantism. The Reformation quickly took firm hold in many parts of Europe and although there was no question of France remaining a Roman Catholic country, many of her people took to the new religion. Religious persecution and execution started in 1523 when the first Protestants were put to death. Soon the city was not safe for any nonconformists as rabble-rousing preachers encouraged the mob to seek out heretics. The dreadful culmination came on the night of St. Bartholomew's Eve August 24, 1572.

The late sixteenth century was a particularly bloody time for France and Paris in particular. The religious wars took a heavy toll on everyone from the lowest to the highest as theological differences meant the difference between life and death. The Protestant Reformation, with its emphasis on reading the Bible and leading an austere life, found many willing followers in France, particularly among the nobility. Few peasants took to the new religion and the Paris mob remained firmly Catholic, as did the city's main institutions, in particular the monarchy and the court. Fanatical preachers urged the mob to violence against Huguenots (French Protestants) and their businesses and families.

Then, on the night of August 24, 1572, French soldiers enthusiastically helped by the mob turned on the Protestants and butchered them wherever they discovered them. Somewhere around 2,000 Huguenot men, women, and children were massacred in Paris that night and many more were killed over the ensuing week. The roads of Paris were literally running with blood and many corpses were tossed into the Seine making the water rancid for months. The order for the killings was signed by Catherine de Medici, the regent and mother of the last three Valois kings—François II, Charles IX, and Henri III.

In 1588 King Henri III tried in vain to stop the rabble-rousing preachers who were calling for the death of all Protestants, but the Paris mob turned on him. France was ripped apart by the religious wars and peace was a long time coming. Eventually, the Protestant Henry of Navarre—together with his old rival King Henri III—besieged Paris in 1589. During the ensuing months of the blockade, famine stalked the streets of Paris and almost 15,000 people died. Henri III was murdered in July 1589, leaving the Protestant Henry of Navarre heir apparent. He proclaimed himself King Henri IV, but because many of the troops refused to support a Protestant king,

he was forced to withdraw the siege. When Paris finally capitulated, the victors took revenge by declaring Paris guilt of felony and stripping the city of all ancient rights and privileges and independence of action.

Paris was run by the mob and its economy was in tatters. Much of the outskirts had been burned to the ground. In 1593 it became politic for Henri IV to appear to convert to Catholicism—his famous remark "Paris is well worth a mass." But Paris was in ruins, with the suburbs in particular badly damaged and uninhabitable. Rents had dropped by as much as a third, the mob was starving, unemployed, and always on the lookout for trouble. Troops had to patrol the streets and ruthlessly suppress any sign of insurrection.

Henri knew that the city needed rebuilding and he started organizing a public works building program: there were new squares; the Hospital of St. Louis was built to treat victims of the plague; the Louvre and Tuileries were refurbished and enlarged; and new bridges were built, including the Pont Neuf, which was completed in 1604. This was the first stone bridge without houses on it. It linked the Louvre palace and the church of St. Germain-des-Près. Many streets were paved and wherever possible they were also widened. In addition Henri tried to balance the city on either side of the Seine by building an additional 35 new streets on the Right Bank and 33 new streets on the Left Bank. In 1607 there was an important new regulation designed to open up the streets and reduce congestion points: The king ordered that buildings should no longer be made of wood, have overhanging stories, or be out of alignment with their neighbors. Much of this was ignored.

The lack of clean water in Paris was still a major problem, as were the poor sanitation and the waste littering the streets. All the water pipes providing water to private houses were destroyed so as to provide a more even distribution to the poor. Then in 1608 the Pont-Neuf pump (the Samaritaine), a hydraulically operated machine, was installed in the Seine to pump water into a reservoir above the Pont Neuf, and did improve the water supply in part of the city. It provided running water for the Right Bank until 1813. The pump was decorated with the woman of Samaria giving a drink of water to Jesus.

The result of all these projects was a surge in employment and an improving economy.

A measure of peace came in 1598 when Henri IV signed the Edict of Nantes that gave the Huguenots (French Protestants) the right to public worship and freedom of conscience. The two sides were still often openly hostile to each other, but at least it was an

improvement and a structure from which to develop a more tolerant society. (The Edict of Nantes was revoked in 1685 as part of Louis XIV's anti-Protestant measures.)

## Expansion

In the 1590s, records put the Parisian population at 200,000; by 1637 this had risen dramatically to 400,000, and the city had grown in size to accommodate everyone. During the seventeenth century, Paris expanded even more with buildings and grand projects. Land prices shot up and increased to become a staggering sixty times more expensive in only forty years. Inevitably rents, too, shot up. In 1616 a series of gardens were laid out along the Cours de la Reine on the Right Bank. This open space proved extremely popular with Parisians and they were continually improved and made larger until they were renamed the Elysian Fields—or the Champs-Élysées.

The Left Bank was now becoming fashionable especially after Marie de Medici built the Medici Palace (later the Palais du Luxembourg) and Cardinal Richelieu built the Palais-Cardinal (later the Palais Royal). To bring the luxury of water to the area the Arcueil viaduct was built and this in turn made possible the construction of new districts for the aristocracy, such as the Marais and the Pré-aux-Clercs (Faubourg St. Germain). In addition, the uninhabited island of Île des Vaches in the middle of the Seine was joined by a bridge to the Île de la Cité and given the important name of Île Saint Louis.

The expansion of the city included the extension of the power and importance of the church. In 1622 Paris became an archbishopric: between 1600 and 1640 sixty monasteries were founded in Paris—by 1700 this had reached a staggering 110 monastic foundations in Paris alone.

In 1635 it was felt necessary to invest in building a fifth city wall. In addition the city dumps were cleared and all the refuse removed to beyond the swamps; this cleared the way for more buildings as well as reducing the volume of vermin and pestilence. However, raw sewage was still being poured into the Seine.

## The Paris and the Fronde

By 1650 times were hard and the building boom in Paris was over until the end of the recession—which wasn't until 1715. In the early 1650s, peasants from the French countryside flocked into Paris hoping for better times. Rents had dropped enormously, but there was little or no work to be found. An estimated 48,000 beggars thronged the streets. As is often the case, merchants raised the price of goods for short-term profit. The mob began to mutter and tension increased on the streets; more people lost their jobs and more people were left with nothing to lose by insurrection.

Matters came to a head in 1648 with the Fronde—a bitter civil war that lasted until 1653. When Louis XIII died he left the young Louis XIV the throne, so his mother Anne of Austria was appointed regent. She relied on the unpopular and ambitious Italian Cardinal Mazarin. The trouble started on the streets of Paris with the "frondeurs," named after the fronds (or slingshots) they used to throw missiles. Many French nobles used the opportunity to try to seize power and influence over the young monarch. Within the year the frondeurs ran Paris and the mob alternately welcomed or reviled Louis and his mother as the political climate shifted. Paris as a city suffered badly during this period. Thanks to the fluctuations of war and shifting alliances outside, food supplies rarely got through to the starving Parisians. The streets, where anarchy was the rule, were unsafe for anyone. By 1652 the Fronde was over in Paris, though it continued for another year in the countryside. The city had to bend to royal authority: Louis returned to live in Paris, but this time at the bastion of the Louvre. However, it is

**RIGHT:** Black and white photographs of Paris horse-drawn traffic from about 1910. Top, the Bois de Boulogne; Center, Les Acacias; Below, Boulevard de la Madeleine.

**BELOW:** Two hand-colored lithographs of Paris dating from about 1840. Top, the Boulevard Beaumarchais, Rue du Chemin Vert. Bottom: Boulevard des Italiens, Opéra.

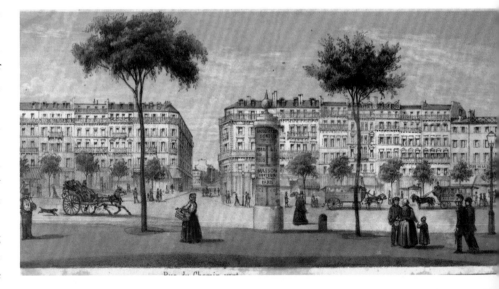

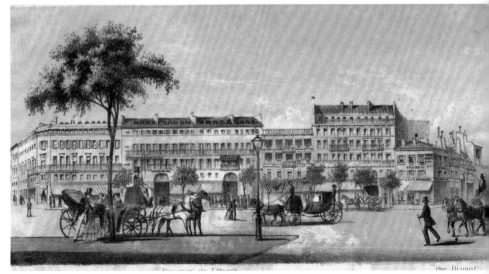

probable that he had already decided to abandon Paris for the safety of a palace in the country. So the idea of Versailles was born.

## Le Roi Soleil—"The Sun King"—Louis XIV

After the Fronde, Paris covered about 2,000 acres but with stability started rapid expansion again. By 1715 the city had expanded an additional 750 acres. Statistics for Paris become more certain thanks to Minister Colbert, who in 1670 started an annual census of births, marriages, and deaths—all the better to collect taxes with. These indicate that the population of Paris had grown to around 500,000 in 1715. In addition the figures show that the overcrowding and lack of sanitation gave a higher mortality rate than the birth rate, and also that the expansion of the population of Paris was owed almost entirely to rural migration into the city.

With the help of Colbert, Louis XIV established many grandiose architectural projects. His philosophy was "*L'état, c'est moi*" (I am the state) and he turned France into the most formidable and powerful nation-state in Europe—justifiably feared and hated by her neighbors.

Colossal sums of money were also spent glorifying Paris. The Tuileries gardens were laid out, and the hospitals of Hôtel des Invalides for soldiers and the Pitie-Salpêtriere hospital for the poor and insane were founded. Louis celebrated his military victories by replacing the old city gates with new triumphal arches at Saint-Martin, Saint-Denis, and Saint-Antoine. Much of the gypsum and limestone for these developments was quarried from directly underneath Paris from mines dating from Roman times. Even now there are more than 186 miles of underground tunnels on the Left Bank alone. Around 1760 Louis XV commissioned the building of the École Militaire, the Panthéon, and a square that would become the Place de la Concorde.

As Paris expanded the water supply was not improved—in fact it was badly under-funded and neglected. Louis was only interested in visibly grandiose projects; the continuing problem of lack of water and poor sanitation in Paris did not interest him. The department of city waters was virtually ignored. The only improvement was thanks to Daniel Jolly who thought of using a wheat mill that was powered by the racing currents of the Seine just under Notre-Dame bridge. This pump fed water to 21 fountains and 81 properties—a small improvement, but better than nothing. Following this success, minister Colbert installed new hydraulic pumps in the Seine, this time to the benefit of another 500,000 people.

Another recurrent problem was getting and then distributing sufficient food through the narrow maze of streets to feed the huge population of Paris. Also

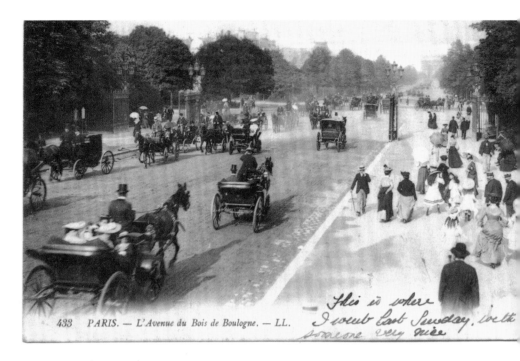

433    PARIS. — L'Avenue du Bois de Boulogne. — LL.

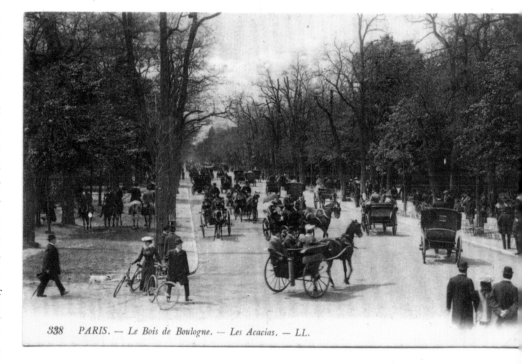

338    PARIS. — Le Bois de Boulogne. — Les Acacias. — LL.

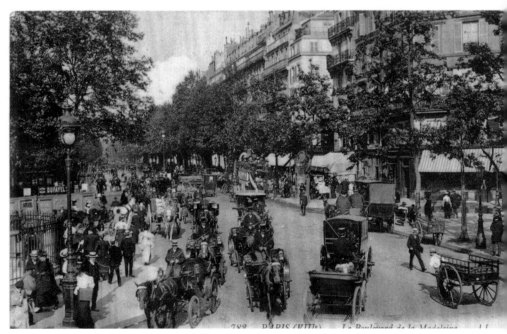

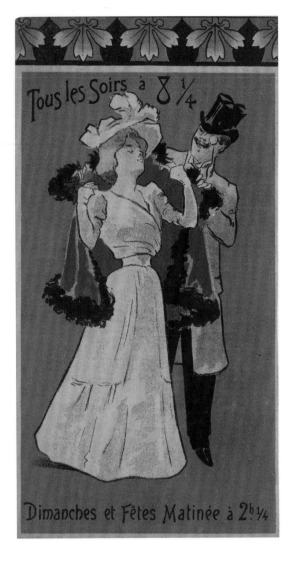

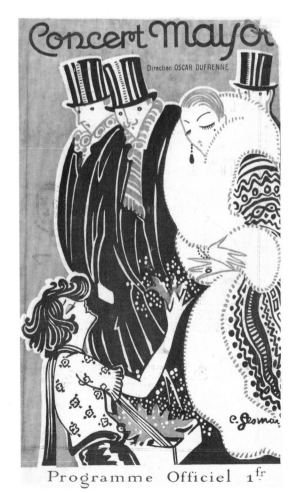

the huge numbers of people attracted to work on the building sites meant even more mouths to feed. Things got so bad that Louis ordered his regional police lieutenants the power to commandeer food for Paris. Such measures caused enormous resentment out in the provinces since in times of hardship or poor harvest entire regions were left to starve when what little food that was available was redirected to Paris.

Louis XIV's extravagant spending on both buildings and warfare pitched France into the general European economic depression and all but bankrupted France. Paris was now the most important economic center in Europe and had the highest population of any city in Europe. To complete the economic transformation, the forerunner of the Bourse (stock exchange) opened as a securities market in 1674.

With France so preeminent militarily and Paris rapidly expanding beyond the city limits, the city walls had become redundant and were increasingly raided for other building works.

The monarchy moved out of Paris altogether in 1678 as Louis completed the vast palatial complex of Versailles, west of Paris. It took 30,000 craftsmen and builders 20 years to complete. When it was finished Versailles was easily the most magnificent and imposing palace in the world. The royal court was established there in 1862 and many of the French nobility moved out of stinking and dangerous Paris to build their luxury homes around the royal court in Versailles. Louis controlled every aspect of French government and culture. Thousands of people had toiled to create the remarkable luxuries that the king demanded—glass, tapestries, silks, elaborate furniture, and mirrors. The famous Gobelin tapestry factory was founded to make wall coverings for Versailles. All this cost huge amounts of money—a lot came from the spoils of war, but much also was squeezed out of an increasingly resentful tax-paying public.

Following the death of Louis XIV in 1715 at the age of 77, his extravagance had left France almost bankrupt. To make matters worse, the thousands of craftsmen he had employed at huge expense lost their living as the luxury industries collapsed. Many of those left without a job lived in Paris.

### Paris in the eighteenth century

As the century progressed and the prosperity of Paris grew so did the population—until it was again at bursting point. The city was continually expanding on all available ground with no regulations to control the sprawl. In an attempt to get a grasp of the situation in 1728, houses in the suburbs started to be numbered. This provided a measure of control and

*continued on page 27*

**LEFT:** Theater program dating from about 1900.

**BELOW LEFT:** Concert program from about 1920. The French artist Charles Gesmar was well known for his posters advertising the exciting nightlife of Paris.

**RIGHT:** Getting high above the street level is instructive in any city. Thanks to Baron Haussmann many of the buildings have roofs made of zinc, which is more useful and flexible than slates and tiles in such a varied and compact roofscape as Paris.

**BELOW RIGHT:** There are many roof gardens to be found in Paris. This one, with a view of the Eiffel Tower, is atop Galeries Lafayette, on Boulevard Haussmann.

**PAGE 24–25:** Paris's oldest bridge is the stone-built Pont Neuf on the Île de France, built for Henri IV between 1578 and 1607. The 381 stone masks are copies of the Renaissance originals. When the bridge was rebuilt 1851–1854 the masks had to be recreated. There was a further major restoration of the bridge between 1994–2007.

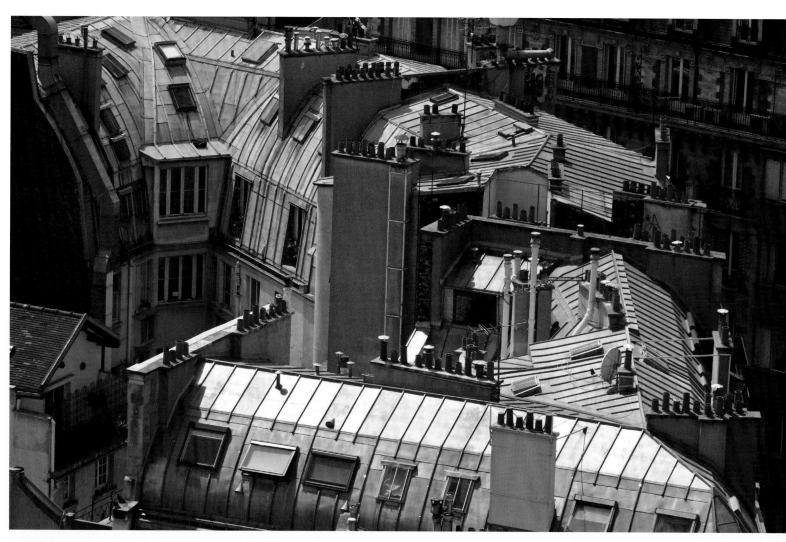

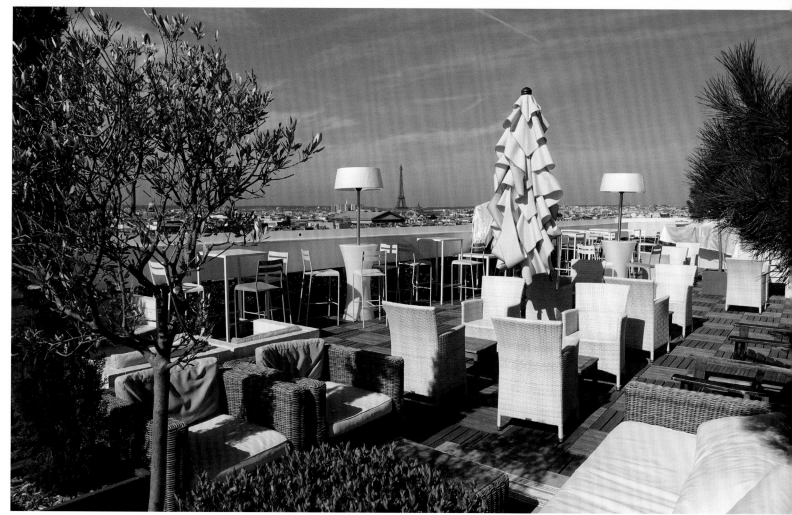

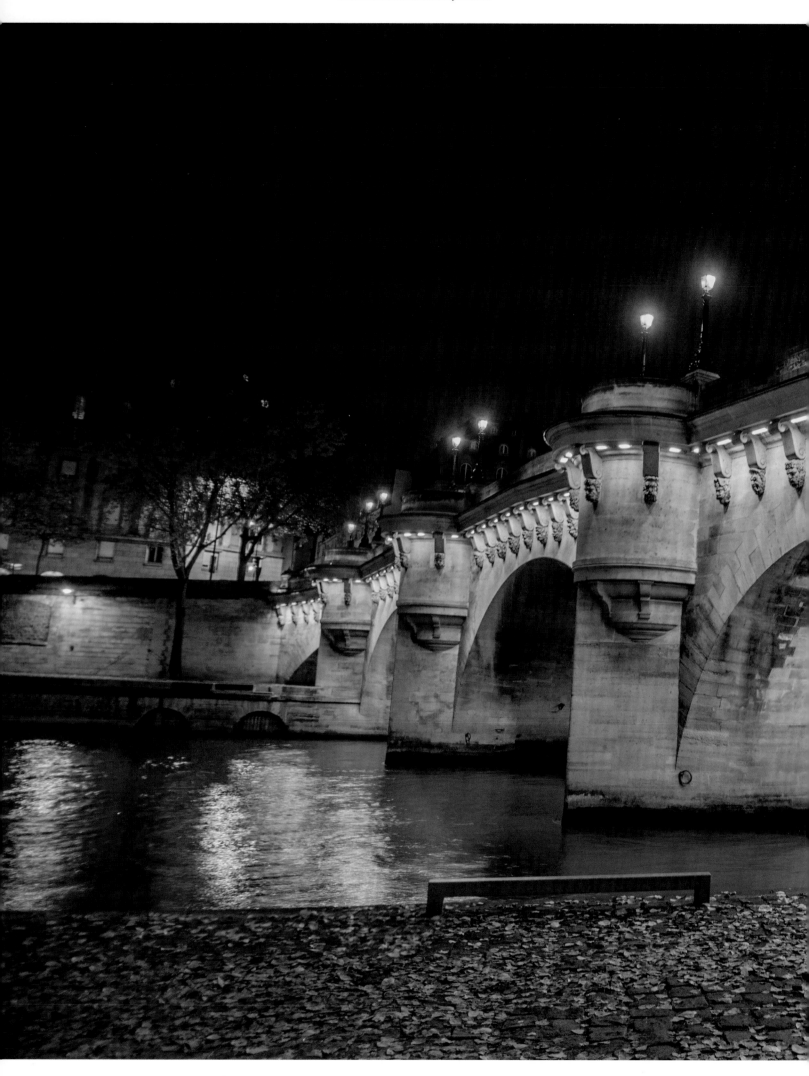

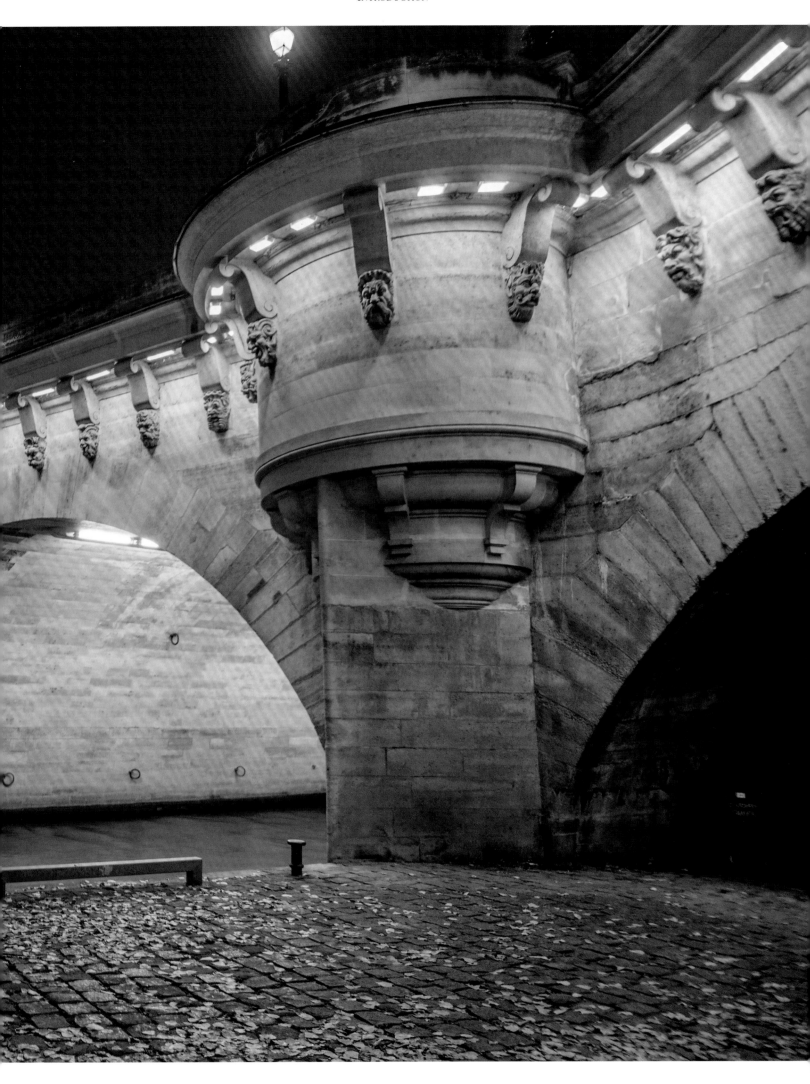

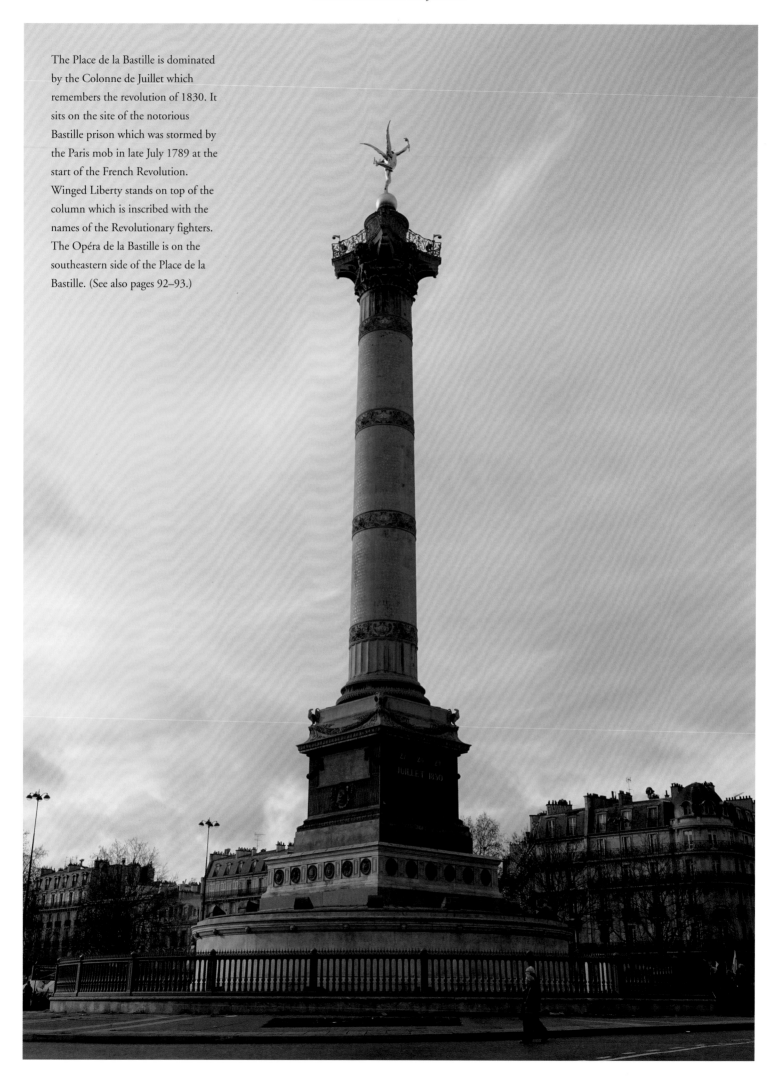

The Place de la Bastille is dominated by the Colonne de Juillet which remembers the revolution of 1830. It sits on the site of the notorious Bastille prison which was stormed by the Paris mob in late July 1789 at the start of the French Revolution. Winged Liberty stands on top of the column which is inscribed with the names of the Revolutionary fighters. The Opéra de la Bastille is on the southeastern side of the Place de la Bastille. (See also pages 92–93.)

MAXIMILIEN ROBESPIERRE

An austere, rabble-rouser nicknamed "the Incorruptible," Robespierre's name lives on as the ultimate revolutionary. During his period in power the French monarchy was eliminated—along with many intellectuals and the aristocracy, too—by "Madame la Guillotine." Maximilien Marie Isidore de Robespierre was born in Arras on May 6, 1758. At eleven, he left home with a scholarship from the College Louis-le-Grand in Paris, where he developed a passion for the philosophy of Rousseau who believed that men are born good but are corrupted by society. Robespierre got his degree and law license, and returned to Arras where he set up practice. He entered the Estates General representing Artois in 1789. There he allied himself with the extremist left and his rise through the ranks was rapid. During the Reign of Terror, France was governed by the 12-man Committee of Public Safety: Robespierre was elected to it on July 27, 1793. About 16,000 people, mostly aristocrats, were sent to the guillotine in the nine months the committee prevailed. On January 21, 1793, King Louis XVI was condemned to the guillotine. Robespierre then assumed complete control of the Revolutionary Tribunal. He also started the beginnings of a form of welfare state, and the adoption of a revolutionary calendar with 10-day weeks. He even sent his one-time ally Danton to the guillotine. Robespierre had many and various enemies, and fearing a dictatorship, they allied to denounce him in the convention on July 27, 1794; a deputy called for his arrest. When he fled to the Common Hall, the Convention declared him an outlaw and sent the National Guard to capture him. Next day Robespierre and 21 supporters were guillotined without trial.

the numbering was brought into the city of Paris until 1780. In 1729 street name signs were put up for the first time. But still people poured into the city and the population expanded. Every ambitious Frenchman made his way to the capital to be near the royal patronage and chances of appointment to office. The Paris stock exchange, the Bourse, had been created in 1724 to take advantage of the newly created wealth. This emptied the rest of France of many of its most able and innovative people and much of the wealth of the provinces as well. Nobody seemed capable of stopping unregulated building. The swamps were drained more effectively for yet more building land. New areas became fashionable as the latest homes were built, which due to the pressure on land, grew ever taller.

As usual, the poor suffered the worst as they were squeezed into smaller, smellier, and more expensive apartments. Slums infested the heart of Paris, making the center unsafe and unhealthy for everyone. The other great slum district was St. Michel but even there the high rents forced the very lowest of the low further out. The city authorities made frequent but futile attempts to clean up the housing problem but the continuous influx from the provinces filled up any recently vacated places. Urban renewal projects were started but always overwhelmed by the demand for homes. Despite all this the city was taking shape and in 1757 the first oil lamps were used to light Paris for the first time.

Human waste and lack of clean water were perennial problems. Some districts had water; most had access to reasonable though inadequate supplies. The problem was particularly acute in the southeast after 1760 when the great Oberkampf cotton-printing factory started operating in Jouy-in-Josas and pouring all its chemicals into the River Bièvre, a tributary of the Seine. Ironically, the factory was positioned at Jouy because of the good quality of the water there. (By 1821 the factory had become the biggest in Europe, employing 1,237 people.)

Improvement came in 1778 when the Périer brothers established the Compagnie des Eaux de Paris, which allowed paying customers to connect their homes to the water supply. They also provided fountains where water could be sold directly to anyone who could afford to pay.

Paris remained a great European financial center but by the mid-eighteenth century the only economic business left was the supplying and servicing of the population in Paris. All other jobs had disappeared except for manufacturing a few luxury handicrafts desired by the king and court. The perennial Parisian problems of overcrowding, unsanitary conditions and pollution remained. Starting in 1786 it was decided that the smelly and

overcrowded city cemeteries should be cleared. In particular, the fumes given off by decaying bodies in the Cimetière des Innocents graveyard was a severe hazard to the living; the graveyard was said by some to have been 1,000 years old by the time it was emptied. Accordingly, around six million bodies were respectfully disinterred, blessed by the local parish priests, and removed by horse-drawn carriages to the vast underground limestone catacombs 65 meters below southern Paris at Place Denfert-Rochereau. There the bones were carefully arranged in artistic tableaux and again blessed with a new mass. In this way, over a period of fifteen months, the central Parisian graveyards were cleared. At the same time, in 1787, the first detailed map of Paris was compiled by Verniquet to assist with city planning.

**The French Revolution**

Louis XVI came to the throne in 1774 at a time when Paris was completely reliant on the French countryside for food and supplies. But the harvests of 1787 and 1789 failed in northern France and people starved in the countryside and in Paris. This led to food shortages and the inevitable Parisian food riots and ten years of deep civil unrest accompanied by rioting. The major grievances were hunger, high taxation, and a deep resentment of the aristocracy and royalty. No obvious solutions presented themselves to the politicians until they finally agreed to hold the first National Assembly on June 17, 1789. Their pledge was not to withdraw until a French constitution had been agreed on that established liberty, equality, and fraternity and limited royal powers and privilege.

The causes of the French Revolution were many and complicated, but it basically stemmed from the injustice of the poor living in famine and squalor and suffering crippling taxation while the rich lived an idle life of luxury and plenty. The monarch, Louis XVI, was particularly resented and hated for his royal insistence on absolutism.

The revolutionaries were also inspired by the freedoms acquired by the American Revolution of 1776 and the new intellectual thinking and approach inspired by the Enlightenment philosophers. So knowing this alternative, all talk and no food or justice proved too much for Parisians and one month later, on July 14, 1789, the Paris mob stormed the Bastille—the hated symbol of royal repression—urged on by a young lawyer, Camille Desmoulins. The Bastille fell within four hours. The governor and some guards were killed and seven prisoners released.

Revolutionary fervor swept France and the aristocracy feared for their lives and fortunes. Rioting and looting caused a great deal of damage to magnificent Parisian buildings. Numerous political reforms were forced through in the first few months of

revolution as the king and National Assembly formed a temporary reconciliation, but anarchy filled the streets and revolutionary fervor could not be suppressed. Those nobles who could escaped to the countryside or to the safety of England. In the countryside many peasants took up the cry and burned their local chateau (castle) in the agrarian revolution known a *La Grande Peur* (the Great Fear).

On August 4, 1789, the National Assembly abolished feudalism altogether, removing centuries of aristocratic and clerical privilege. The church was, along with the aristocracy, one of the great losers of the revolution. Church lands were nationalized and religion was outlawed. At the start of the revolution Paris was home to 50 monasteries, 62 nunneries, 41 churches, 22 important chapels, and 11 seminaries—all of which were taken by the authorities and sold off. Also appropriated were hospitals that were administered and funded by the church.

In 1792 King Louis and Marie-Antoinette realized that their lives were in imminent danger and fled Paris only to be caught and brought back to confinement in the Tuileries. With the monarchy firmly under lock and key, the First Republic was declared on September 20, 1792. Soon the relatively moderate Girondin party was replaced in the National Assembly by the far more republican Danton, Robespierre, and Marat. On January 21, 1793, King Louis XVI went to the guillotine in the Place de la Révolution (now Place de la Concorde) with the crowds cheering all the way. A collective shiver ran through the European monarchy when the news reached them. A few months later Marie-Antoinette followed her husband onto the guillotine and in time their great Louvre Palace became a public museum.

Any suspected aristocrat or monarchist was taken by tumbril (open cart) to the guillotine during the ensuing period known as the Great Terror. Thousands of people were pulled off the street, questioned, and often imprisoned. In a period of 13 months around 2,800 people went to the guillotine; the most famous executioner was Henri Sanson who claimed to have cut off 54 heads in 24 minutes—one every 30 seconds! Finally, with poetic irony, the hated leader of the terror, Maximilien Robespierre, was sent to "Madame La Guillotine."

Paris suffered economically as well physically during the terror. About one-eighth of Parisian property was seized by the commune and sold off— royalty, nobility, the church, and foreigners all lost their properties. Thanks to the prevailing anarchy and wholesale disruption, food distribution was virtually nonexistent and the people were starving and very unhappy. What little food that was available—and this was mostly just bread—

was hugely inflated in price. Coupled with unemployment it was inevitable that the mob would riot at the slightest opportunity. Such chaos left the path open for a clever and ambitious man like Napoleon Bonaparte.

Others also found the climate ripe for change. The church was able to return to the city and reclaim much of its former holdings: by 1799, sixty-two monasteries had been reinstated. Within two more years most of the churches had been repaired but to the priests' dismay many of the former congregation had abandoned religion altogether. A few churches were given to the Protestants.

## Napoleon Bonaparte

By 1799 Napoleon was starting to accumulate power and the Parisians welcomed him with open arms as their savior. However, the city authorities were reluctant to allow him control of their business, so Napoleon simply removed their authority and instead created the Préfecture of Police to control the city. The first population census of Paris was held in 1801 and it showed that the city contained 547,756 citizens and was (again) bursting at the seams.

Accordingly, Napoleon ordered the clearing of the sixteen city cemeteries that had filled up again after the 1786 clearances. He announced his intention of making Paris into a magnificent imperial city in the style of ancient Rome. For this he had drawn up a comprehensive urbanization scheme. This included the creation of specialized district market-places and a food distribution scheme so that in times of trouble Parisians would not starve again as quickly. As further proof of his iron hold over France, Napoleon ordered that all French provincial archives be sent to Paris. Paris was to be his imperial city and he poured the spoils of his conquests into grand building projects. Monuments were built— including the triumphal arches of Carrousel and Étoile, and the Grand Army Column at Place Vendôme. New bridges were built across the Seine and docks were rebuilt along the riverside; an improved sewage system was also installed. In addition, new and better housing was built—at last standards of living for everyone improved. All this had the additional benefit of providing much-needed work for previously unemployed Parisians. Meanwhile, the population rose to top 700,000.

Napoleon tackled the ever-present water shortage problem by creating a public service for water—all water production and distribution became the responsibility of the Seine prefect. The Ourcq Canal was built and the Grenelle artesian well was drilled. Fountains to provide water were installed across the city so nobody was far from a water source. However, much of this water was still drawn from the polluted

**RIGHT:** At a glance many buildings in Paris appear broadly the same, but in fact there is huge variety in the details such as this elaborate door knocker. Fine ironwork grills cover windows and beautifully designed handles, rails, and signs appear on many of the older buildings. Some of the metalwork is lovingly polished while other objects lie undiscovered under layers of old paint or verdigris just waiting to reappear.

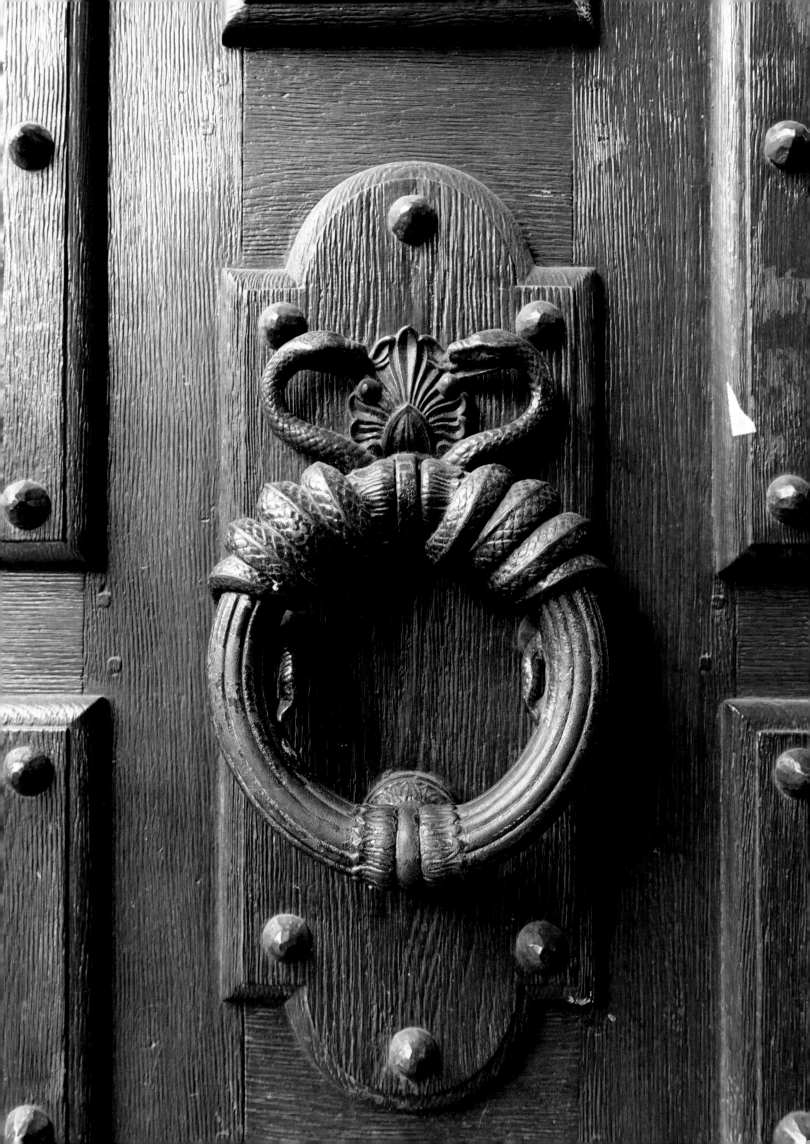

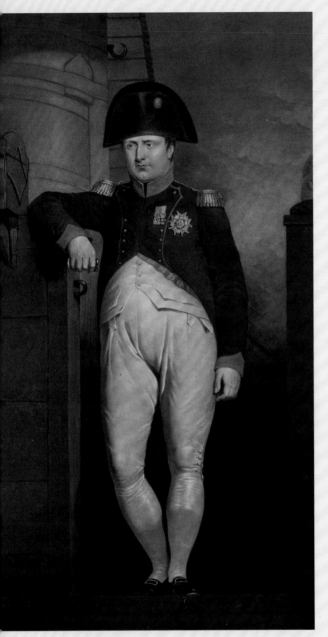

Napoleon used the capital of France as the monument to his own greatness and turned it into an imperial city. He started a program of grand plans and building works that included new bridges, fountains, sewers, and markets.

He was born on August 15, 1769, in Ajaccio, Corsica. His military career started at age nine when he was sent to the French military academy at Brienne-le-Château, near Troyes. After proving an excellent student, Napoleon was selected to attend the elite École Militaire in Paris in 1784. A year later, he joined the French army as a second lieutenant of artillery in the regiment of la Fère garrisoned at Valence. At some point his nickname of the "little Corsican" was coined, thanks to his diminutive 5ft 2in height. When the French Revolution started, many French cities openly revolted against the government. For his part Napoleon returned to Corsica where he tried to organize a revolution. He was discharged for desertion, but rejoined his regiment in 1792. Sent to Toulon to take charge of the artillery during the siege, he excelled himself and was promoted to brigadier-general. In 1795 as the counter-revolutionary mob threatened to take Paris, Napoleon successfully saved the day at the Tuileries. In gratitude for his actions, the new French administration made him commander of the French army in Italy against the Austrians. Two days before leaving he married a woman six years his senior, Joséphine de Beauharnais, widow of General Vicomte de Beauharnais and mistress to several leading political figures. In his first big campaign, Napoleon defeated four armies much larger than the one he led. Austria was forced to ask for peace as Napoleon marched on Vienna.

He next saw action when he took 38,000 men across the Mediterranean to Egypt in May 1798 with the intention of damaging Britain's trade with India. In Egypt, Napoleon successfully defeated the ruling Mamelukes and took Cairo on July 24—but the French fleet was defeated at the Battle of the Nile by the British led by Admiral Horatio Nelson. This left the French army stranded and Napoleon fled back to France on August 22, 1799, before the news of defeat could precede him. In Paris he staged a coup d'état on November 9, 1799, making himself First Consul for a ten-year term and head of the new three-member Consulate. France was saddled with debt and could not afford further military campaigns without fixing its economy. The country was still riddled with corruption and ravaged with poverty and unemployment; part of Napoleon's solution was to regulate tax collection by using paid collectors. With the money he went to war. Europe was soon in turmoil; country after country fell, and Britain became the only standing enemy until 1802 and the treaty of Amiens.

In 1802 Napoleon was made First Consul for life, and in March 1804 the senate offered him the title of emperor. The magnificent coronation was held in December 1804 officiated by Pope Pius VII. On a cold and snowy December 2, Napoleon and Joséphine were taken through the boulevards of Paris by an elaborate royal coach drawn by eight horses to Notre-Dame Cathedral. The emperor wore purple velvet and both were swathed from head to foot in gold and gems. During a three-hour ceremony Napoleon crowned himself with a gold laurel wreath—he would acknowledge nobody as able to confer the honor on him, not even the pope.

To record the event Napoleon commissioned Jacques-Louis David to produce a monumental painting—it hangs now in the Louvre.

France's main enemy was still Britain, which now headed a coalition comprised of Russia, Sweden, Austria, and Naples. Napoleon's fleet was destroyed on October 21, 1805, at the Battle of Trafalgar but on December 2 Napoleon had one of his greatest victories, at Austerlitz against the Russians and Austrians, and the coalition collapsed. Napoleon wanted his exploits recorded for posterity in Paris and ordered a great triumphal arch—the Arc de Triomphe—in 1806. (The Arc was completed in 1836—some 20 sculptors worked on the project.) Napoleon's victories saw him become the strongest ruler in Europe from the Pyrenees to the Dalmatian coast. For local control he installed his brothers as rulers. However, the British were a constant thorn in his side, particularly in Portugal and Spain, where his brother Joseph ruled. The Peninsula War sapped France of men and money until eventually in 1813 Wellington forced the French out of the peninsula and invaded France.

Napoleon was not universally popular even in France and a failed attempt on his life turned his mind to his lack of a successor. In December 1809, he annulled his marriage to Joséphine and married Marie Louise, daughter of Francis I, emperor of Austria. On March 20, 1811, Marie Louise bore him a son, destined to bear the empty titles of King of Rome and Napoleon II. Next, Napoleon attacked Russia with a 600,000-strong army. The 1812 march into Russia, the burning of Moscow, and the long retreat has gone down as one of the greatest blunders of military history. The Russian winter devastated the French, and the Cossacks ripped the stragglers to pieces. The army was reduced to 30,000 weak and malnourished men. Napoleon had never been weaker and Britain allied with Austria, Russia, Prussia, and Sweden and marched on Paris. On April 11, 1814, Napoleon abdicated and was sent to rule the small Mediterranean island of Elba; his wife, Marie-Louise, refused to join him in exile and stayed in Austria with her family. On Elba Napoleon plotted his return. In February 1815, he escaped, landed in France, and started marching toward Paris picking up supporters along the way. The king sent the French army to stop him, but they joined his ranks. Napoleon entered Paris on March 20 and the old regime fled the city.

Napoleon's second reign lasted one hundred days. On June 18, 1815, his army was defeated at Waterloo, and he fled back to Paris. On June 22 he was forced to abdicate again. The allies sent him into exile on the remote island of St. Helena off the southern coast of Africa. There he wrote his memoirs and died of stomach troubles on May 5, 1821. On December 15, 1840, Napoleon's remains came back to Paris and were interred under the dome of Les Invalides. His red porphyry tomb was built in the specially redesigned crypt.

waters of the Seine and this resulted in regular epidemics of cholera and typhoid.

Throughout the Napoleonic period France was completely centralized, with every important aspect of French life decided in Paris. Every Frenchman had to go to Paris to advance his career whether it was in politics, commerce, or culture.

Napoleon was so successful in war that he managed to ally many of his enemies together to fight against France. On March 31, 1814, Paris surrendered to the Grand Alliance after skirmishing around Montmartre. Napoleon was forced to abdicate at Fontainebleau and was sent into exile on Elba. While there he plotted his return, and after escaping went on to lose once and for all at the Battle of Waterloo on June 18, 1815. Forced to abdicate again on June 22, he was exiled to the remote island of St. Helena in the South Atlantic where he died in 1821.

## Restoration of the Monarchy

Under the restoration of the Bourbon kings, France and Paris were able to reclaim their position as Europe's cultural and intellectual center. However, both country and capital were unprepared to take on the innovations of the Industrial Revolution that had started in Great Britain in the 1750s. Paris remained stuck in the past, with many small workshops producing goods, but few factories. The first steam railway to arrive in Paris was the Le Pecq, which connected Paris with the suburb of Le Pecq-sur-Seine. By 1842 six railway lines converged on Paris. As an experiment gas street lighting was tested in some central streets of Paris in 1808. This innovation proved popular by making the streets safer from thugs and pickpockets, and marked the beginning of Parisian night life of theaters, burlesque shows, bars, and restaurants. Lighting was extended to a wider area in 1819 and then all of Paris by 1829. In 1828 the first public transport bus started working in Paris.

In 1830 Paris still had its medieval street plan, with narrow twisting alleys and mazes of lanes known only to locals. Most of the poor lived in the east and many of these (about half the population of Paris) were uneducated, rural peasants who had come to the big city looking for work, higher pay, and social advancement. Their standard of living was appallingly bad with dense overcrowding, poor sanitation, and increasingly rising rents. The only work for most women was prostitution, while men were forced to steal to put food in their mouths. Gangs of thugs patrolled the streets, terrorizing everyone they came across. The city was not safe for honest folk. Between 1824 and 1847 80 percent of Parisians were so poverty-stricken that they went to

an early pauper's grave. Inevitably, those who could—notably the wealthy bourgeoisie—moved out of the center of Paris for the security of the suburbs.

The restored constitutional monarchy of Louis XVI and then his brother Charles X seemed oblivious to the realities of life for the vast majority of their subjects, and attempted to re-impose the autocratic dictatorship of their ancestor Louis XIV. By 1830 Paris was at a boiling point; it lacked jobs—an estimated 64,000 people were unemployed—the price of bread was constantly rising, and wages were being cut. All of France was in recession.

Charles X instead dismissed the new constitutional government, the Chamber of Deputies, and attempted to rule directly himself. He stopped the freedom of the press and reformed the electoral law—he may as well have put a match to a tinderbox. Paris exploded, the deputies refused to dissolve, and the barricades went up. Even the army was not eager to get involved. By May 29, 1830, Charles had lost Paris and soon after the throne. Forced to abdicate, he named his grandson, Henri V, as his successor rather than become a constitutional monarch. He fled to exile in England on August 17. The deputies declared that the throne was vacant and offered it instead to Louis-Philippe, duc d'Orleans.

## Paris in the nineteenth century

Just after this constitutional chaos, in 1832, a devastating cholera epidemic hit Paris after sweeping westward from Asia; it was exacerbated by the city's filthy water, overflowing sewers, and unhealthy living conditions. An astonishing 39,000 Parisians out of a population of 900,000 caught the disease, and 18,400 died; even the prime minister, Casimir Pierre Périer, died in May after visiting the sick in the hospitals of Paris. The air stank, especially in the summer heat, due to the lack of even basic sanitation. Human waste was just slung out into the street and around two-thirds of the streets contained open sewers. The throwing of human excrement, urine, water, and garbage into the street had been made illegal in 1780, but the law was largely ignored and generally unenforceable. The sewers emptied straight into the River Seine and these polluted waters were used to provide water for the city. Generally the rich lived on the west side of the city while the poor occupied the center and eastern sides.

Between 1840 and 1844 in an attempt to prevent further outbreaks. The heavily polluted River Bièvre

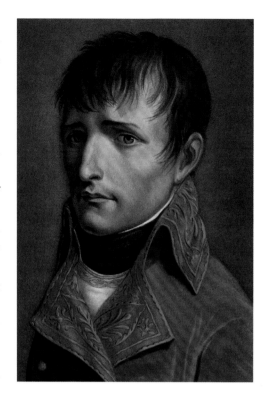

**ABOVE:** Napoleon Bonaparte whose charisma resonates down the years.

was culverted underground and the noxious Montfaucon city dump was abandoned. The dump had started in the time of Philippe-Auguste as both the royal gallows and city dump. For centuries the bodies of criminals as well as garbage were left to rot at Montfaucon and were the main cause of the stench in Paris. Corpses of those unfortunates guillotined during the French Revolution were also dumped there. After 1781 it became the only dump in Paris and so many of the slaughterhouses were established in the area.

One of Paris's great landmarks arrived in 1833. The magnificent 3,300-year old, 230-ton Obelisk of Luxor was received as a gift from Mohammed Ali Pasha, Viceroy of Egypt. 200,000 people came to see it being lifted into position on the Place de la Concorde, where Louis XV's equestrian statue had been removed during the Revolution.

In 1840 Napoleon Bonaparte's funeral procession arrived in Paris. Thousands turned out to witness the spectacle, as he was taken to his internment under the great golden dome of Les Invalides. The population of Paris had doubled within 50 years and topped a million by 1846, but since the great building works had been completed there was relatively little employment for all the people pouring into Paris; many lived in extreme poverty and depravation. The only major works in progress were the three canals currently under construction and the addition of 70 miles of sewers. On a smaller scale, the city walls were brought up to date and fortified; a number of the boulevards were leveled and some pavement was asphalted.

In 1848 the dreaded cholera returned to claim some 19,000 lives. On February 22 the barricades went up again and the starving mob turned to three days of rioting to vent their frustration. Known as the "Three Glorious Days," their main target was Louis-Philippe: he was quickly overthrown, elections held, and Bonaparte's nephew, Prince Louis Napoleon was elected by a margin of five million votes—a huge 75 percent of the vote. The Second Republic was declared. Then, in December 1851, a coup d'état overthrew the regime and Napoleon seized direct power and declared himself Emperor Napoleon III and leader of the Second Empire.

Paris was by now a city of real contrasts—after centuries of completely haphazard building and development, magnificent buildings were often found in the immediate vicinity of slum tenements. Many of the city's streets were a maze of medieval passages and lanes with no direct routes across from one area to the next. Such street patterns

**RIGHT:** The biggest street party and parade anywhere in France is on Bastille Day—July 14—a national holiday when the *Marseillaise* rings out the length and breadth of France. On July 14, 1789, the Paris mob stormed the Bastille starting the French Revolution and heralding the beginning of the end of the French monarchy and the foundation of the First Republic. Every Bastille Day there is a huge military parade down the Champs-Elysées in Paris with brass bands playing, flags waving, and crowds singing and cheering and celebrating the Republic.

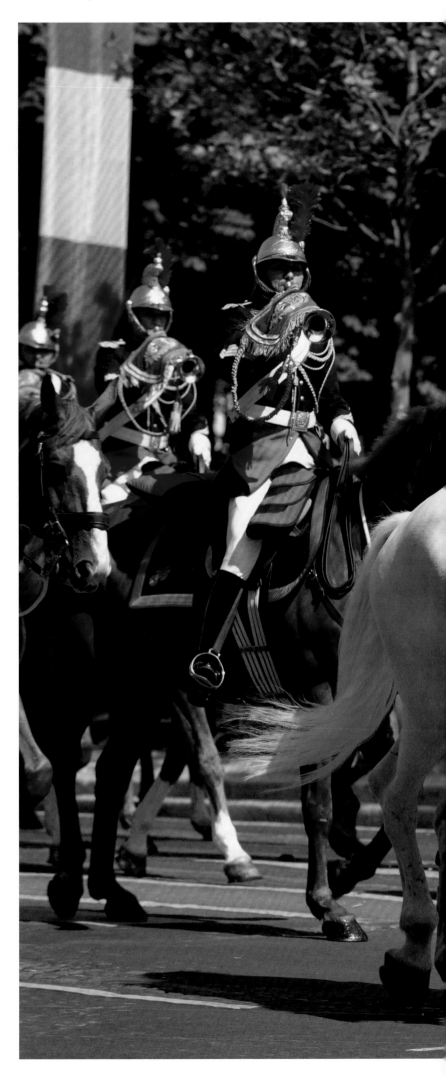

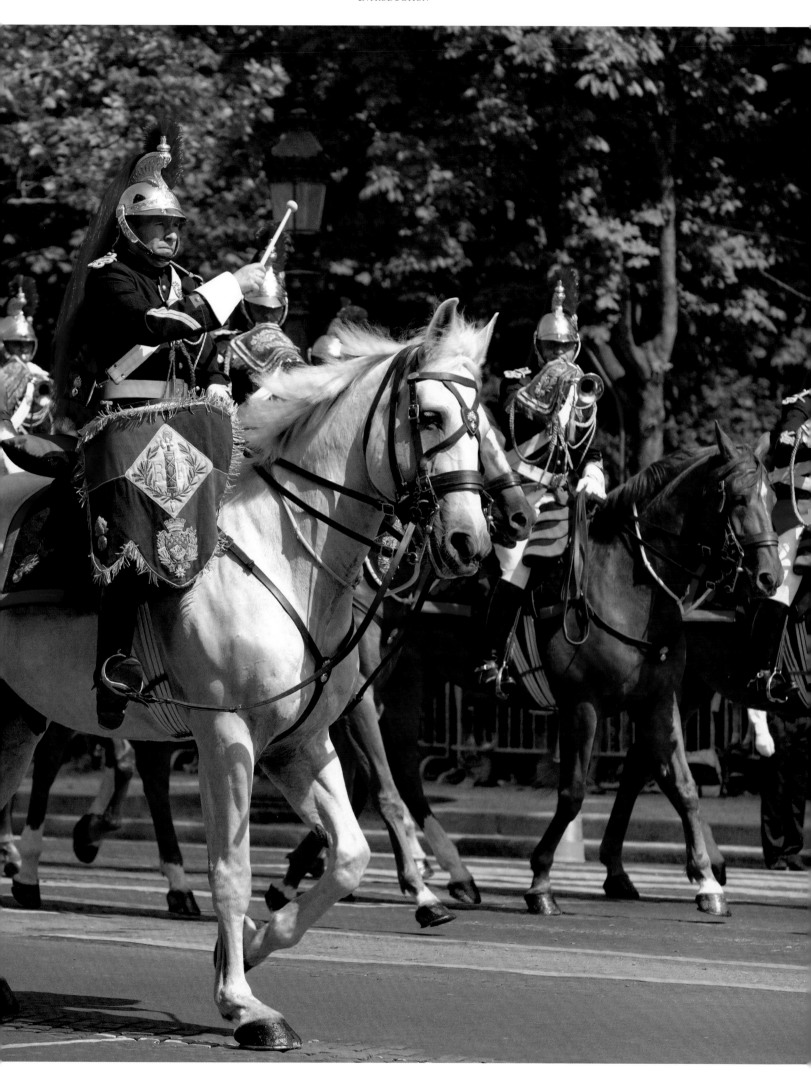

historically helped to foment riot and disorder since barricades could easily be thrown up to blockade official passage. Following the revolution the countryside had more than before emptied of people as thousands moved into the big cities.

Unlike his predecessors, Napoleon III realized that the cycle of unemployment, poverty, disease, and rioting could only be broken by decisive action. He formulated a grand plan to wipe away medieval Paris and replace it with a grand city of wide boulevards and magnificent vistas. A great survey of Paris was ordered, the land was accurately surveyed, and the project divided into three phases. Aided by the Prefect of the Seine, Georges-Eugène Haussmann, over the following 20 years large areas of central Paris—in particular the slums of the Île de la Cité—were ruthlessly cleared away and leveled. They were replaced by the desired modern, grand city. Haussmann and Napoleon ignored the protests and much of the old medieval charm of Paris was lost in the process. In its place appeared a city of wide,

long, and straight boulevards that converged on each other at important intersections. Many roads were asphalted and by 1870 there were 683 miles of sidewalks in Paris. To provide fresh air, three great public parks were created: Bois de Boulogne, Bois de Vincennes, and Buttes-Chaumont. The vast costs of the scheme—the final cost was in the region of 2.5 billion francs—were met by Paris itself, plus state subsidies, loans, and the sale of land and property.

The expanding population meant that Paris had to grow; in 1860, the city limit was enlarged to swallow 18 small outlying towns, adding another 40,000 to the population. As part of the reorganization, the arrondissements (districts) of Paris were numbered in a clockwise spiral from 1 in the center to 20 on the outskirts (see pages 50–51).

One of Haussmann's great personal projects was improving the water supply. It was decided that Paris would have two great water circuits, one for pure drinking water and the other for non-drinkable river water for sanitation and street cleaning. New

**BELOW:** Typical Parisian street scene with a café on the corner and exclusive private apartments in the building above. Cafés have their own clientele who meet to chat and philosophize about love, life, and politics and every point in between. On the other hand they are great places to enjoy a coffee or beer and just watch the world go by.

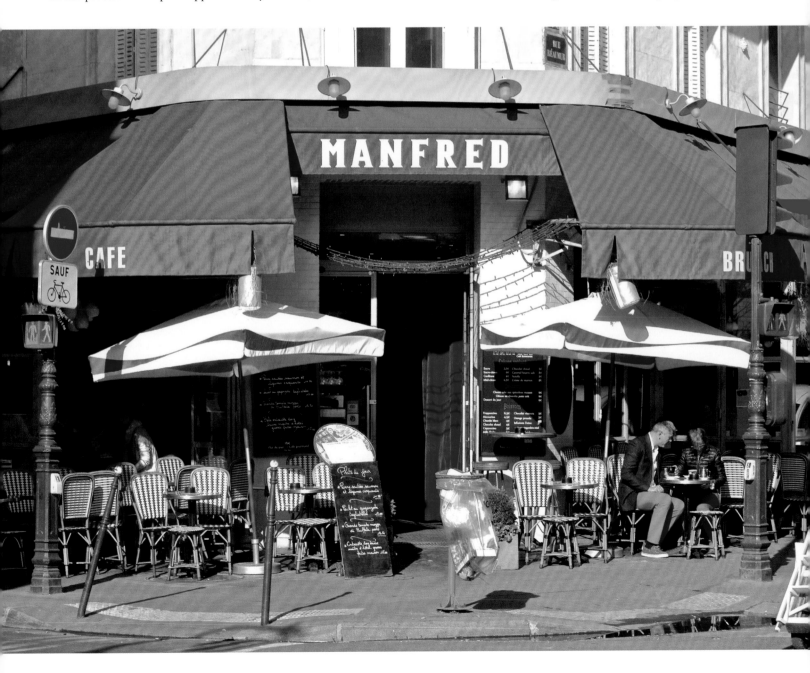

waterways were created to distribute the water across Paris, and three processing plants—at Joinville-sur-Marne, Ivry, and Orly-sur-Seine—were built to filter and sterilize the spring waters into suitable drinking water. These fed water into seven reservoirs at Ménilmontant, Belleville, la Haye-les-Roses, Montmartre, Saint-Cloud, "Les Lilas," and Montsouris.

Paris had become an exciting city and again regained its preeminence as the European center of culture. Foreigners poured in to find work and culture. Part of this was the annual exhibition of works of art at the Salon de Paris sponsored by the Académie des Beaux-arts. In 1863 the selection committee rejected 2,800 paintings and only accepted 988. There was a huge outcry from the artists, because without exhibiting they had no hope of sales. Napoleon III himself got involved and asked to see some of the rejects. Sufficiently impressed he ordered that the rejects be exhibited at the Salon des Refusés. Many of the artists that the crowds came to laugh at quickly became household names—Manet, Pissarro, Whistler, Monet, Cézanne and many more. Paris as the great center for artists had been born.

The building work was aided by the new railroad system that brought men and materials right into the heart of Paris with minimum disruption on the roads. The economy of Paris and France as a whole improved and the population started to increase again. The census in 1866 counted 1,825,274 people in Paris; by 1870 this increased to just short of two million.

Industries sprang up on the outskirts of the city along the highways created by the new canals and railroads. Soon the slums reappeared in these places as the influx of relatively wealthy foreigners pushed out the poor from their inner city districts. All the rebuilding had simply segregated the rich from the poor. The rich scrambled for the new townhouses along the Champs-Elysées and the great new boulevards; the middle class bourgeoisie filled the expanding suburbs; the poor were squeezed to the edges and industrial zones. The suburbs had grown thanks to the arrival of the new belt railway that ran for 19 miles and stopped at 27 stations along the way, in the process helping the development of suburbs like Versailles and Saint-Cloud.

**The Franco-Prussian War and the Commune**
In 1870–1871 France became embroiled in the Franco-Prussian War, in which Emperor Napoleon III and 83,000 men were taken prisoner at Sedan. The emperor was sent to England where he died three years later. The mob invaded the National Assembly and proclaimed the Third Republic on September 4, 1870. The Prussians laid siege to Paris and its two million citizens starting in October 1870.

Parisians responded by arming themselves and joining their local National Guard battalions (about 560,000 men), the voluntary citizens militia. Many of these battalions were armed with cannons paid for by public subscription; in this way the National Guard took control of around 400 cannons, much to the alarm of the government. The Central Committee of the National Guard was nearer control of Paris than the government, growing in power by the day and getting increasingly radical. One of their major grievances was that they wanted Paris to be self-governing with its own elected commune like all the other French cities—crucially, this was something the French government would not allow.

Outside Paris, 236,000 Prussian troops surrounded the city walls along a 50-mile front and blockaded the city. A long siege and bombardment ensued. Some 12,000 shells fell on the Left Bank, destroying 1,400 homes and killing about a hundred people. The blockade took effect and people started to starve. The winter weather was particularly harsh that year and zoo animals as well as cats, dogs, horses, and rats were all soon eaten. However, industrial ingenuity thrived. Parisians were able to make huge amounts of ordnance. The Louvre was turned into an armament workshop; in four months 400 cannons were made at the Gare de Lyons; gas balloons, which carried 2.5 million letters out of Paris, were made at the Gare d'Orléans.

The blockade stopped on January 28, 1871, when 20,000 Prussian troops entered the city. Most departed on March 3 leaving an angry and humiliated population behind. The National Guard's pay was stopped by the government still lurking in Versailles and all economic activity halted in the city. By March 18 matters came to a head, in particular in the artisan eastern districts, where people were angered by the government's supine behavior to the Prussians and the heavy war reparations imposed. The commune was declared ten days later.

When a unit of French troops was ordered to retrieve the cannons and fire on an unarmed crowd, they instead joined the people of Paris and watched while the mob shot their two officers. Other regular army units quickly joined the rebellion and the government hastily ordered any remaining loyal soldiers, police, and officials to evacuate the city.

The Central Committee was now the government of Paris, but it abdicated and held elections in March for the 92 seats on the Communal Council—better known as just the Commune. The Paris Commune was proclaimed on March 28. During its short rule the Communards passed democratic laws including the abolition of the guillotine, made all church property state property, excluded religion from schools, and ended conscription.

Symbolic of the overthrow of the old order, the Vendôme Column, celebrating the victories of Napoleon I, was pulled down.

All this greatly alarmed the government lodged in Versailles. On April 2 government forces started a bombardment of Paris and quickly gained the upper hand. Between May 22 and 28 Paris was besieged again but this time by French government troops.

Vicious street fighting, fires, and mob rule became the norm as the government troops pressed further and further into Paris, despite the hundreds of barricades, through gardens and over rooftops. Both sides committed atrocities. Cannons fired down the long boulevards and snipers picked off the fighters from the roofs. Much of the center of Paris burned.

Finally, eight days of fighting in the eastern districts (known as *La Semaine sanglante*, the bloody week) came to an end on May 27. An estimated 34,000 Communards died, plus many more were wounded. The last barricade fell on the afternoon of May 28 in Belleville. Paris was placed under martial law, which lasted for five years. The government was back in control after two months of Commune control and immediately took revenge against anyone who was suspected of supporting the Commune. Thousands of Parisians were accused, and many were shot. Around 40,000 men, women, and children were marched under military escort to stand trial at Versailles. Some were executed, and many were sent into hard labor; 8,700 were deported to New Caledonia in the Pacific for life or long terms. Most of those made to suffer were working-class poor.

**The years leading to World War I**

Structurally, Paris had suffered enormously. The persistent fires had destroyed much of the city center; buildings had been ransacked of their wealth and entire streets reduced to rubble. The destroyed public buildings included parts of the Tuileries burned down by the Communards, along with the Hôtel de Ville, which housed many unique and valuable historical records. After all the denunciations between neighbors, trust had become a major problem and neighborhoods fragmented as the one-time comrades of the lower, middle, and working class became completely alienated from each other.

Paris now had a population of a little less than two million, but soon was at bursting point once more. As order was reestablished, people from the countryside came to Paris looking for work. As before, public works were devised to provide employment: two of the most prominent projects included the building of the basilica of Sacré-Coeur and the Palais du Trocadéro. Foreign emigrants started to appear in Paris, most notably Central European Jews,

some 30,000 of whom settled in Paris between 1881 and 1914. But times were still hard, rents were still climbing, and the early 1890s saw many French peasants return home disillusioned by the tough city life. In 1879 building inspectors were appointed to try to improve building standards, just in time as the elevator was being incorporated into the bigger buildings around Paris. Even as the number of children in families declined, divorce was legalized in 1884, leaving more single people looking for housing.

The economic depression lasted until 1886—not helped by the continuing huge debt incurred by Haussmann's enormous project to redesign Paris. But the suburbs still expanded. As part of the regeneration attempts the Paris Expositions were held in 1878, 1889, and 1900 and ushered in the era that became known as the Belle Époque. The 1889 World's Fair or "Universal Exposition of the Products of Industry" was planned to celebrate 100 years since the French Revolution and to showcase French technology to the world. For this a massive symbol was needed: a competition was held to build a huge metal tower in the heart of Paris. It was won by Gustave Eiffel and, in spite of impassioned protests from mainly artists, designers, and writers, the tower was an immediate success: more than two million people climbed up it in its first year—before the elevators were installed.

Slowly the French economy picked up. Visitors poured in for the expositions and Paris made a name for its nightlife and general good living. This brought greater social and financial stability to the city and with renewed social confidence, wealth started to be put to good use with the building of hospitals, schools, and university facilities. The first street electric light was installed at the Place de l'Opéra in 1878, and the first telephones in 1881. By 1905 the first radio station was installed on the top of the Eiffel Tower—in fact, this was one of the main reasons that the tower was not demolished as originally intended.

Now the biggest problem in Paris was the chaotic public transportation system, which consisted of the haphazard movements of trams, trolleybuses, horsebuses, cablecars, and riverboats plowing across the Seine. The city authorities wanted a subway system like the hugely efficient and successful ones in London and New York, but the French state wanted to continue the existing train services. In defiance, Paris started to build its own subway system (the Métro) starting with Line 1 from Porte de Vincennes to Porte Maillot, which opened in July 1900. Furthermore, the Métro was deliberately built with tunnels too narrow for state railway trains.

By the turn of the twentieth century, Paris was enjoying a golden age as the world center for arts,

**RIGHT:** Bookshops are found across the city but particularly around the university and college areas of Saint-Germain and in the Latin Quarter. Secondhand booksellers are a speciality of the riverside and 245 concessions (renewable annually) are allowed by the City of Paris. Find them on the Right Bank at Quai du Louvre, Quai de la Mégisserie, Quai de l'Hôtel de Ville, and Quai de Gesvres. On the Left Bank the booksellers are at Quai Conti, Quai de la Tournelle, Quai Malaquais, and Quai de Montebelle. The anglophile Shakespeare and Co is at 37 rue de la Bûcherie, on the Rive Gauche opposite Notre-Dame. It was founded by American George Whitman in 1951.

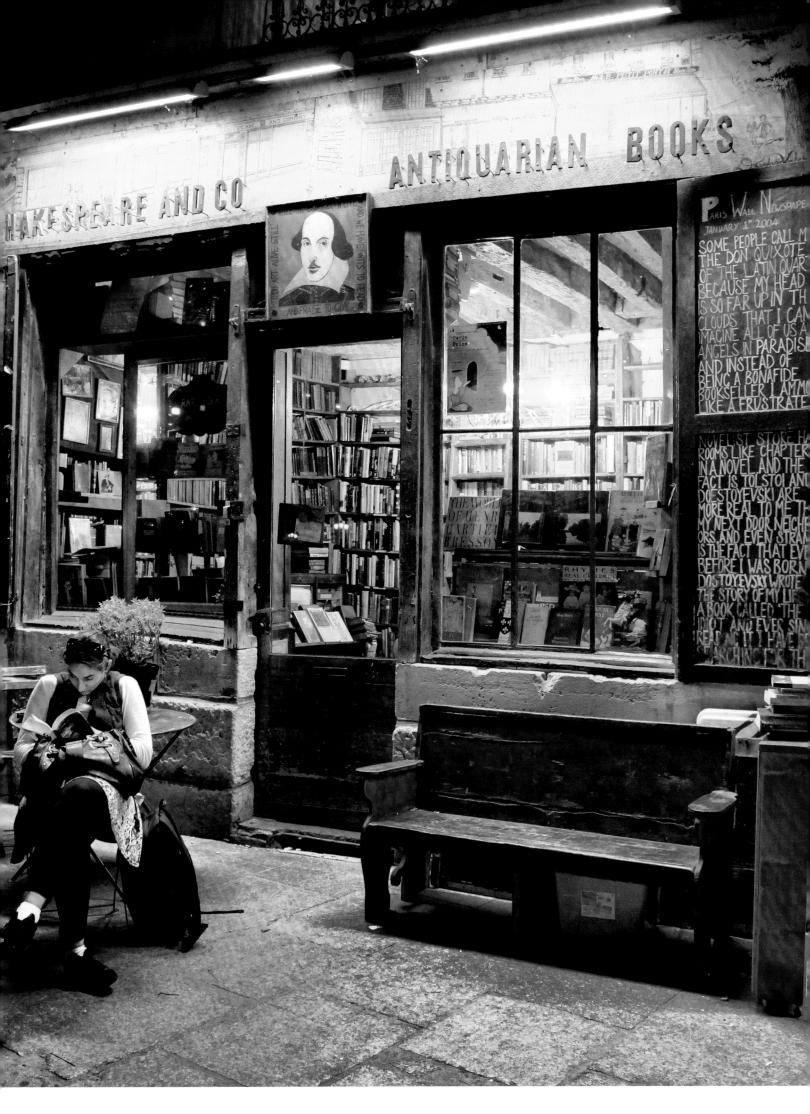

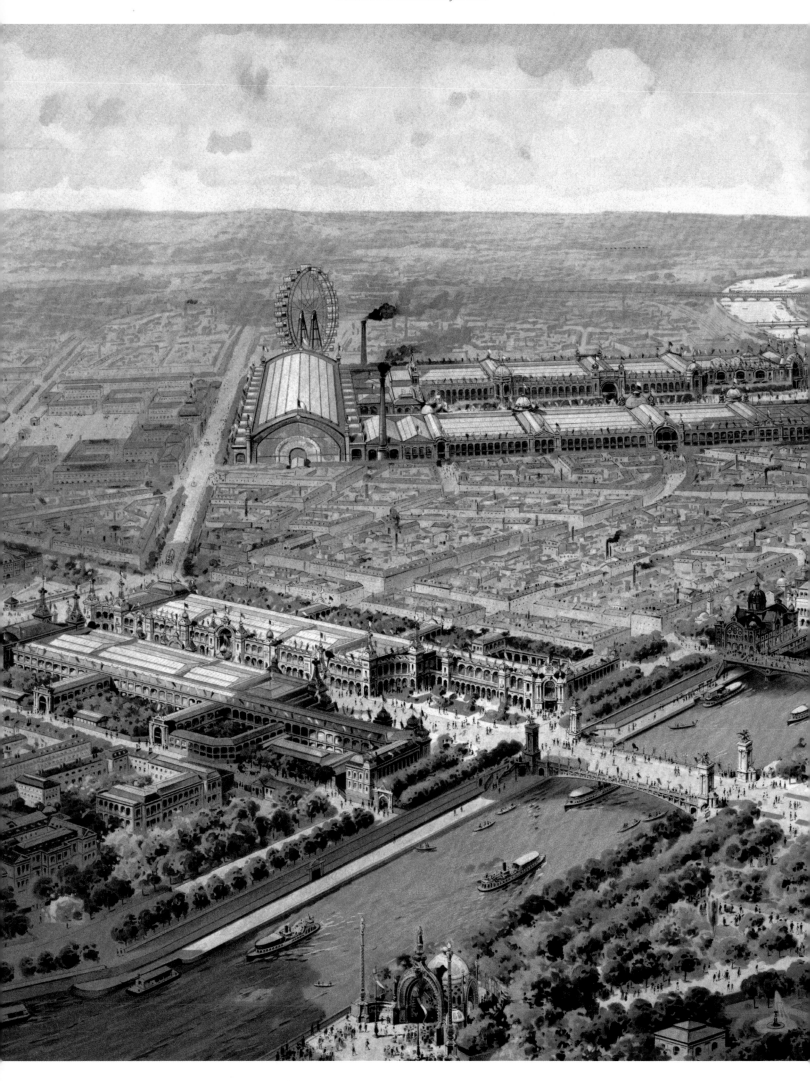

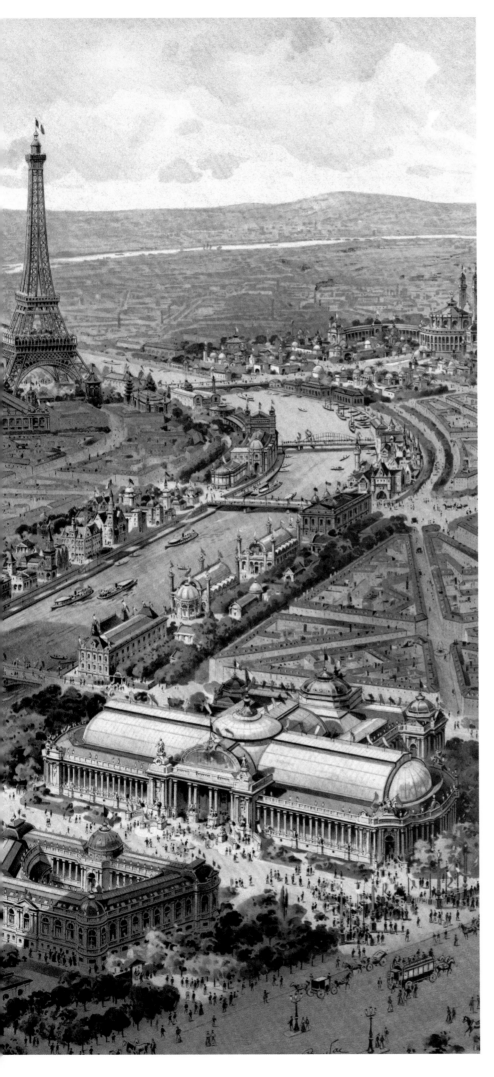

entertainment, literary society, and nightlife. All this activity had been helped enormously by the widespread installation of electric lights, giving the streets of Paris a greater degree of safety and security, though some areas were still best avoided by strangers at any time of day. As the Impressionist painters became popular, the Parisian art scene attracted would-be artists in huge numbers, particularly to the Montmartre area. Soon the motion picture theaters opened and the public flocked to see the latest marvels. The first film was shown in 1895 and the movies became an instant sensation and huge attraction, so much so that by 1911 Paris had 64 movie theaters.

Heavy rain fell in the cold of January 1910 causing La Grande Crue de la Seine, Paris's worst flood in 300 years. The Seine burst its banks on January 21 and poured across the city, filling subway stations, sewers, and cellars. At first the excited crowds gathered on the bridges and embankments to watch the swirling silent yellow waters flash past carrying barrels, carts, logs, and animal corpses. The public clocks—all controlled by compressed air from a power station—all failed at *onze heures moins dix* (ten to eleven in the morning) when the plant itself flooded. But as the water crept up to almost cover the low arches of the Pont d'Alma, Parisians realized the very real danger. All transport stopped in the freezing cold and the electricity supply failed. Many stores and businesses were flooded, some never to reopen. For three days men frantically sandbagged the Right Bank—by the time the Seine stopped rising, the sandbags were 5 feet over the level of the embankment and formed a bulwark half a mile long. If it had burst, the Place de la Concorde would have been inundated along with much of central Paris. There were real fears that the cellars of the Louvre would be flooded, causing immense damage.

The low-level railroad lines from Quai d'Orsay to Gare d'Austerlitz and from the Esplanade des Invalides to the Auteuil viaduct were under 20 feet of water. The trains at Gare d'Orsay disappeared 10 feet under muddy waters as the concourse turned into a giant lake when water poured in through the ventilation shafts. Soon the bridges across the Seine became too dangerous to use and had to be closed; at the worst point of the flood all nine bridges between Pont de Grenelle and Pont Neuf were closed. In some

LEFT: A contemporary panorama of Paris's 1900 Great Exposition—a world's fair. It was held between April 14 and November 12 and was visited by around 50 million visitors—although in spite of this, it lost money. One of the centerpieces was the Eiffel Tower built for the 1889 World's Fair.

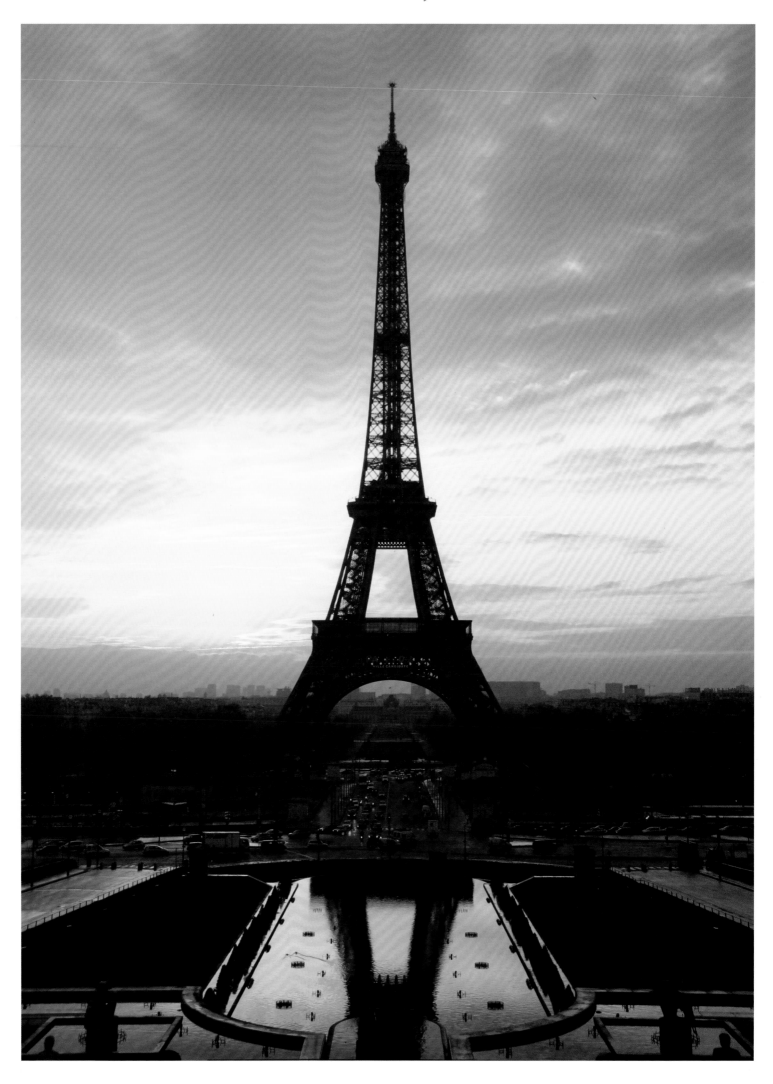

## GUSTAVE EIFFEL

Nothing conjures up Paris so much as the sight of the Eiffel Tower. Yet when the tower was built it was by no means a popular structure. Many Parisians loathed it; the writer Guy de Maupassant claimed that he went up the tower every day so as to be able to enjoy the sight of Paris without the tower spoiling his view. Alexandre -Gustave Eiffel (1832–1923) was born in Dijon on December 15, 1832. He went to Paris to attend the École Centrale des Arts et Manufactures from where he graduated in 1855. In 1864 he started his own engineering construction and consulting firm, Eiffel et Cie, and he soon made his reputation as an engineer of bridges and viaducts. One of his first bridges was the 525ft long Ponte Maria Pia railroad bridge over the Douro River in Portugal. In 1885 Eiffel joined Auguste Bartholdi and Richard M. Hunt to design the internal ironwork skeleton for the Statue of Liberty. Eiffel also supervised the erection of the statue. In 1886 Eiffel's was the best of 700 proposals to win a competition to design and build a "monumental landmark" for the 1889 World's Exhibition. The Eiffel Tower at the head of the Champ de Mars was his masterpiece. It is 985ft high and contains 7,000 tons of iron. Built 1887–89 just in time for the opening, it was a sensation. During the year-long exhibition more than 1.9 million people went up the tower. It was far more than just a tourist attraction. Later, in cooperation with the French Central Weather Bureau, Eiffel added a meteorological station, a military telegraph, and an aerodynamics laboratory. Eiffel used the tower for his first aerodynamic experiments and built the first successful wind tunnel there. It was thanks to its scientific usage that it escaped its intended fate of being dismantled in the 1920s. Eiffel died in Paris on December 27, 1923.

places, entire streets collapsed suddenly into the flood. About 20 percent of central Paris was under water. The Seine only started to recede on January 29; by then thousands of people had lost their homes and possessions and some of them their jobs as well.

### World War I and II

World War I started in 1914, and one objective for the Germans was the capture of Paris in a preemptive strike. Parisians braced themselves for a siege; the French government moved to Bordeaux and about 500,000 civilians fled the city. The combined French and British forces were continually pushed back toward Paris for 10–12 days until they reached the River Marne. There the First Battle of the Marne—the "miracle of the Marne"—lasted from September 6-10, and the exhausted allied forces may well have been defeated were it not for the arrival of 6,000 French reserves transported to the front by 600 Parisian taxis. By the end of the battle, Paris had been saved and much of the rest of the war was fought on the plains of northern France and Belgium. Paris itself was largely unaffected, although the sound of distant gunfire could sometimes be heard. The Germans made sporadic attempts at long-range bombing and aerial bombardment, but it caused little damage.

The war soaked up money; almost all construction work stopped and Paris rents were fixed at the lowest possible rate to avoid inflation. During the six war years, there was little maintenance carried out on buildings because most of the able-bodied men were sent to the war fronts. A general air of decay and deterioration filled the Parisian air. By the time the armistice was signed on July 14, 1919, more than five million Frenchmen had died. Between four and five million people took to the streets of Paris to celebrate peace, though the city population decreased for a time because of the impacts of the war. The city fortifications were removed between

*continued on page 44*

**LEFT:** A moody view of Paris's greatest landmark. The photograph is taken from the Trocadéro, looking over the Pont d'Iéna. Through the feet of the tower can be seen the École Militaire, set up in 1750 by Louis XV.

**BELOW:** This 1889 photograph shows visitors to the World's Fair under the base of Eiffel Tower. In the background is the Central Dome of the exposition.

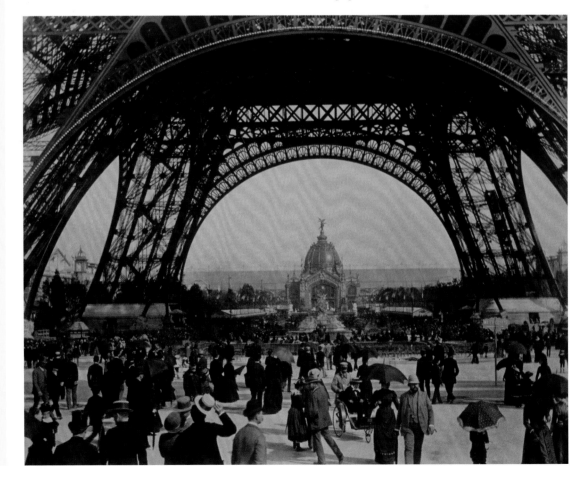

1919 and 1924, and were replaced with wide boulevards. On November 11, 1920, an unnamed French soldier from the trenches was buried with solemn ceremony under the arch of the Arc de Triomphe. Known as the Tomb of the Unknown Soldier, it is accompanied by an eternal flame to commemorate the dead of World War I.

Between the world wars Paris again became an exciting cultural city and the destination of many foreigners. It also became home to many political and economic refugees, especially Jews from Poland and Russia. More people meant that urban sprawl was inevitable, and the farmlands that historically fed Paris started to disappear under the weight of new buildings and industrialization. Thanks to French political and economic centralization, as well as the convergence of road and railway lines on Paris, the city soon became the principal manufacturing and industrial area for all of France. Industrial suburbs soon encircled Paris, with those to the north and west appearing first thanks to the canals and railroads. Rural immigration resumed on a huge scale as people left the low employment prospects of the country for likely work around Paris.

As the century progressed, more and more people became able to afford an automobile. Even Paris, despite its grand boulevards, was not equipped to cope with large numbers of vehicles and many roads had to be widened. Better transportion facilities meant that more people could live in the suburbs and work in the city. The suburbs grew by a massive 500 percent—with towns owning a railway station growing ten times faster than those without. But such building was haphazard and unregulated and many houses were built without any sanitary provision. The Paris Métro was extended out into the suburbs, providing valuable employment as well as transport for workers and commuters. Construction work finished in 1937.

Such urban sprawl needed regulating and in 1928 the Committee for the Organization and Expansion of the Paris Region was set up—but it took them six years of arguing and bureaucracy to agree on a suitable plan. Meanwhile, the unregulated sprawl grew along with discontent among the people forced to live in such squalid conditions. About six million people lived in the Paris conurbation in conditions six times the density of New York City. Politically and economically things approached a breaking point. The suburbs became hotbeds of discontent and political unrest; soon communism had a strong hold among the masses. Left-wing areas became known as the *ceinture rouge*—the red belt. At the same time the wealthy and middle-class Parisians moved to the right politically.

Culturally, Paris was still thriving: many famous writers and artists lived in the city and Paris had taken to its heart the latest American music and made it its own—jazz. But another American factor was making itself felt: economic depression. Businesses started to close and jobs disappeared. The price of food went up as the supply diminished and rents followed the same course. Already close to the boiling point, the mob collected and converged on the Place de la Concorde and held regular violent riots in January and February 1934. Strikes were held across the city. Politicians argued about solutions but failed to act coherently. The tense situation did not improve.

Change was forced in 1939 with the start of World War II. German troops invaded France in 1940 and marched on Paris. As many as were able fled Paris while the aging French premier, Marshal Pétain, made plans to open the city to the invaders in the hope of avoiding the destruction of Paris under Nazi bombs. On June 14, 1940, the Germans entered Paris without a shot being fired, starting four years of occupation. During the occupation about 2,295,000 people lived in Paris—rents were frozen and the tenants protected from eviction.

During the German occupation of Paris the French government was elsewhere. The Free French under General de Gaulle was operating from London and the German puppet government of Marshal Pétain was located in Vichy, an old spa town deep in central France. The Régime de Vichy—or Vichy France was officially neutral but actively endorsed and supported Nazi policies. The former World War I hero, Marshal Pétain was disgraced after the war and tried and convicted for treason.

Following D-Day and the invasion of Normandy in June 1944 Hitler appointed General von Choltitz commander of Paris with orders to defend the city, but to burn it to the ground if German forces had to withdraw. Hitler later changed his mind and ordered preparations for the destruction of Paris on August 7. On August 15, Paris police and Métro staff went on strike and the Germans were too busy to stop them. The following day the postal workers joined them; by August 18 this had become a general strike and all Parisians were ordered to mobilize. The barricades appeared again and fighting broke out sporadically.

During August, Nazi engineers started placing explosives at electric and water facilities and the strategic bridges across the Seine. On August 16 Hitler ordered all administrators and the Gestapo out of Paris; the latter murdering 4,500 French resistance fighters in the Mont Valerien Gestapo prison before leaving. Von Choltitz delayed the detonation of the explosives by saying that preparations were not complete. As the sound of gunfire drew closer incriminating documents were burned and many

---

## HECTOR GUIMARD

Although neither a Parisian by birth nor death, Hector Guimard (1867–1942) has left an indelible legacy on Paris. It is thanks to his amazing design skills that the city possesses some of the most evocative Art Nouveau ironwork in the world and that the Paris Métro has become synonymous with his sinuous ironwork. Hector Guimard was born on March 10, 1867, in Lyons, France. He moved to Paris in 1882 determined to become an artist and designer. Accordingly he studied for three years at the École des Arts Décoratifs and at the École des Beaux-Arts. He then set up his own practice. One of his earliest buildings was shown in the Hall of Electricity at the Universal Exhibition of 1889. Despite the Art Nouveau movement gathering pace, Guimard did not become a convert until he visited Brussels in 1895 and saw Victor Horta's revolutionary Hotel Tassel. Struck by the beauty of the naturalistic lines of the building, Guimard became a disciple of Art Nouveau and completely altered his approach to design. He now incorporated all the sinuousness of the style into his work, often designing the interiors as well, including all the furniture and fittings. His work was immediately popular and Guimard was soon the foremost French architect and designer of Art Nouveau. Guimard's most famous work was designing for the Paris Métro between 1898 and 1905. In the heart of the city many of the old Métro entrances for the Métropolitain line bear his distinctive iron and glass-work. In 1909 Guimard had fallen in love and married the American painter Adeline Oppenheim. They lived together at Hotel Guimard in the 16th arrondissement. He worked in Europe until the 1930s and emigrated to New York City in 1938 when war threatened. He died there on May 20, 1942.

**PAGES 42–43:** Chandelier in the Hôtel de la Marine, built during Louis XV's reign on Place de la Concorde. From 1789 it housed the Naval Ministry.

**BELOW:** Guimard's Art Nouveau designs give the Paris Métro a distinctive appearance.

more resistance supporters were murdered. Those still at liberty did what they could to attack the engineers wiring the explosives. As the Americans started fighting in the suburbs on August 24, most of the Germans withdrew. General Leclerc entered the city that day and on August 25—the day General de Gaulle arrived—von Choltitz disobeyed Hitler's orders and surrendered the city. On August 26 a victory parade was held down the Champs-Élysées, with another for the Americans on the 29th. About 1,500 Parisians were killed during the fighting to liberate Paris.

The Germans had not damaged the city but neither had they done anything to stop its decay. All the public facilities had been badly neglected and housing had deteriorated without money and attention. The Métro was in a deplorable state and virtually all the city buses had disappeared. There was no money free to use on rebuilding public works that had risen in cost by 40 percent since 1914.

**The Fourth Republic**

In October 1946 the Fourth Republic was declared and for the first time women received the right to

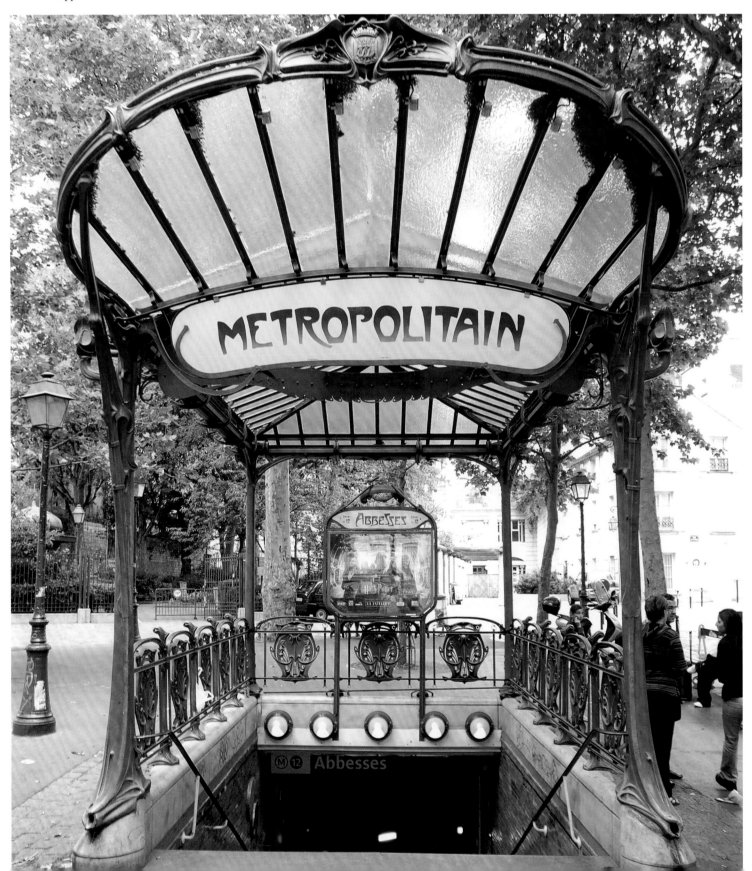

vote. When the war ended, France, like its neighbors, had a lot of rebuilding to do, but the economy improved slowly as industry and businesses resumed. Speculators moved in and land prices soon skyrocketed as unregulated developments appeared everywhere. Particularly in Paris, many existing private homes and gardens were demolished to make way for high-density, modern buildings. The roads became increasingly congested with private automobiles, and parking became a nightmare—so bad that delivery trucks, public transportation, the police, and emergency services had trouble function-ing in the city. The growing pollution also saw deaths from lung cancer doubled and chronic bronchitis increased by 20 percent.

**The Fifth Republic**

Despite all the problems Paris enjoyed a 30-year period of prosperity, known as the "Trente glorieuses." During this time, in 1958, the Fifth Republic was declared under President Charles de Gaulle. A new constitution was announced and France's political, economic, and social problems solved. One of the goals was to decentralize France and relieve the industrial congestion around Paris. In addition, work started on a modern business district: La Défense. Abandoned projects were restarted, such as the express Métro.

Between the end of the war and 1960 well over a million people came to live in Paris, boosting the population to more than three million. They were attracted by the job opportunities and booming economy. Similarly, the outer suburbs of greater Paris had a population of more than eight million, many of them commuting into Paris daily. In the center of the city lived the wealthy upper and professional classes beside pockets of poor immigrants; the work-ing classes and unemployed lived further out in the less desirable suburbs. By the early 1960s Paris was an ethnically diverse city with large populations of many nationalities, particularly North Africans and sub-Saharan Africans who had poured into France following the relaxation of the immigration laws. In 1962 the French colony of Algeria was given independence and around 700,000 unhappy colonials moved to Paris, almost always to the poorer areas, creating Algerian ghettoes.

There was a great deal of social tension and general dissatisfaction erupted in May 1968 with riots led by Sorbonne students protesting over educational policy. Known as "les évènements de Mai 1968," they shook French society and government to the core. The traditional mob pastimes of barricade building and cobblestone throwing came back to Paris. The events started when students in universities and high schools across Paris went on strike. The de Gaulle government inflamed the situation with heavy-handed attempts to quell the riots using the police, which led to street battles in the Latin Quarter. Soon ten million workers ("les grèves")—around half the French labor force—from all over France joined the insurrection. The factories were occupied and the French economy almost ground to a halt—no mail, banking, public transportation, or gasoline and decreasing labor. The situation came close to toppling de Gaulle's government: he dissolved the National Assembly and called new elections in June. However, the French Communist Party and the unions urged everyone back to work and school. After the election, de Gaulle's right-wing party was returned to power with a stronger majority, but a year later de Gaulle was forced to resign after a narrow referendum loss showed that the French people had lost confidence in him. It was the end of an era.

Parisians wanted to live at the forefront of the modern world. This meant modernizing the city itself—and slowly it changed in front of everyone's eyes. The ancient Marais quarter was improved and the Métro changed to become a reliable, modern transportation system capable of carrying thousands of people around the city. In 1969 the first Réseau Express Régional (RER) above-ground railroad system opened, suburban railway lines were electri-fied, and train stations were modernized. The river-bank roads along the Seine through the heart of Paris were constructed to speed traffic through the capital, and underground parking garages were built to get parked cars off the congested streets. New reservoirs were built to supply water to Paris. But for Parisians perhaps the greatest change was the destruction of the old central market of Les Halles in 1969. It was replaced by an underground shopping mall (constructed 1971–1981), and the market was relocated farther from the city center at La Villette and Rungis.

In the early 1970s the great eight-lane ring road around Paris—the Boulevard Périphérique—was built to further reduce congestion in the center of the city. It was built over the foundations of the great defensive wall of Paris that was destroyed in the 1920s after World War I. The road was completed in 1973 and for many people marks the city boundary, although it is not an administrative boundary. In 1978 Paris elected a mayor for the first time; the winner, Jacques Chirac, went on to become President of France. The other great change in the heart of Paris was the building of the ultramodern Centre Pompidou in the old Beaubourg district in 1977.

New public works projects continued in the 1980s—a science park was built on the northern

outskirts of the city at La Villette. Called Cité des Sciences et de l'Industrie, the park is twice the size of the Tuileries and surrounds a number of housing developments. One of the main attractions is a silver-skinned geodesic dome called La Géode (opened May 1985), which contains a completely spherical cinema. In 1988 a construction boom hit Paris after government policy changes made building speculation easier. Entire districts of Paris were remodeled—especially in the east. In the old artists' district of Montparnasse, old buildings were demolished and replaced by an urban renewal project of modern offices including the Montparnasse Tower, the highest structure in Paris.

In 1989 there were celebrations commemorating the bicentenary of the French Revolution and 100 years of the Eiffel Tower. Paris held massive celebrations and opened a number of showcase buildings—in particular, the Grande Arche at La Défense, the Opéra Bastille, and the hugely contro-versial glass pyramids in the Louvre. The Bastille Opéra and Arche de la Défense were pet projects of President François Mitterrand, who wanted to leave a visible legacy on Paris. Around the arche have sprung up international as well as French corporate buildings and skyscrapers and avant-garde sculptures.

Elsewhere, the old Parc des Princes stadium was deemed unworthy of hosting the 1998 World Cup soccer final. For the event, the new Stade de France in St. Denis was opened, and to the joy of most Parisians France won the competition.

In the second millennium Paris—with a city population of around 2.15 million—has become one of the largest metropolitan areas in the world, with a metropolitan population of 10.5 million (about one-sixth of the entire population of France). The city covers nearly 500 square miles. As always, Paris's fortunes change, but it still remains the center of France.

Tourism is Paris's largest form of income, although it is still ringed with factories and manufacturing works and Paris is the fourth most important port in France (after Marseilles, Le Havre, and Dunkirk). The city has two international airports in Orly and Charles de Gaulle, and Le Bourget for internal domestic flights. About 70 percent of French businesses and banks have their headquarters in Paris.

In many ways Paris is still the city it always has been—a heady mix of culture, politics, business, and power.

Like all great cities it has its own magnetism and style, which attracts thousands to come and live within the city. But more than most cities it offers a unique mixture of the very old and the very new—unexpectedly modern areas sit right next to ancient buildings. Paris has an enviable reputation for culture and romance, but political agitation is never far from the surface. Above all, one thing is sure: Paris never disappoints and never fails to surprise.

**ABOVE:** France is famous for its markets and its capital is no exception. There are said to be nearly 100 markets today—some covered, but most outdoor—with every arrondissement having at least one market a week.

**RIGHT:** Turbot and *cuisses de grenouille* (frogs' legs) on a market stall.

**RIGHT:** Numerous cut flower and pot plant stalls fill the sidewalks of the flower markets around Paris. The best-known are those at Place de la Madeleine, Place des Ternes, and the Marché de la Cité at Place Louis Lépine. The Marché aux Oiseaux (bird market) is held at Place Louis Lépine on Sundays.

# The Arrondissements

### 1er (1st arrondissement)

For a relatively small area the 1er contains a fantastic number of extraordinary places. It is the geographical center of Paris to which all visitors make their way. It is a busy area full of museums and parks as well as the heart of old royal Paris. It contains world-famous locations like the Louvre museum, the Tuileries Gardens, Palais Royal, Place Vendôme, Les Halles, and many others. The 1er also includes the western section of the Île de la Cité in the middle of the Seine.

### 2ème (2nd arrondissement)

This is the theater and business district that includes the Bourse (the Paris Stock Market), as well as the national library (Bibliothèque Nationale), and many other galleries all squeezed into one of the smallest districts of Paris. The Bibliothèque Nationale was founded by minister Colbert, starting with the royal library of Charles V in rue Vivienne.

### 3ème (3rd arrondissement)

Part of the district known as the Marais (the rest is in the 4th arrondissement), this is one of the oldest, quietest, and most exclusive areas of Paris. A number of the buildings date from the seventeenth century and were built by some of the very noblest Parisians. A number of important museums are located here including the Carnavalet Museum, Musée Picasso, National Archives, and Conservatoire des Arts et Métiers.

### 4ème (4th arrondissement)

This is the center of the ancient Marais district and contains most of what remains of medieval Paris, with narrow twisting streets and alleyways. Some of the many high points are Notre-Dame Cathedral, the Île de le Cité, the Île Saint-Louis, and the Hôtel de Ville (town hall). It also includes the oldest and most beautiful square in Paris, the Place des Vosges started by King Henri IV in 1604. Originally called Place Royale, its name was changed in 1800 by Napoleon to

reward Vosges being the first département in France to return its taxes. In complete contrast is the very modern contemporary arts center the Centre Georges Pompidou, which has became an unexpectedly popular attraction in its own right. Much of the district is full of lively bars, restaurants, and shops.

### 5ème (5th arrondissement)

The Latin Quarter or Quartier Latin. This is the bohemian heart of Paris and contains the Sorbonne University—from which the "Latin" tag comes as the students there during the Middle Ages spoke Latin. The Sorbonne was founded in 1257 by Robert de Sorbon to teach theology. Besides numerous restaurants and cafés found all around the winding streets, there is also the Pantheon, and the Jardin des Plantes, the botanical gardens. The Roman Arènes de Lutece amphitheater situated in rue Monge has first and second century remains and originally held 15,000 people.

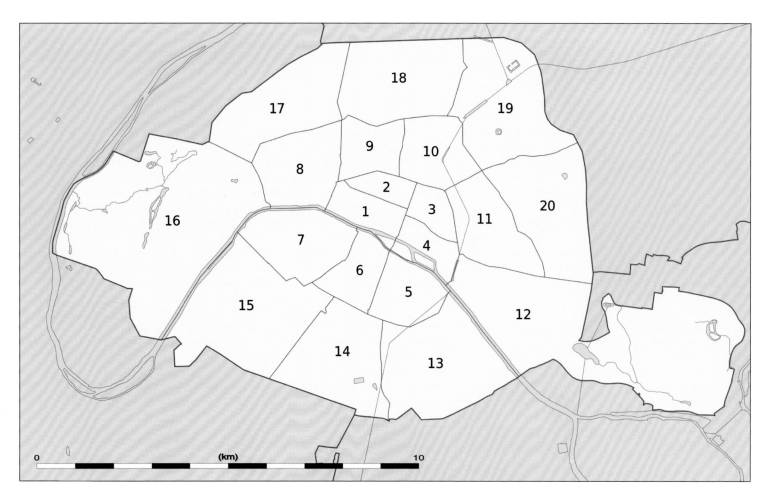

## 6ème (6th arrondissement)

Fashionable St-Germain-des-Prés is one of the great sightseeing spots of Paris especially from the comfort of one of the many elegant cafés or restaurants. Also around here are many art galleries and upmarket boutiques. Still popular with Parisians is the Jardin du Luxembourg originally laid out around Marie de Medici's palace. Its 60 acres is one of the largest green spaces in Paris.

## 7ème (7th arrondissement)

The northern section of the 7ème is demarcated by a large bend in the Seine over which the iconic Eiffel Tower rises. Nearby Napoleon I lies in his tomb in Les Invalides; in the former rail terminus of Musée d'Orsay hang some of the most famous and valuable Impressionist paintings in the world.

## 8ème (8th arrondissement)

The magnificent Champs-Élysées runs through this area to the Arc de Triomphe. All along the great boulevard are showrooms, cafés, shops, and restaurants. This is a diverse arrondissement full of tourists and traffic as well as restaurants, bars, offices, and exclusive haute couture shops on the Avenue Montaigne. Around the Place de la Madeleine are a number of nineteenth century buildings. A number of embassies are located here, as is much of French government administration.

## 9ème (9th arrondissement)

Also known as Opéra, many Grande Boulevards run through the ninth taking you to the Opéra Garnier, the Musée de l'Opéra, and many of the big stores. It also includes the area known as the Pigalle—famous particularly in the late nineteenth century for decadent Parisian nightlife—the old red light district, and the Moulin Rouge. Now the Pigalle is a cheap shopping area and much of its illicit trade has moved elsewhere.

## 10ème (10th arrondissement)

This bohemian multicultural district of Paris contains two of the main gateways into Paris—the Gare du Nord and the Gare de l'Est train stations—as well as the Canal Saint-Martin. On the far southern side is the Place de la République surrounded by bars, restaurants, and cafés. Around the canal lie more bars and restaurants that throng with people at night.

## 11ème (11th arrondissement)

This primarily residential district includes the Place de la Bastille and the New Opera. The Rue Oberkampf, Rue de Lappe, and Rue du Faubourg-St-Antoine are noted for their lively nightlife full of restaurants and wine bars.

## 12ème (12th arrondissement)

This large arrondissement is bordered on the east by the large 2,460-acre Bois de Vincennes pleasure park, which doubles the size of the arrondissement. More prosaically the district includes the Gare de Lyon as well as the Bastille Opéra and Palais Omnisport de Paris-Bercy.

## 13ème (13th arrondissement)

The outer southeastern district is where Paris's Chinatown lies in this otherwise mainly residential and business district. Scholars come here to visit the Bibliothèque Nationale de France which was commissioned by President Mitterrand and opened in 1996. It houses the national French government archive as well as a vast collection of historic books and prints. Since 1537 the national collection has been the legal depository for all books published in France.

## 14ème (14th arrondissement)

Gare Montparnasse serves Brittany and southwest France and Spain. The arrondissement is most visited for the 685ft Montparnasse Tower and its 59th story open-air terrace from which amazing views of Paris can be enjoyed on a fine day. Also in this area are the spooky catacombs where lie the skeletons of some six million or so former inhabitants of Paris's city graveyards moved there in the late eighteenth century. Much livelier are the environs of Cité Universitaire where registered students studying at the University of Paris can have accommodation.

## 15ème (15th arrondissement)

On the southwest edge of Paris is the largest central arrondissement which is primarily a residential and business district part. It includes part of the livelier Montparnasse district to the north. The futuristic Parc Andre-Citroën is where the cars were first manufactured but is now a spacious and modern landscape. It was set out in the 1980s and is sectioned into a variety of specialist gardens. In complete contrast, the largest exhibition center in Paris is found in the 15th.

## 16ème (16th arrondissement)

To the west of Paris is the long and large 16th arrondissement. It borders the Bois de Boulogne and includes the Parc des Princes, the former home of French rugby. This is a leafy neighborhood for wealthy Parisians. At one time the original Trocadero Palace was situated here; it now lies under the Palais de Chaillot that was built for the 1937 Universal Exhibition.

## 17ème (17th arrondissement)

This is a wealthy residential area around the Arc de Triomphe. It was the most fashionable area of Paris in the eighteenth and nineteenth centuries. It includes the Parc Monceau, which was incorporated into Paris in 1860. Originally a garden of illusions created in 1778, it still contains numerous monuments, a pyramid, a grotto, and many interesting design features.

## 18ème (18th arrondissement)

This is Montmartre, the district famous for its artistic connections and in particular the Impressionist painters. The landmark white basilica of Sacré-Coeur sits high on its hill above the network of streets and lanes. Always popular with tourists, there are many restaurants and bars to enjoy as well as the spectacle of artists plying their trade in the historic Place du Tertre.

## 19ème (19th arrondissement)

The main attraction in this northeast arrondissement is the City of Science and Industry in the Parc des Buttes Chaumont. Otherwise this is a residential district that contains an interesting selection of shops and restaurants.

## 20ème (20th arrondissement)

Belleville to the east of the city was once the main working-class town outside Paris—where the poor were forced to move when the inner city slums were cleared. The town was incorporated into Paris in 1860 and split between the 19th and 20th arrondissements. The town was once notorious for its communist politics and in the twentieth century was the main destination for the many immigrants who came to France. It is still a very cosmopolitan area, but is now becoming fashionable with affluent Parisians. For visitors one of the main attractions of the 20th is the huge Père-Lachaise cemetery, which contains the graves of many famous people.

The Right Bank

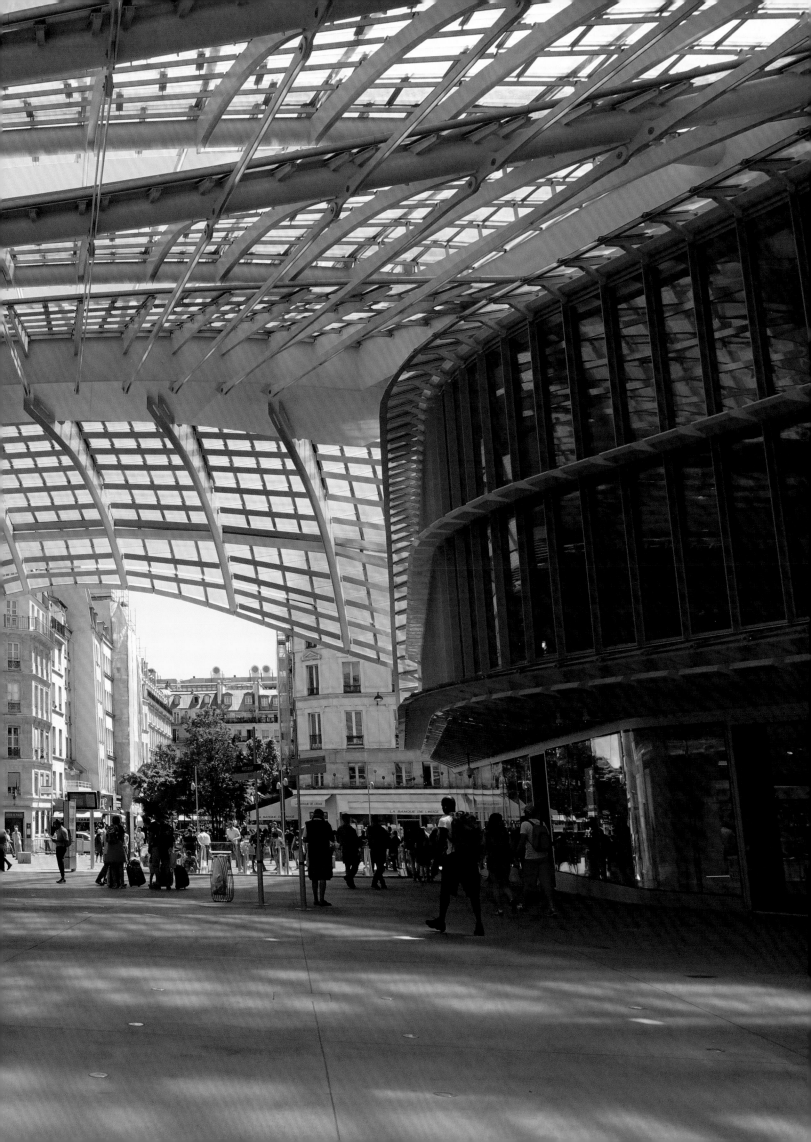

**PAGES 54–55:** The Forum des Halles was built in 1971 on the site of Les Halles—the old Paris fruit and vegetable market which was transferred south of Paris to Rungis in 1969. All but one of the old iron frame market pavilions were removed and replaced by a modern shopping center and the huge Châtelet-les-Halles station. It was renovated 2010–2014 and in 2016 La Canopée over the station—shown here opened.

**RIGHT:** The Trocadéro—the Palais de Chaillot replaced the old Palais du Trocadéro in 1937 but the name is of the area—seen from the Eiffel Tower.

**BELOW:** The Bourse de Commerce was built in the eighteenth century and the dome was added in the nineteenth (1811). Originally made of metal it was changed later to copper and glass. To its left is a column, the only remains of Catherine de'Medici's Hôtel de Soissons.

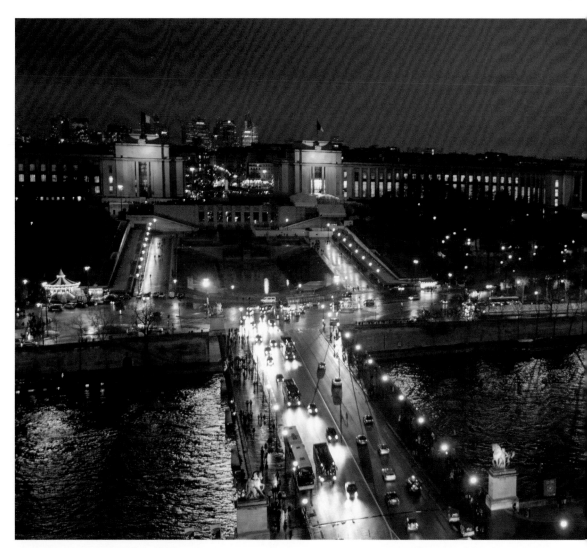

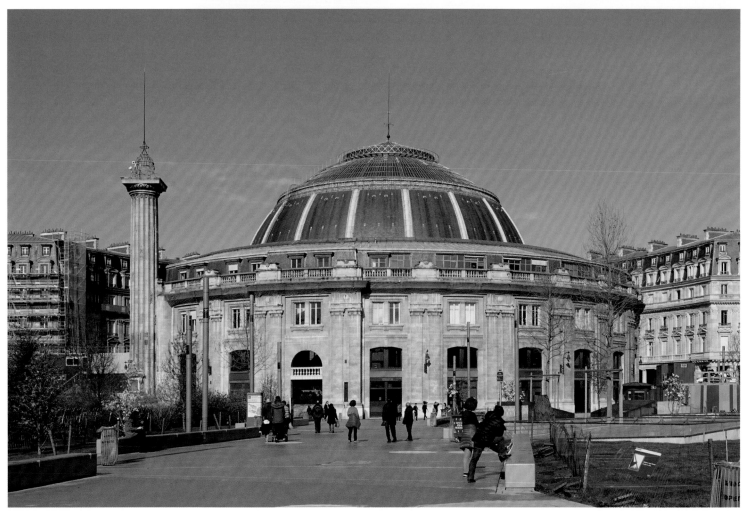

**BELOW:** The Grand Palais—seen in the background over the Pont Alexandre III—was originally built for the 1900 Universal Exhibition which was dedicated to industry and technology. It was subsequently used for many important art exhibitions including the Exhibition of Decorative Art in 1925 which launched the Art Deco movement. After falling into disrepair the Palais was closed in 1993 for 12 years of massively expensive refurbishment; it reopened in late summer 2005 to enormous controversy about its cost to the taxpayer and its future use. The two side wings are home to a science museum (the Palais de la Découverte), and a national art museum. In addition the City of Paris owns the land and the state owns the building and the question of rent is part of the problem.

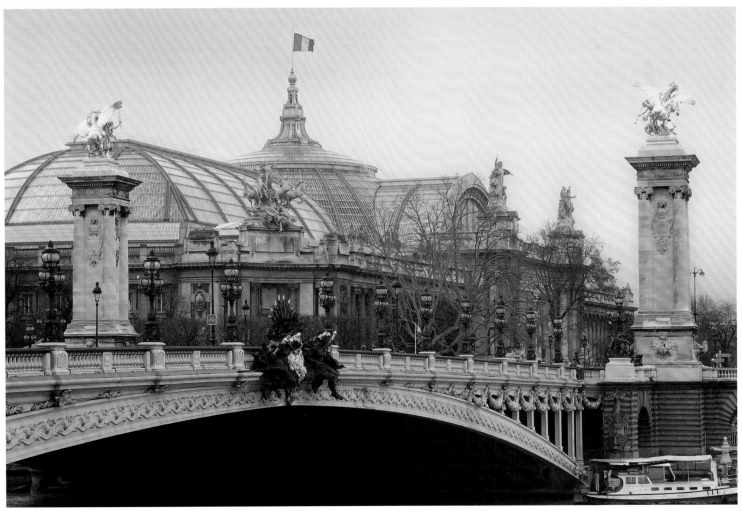

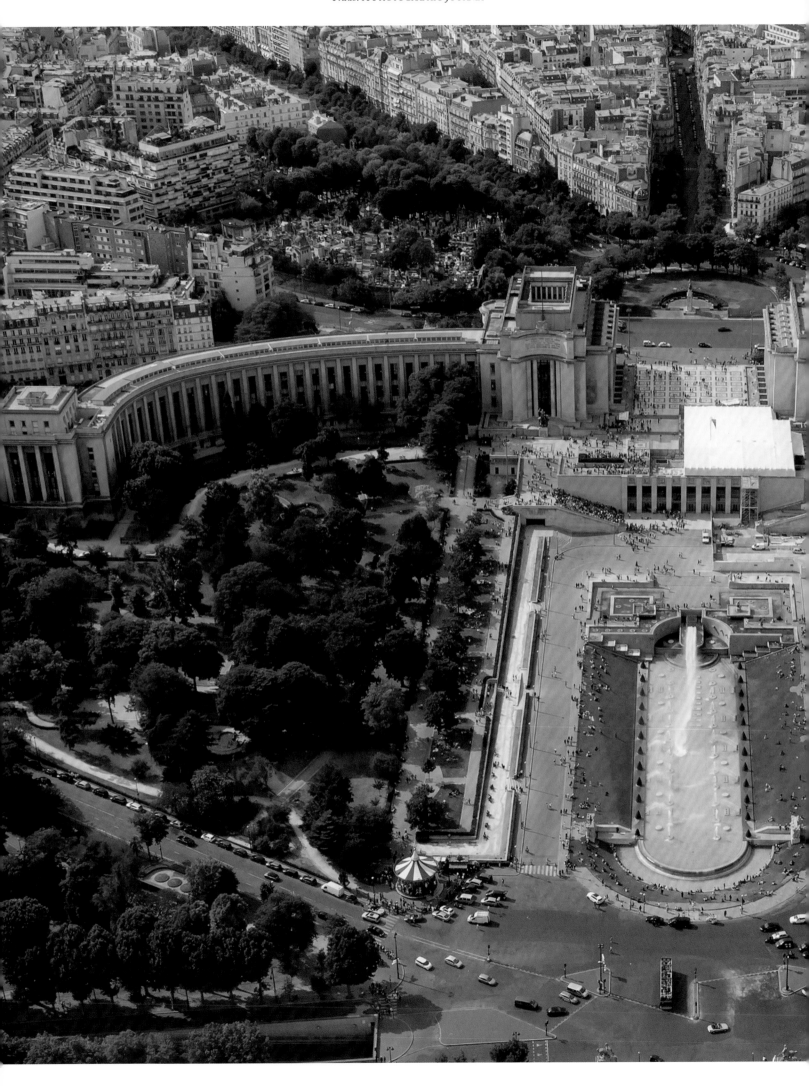

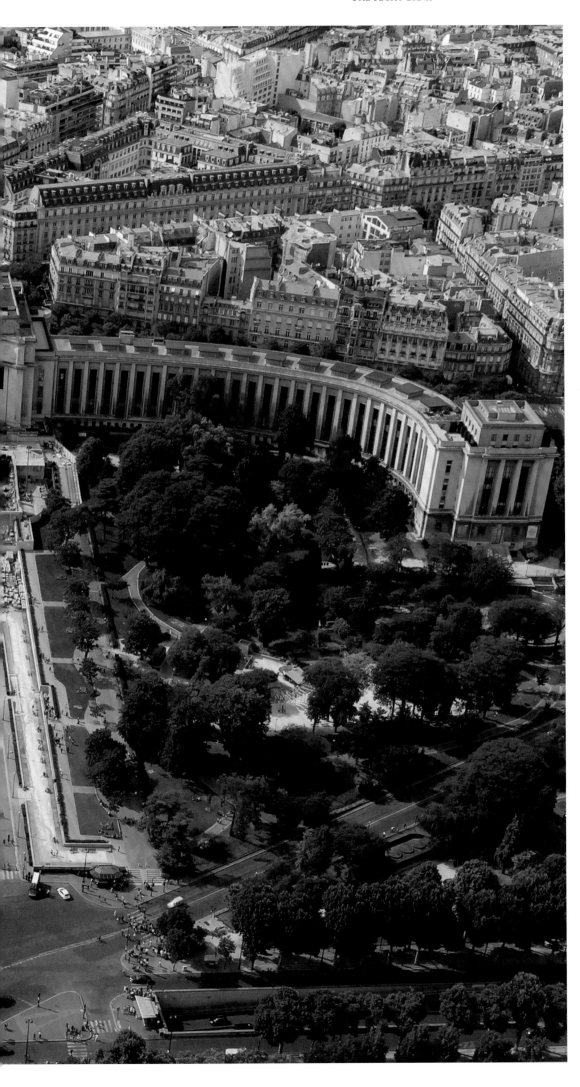

**LEFT:** The Palais de Chaillot sits on the bank of the Seine opposite the Eiffel Tower. Popular at all times, it becomes especially attractive at night when the gardens and fountains are lit up.

**PAGE 60:** In the 9th arrondissement at 40 Boulevard Haussmann is the biggest and grandest department store in Paris—Galeries Lafayette. It was designed in the Art Nouveau style by Cahnautin and opened in 1912. It is classified as an historic monument.

**PAGE 61:** One of the great delights of Paris are the covered walkways or arcades known as *Les Passages* which were originally built in the late eighteenth and early nineteenth centuries for protection from the weather and as safe places to shop— before the advent of sidewalks and electricity. There are about 20 remaining "passages" in Paris, such as the Passage Jouffroy off the Boulevard Montmartre, noted for its toy stores and secondhand book stalls. This is the Passage des Panoramas, the oldest, built in 1799.

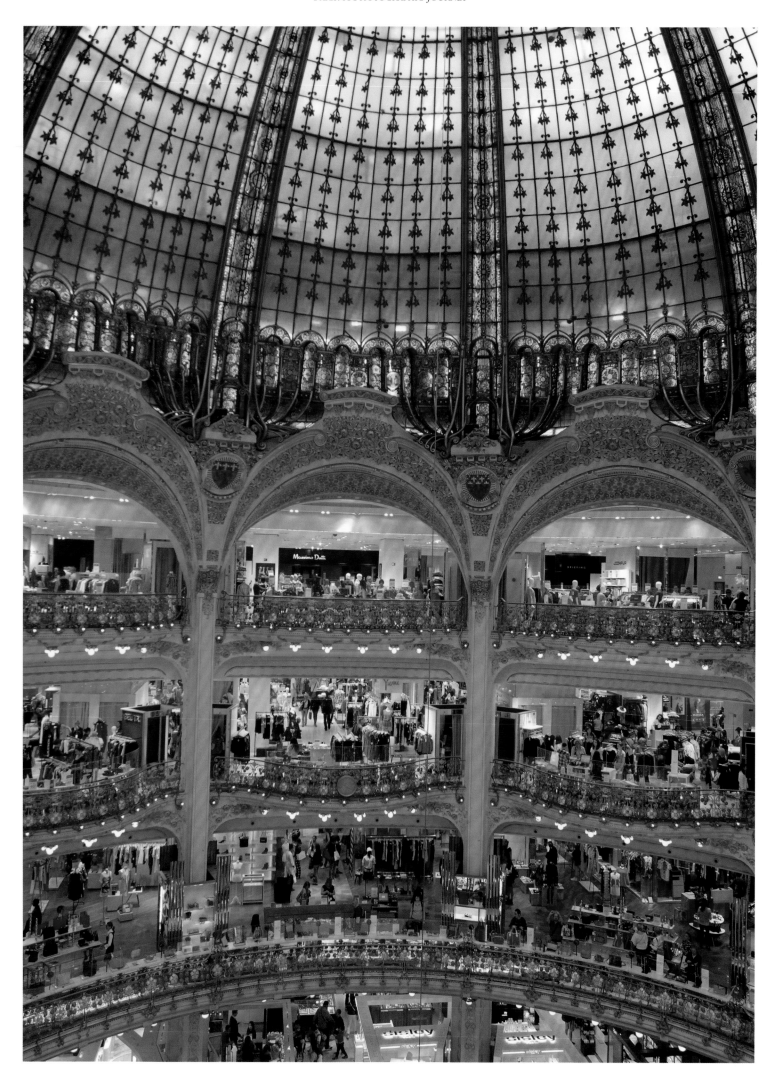

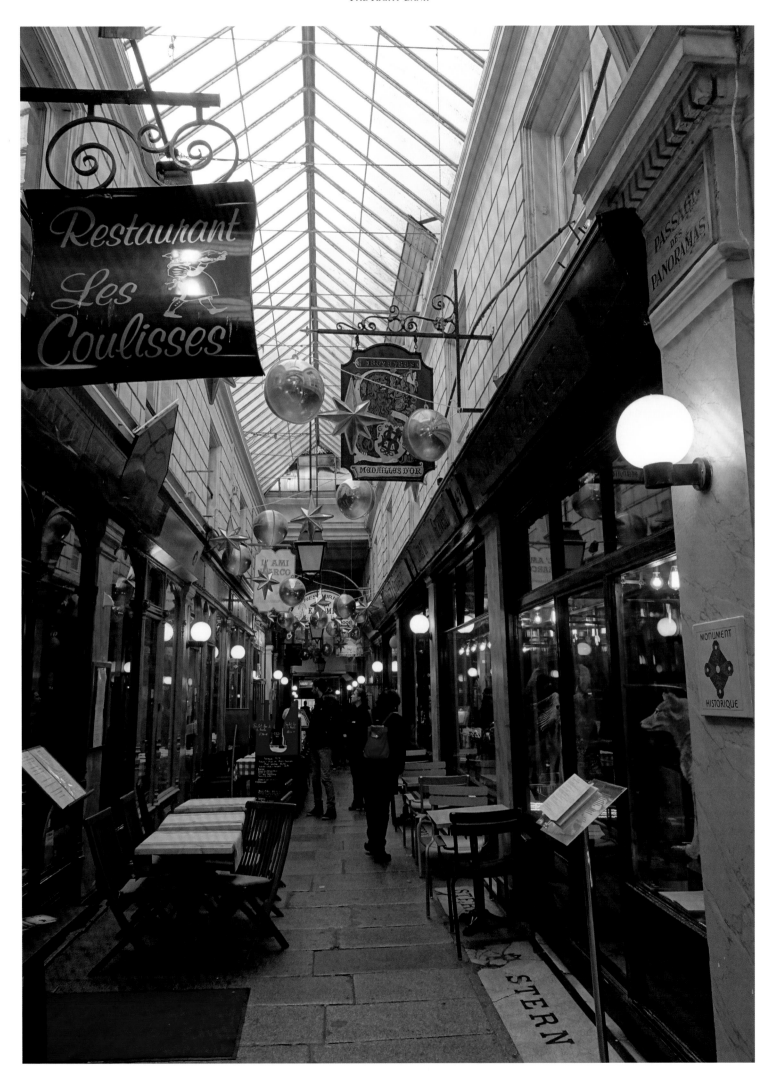

**ABOVE:** French cookery inspired the world and there are many venerable restaurants in Paris. L'Escargot on rue Montorgueil was founded in 1832, and had a makeover in 2014. The restaurant specializes, of course, in snails.

**BELOW:** Les Halles is overlooked by the church of Saint-Eustache, built over a century from 1532 although it has seen much change since then.

**RIGHT:** The Latin Quarter also boasts many restaurants although not always as upmarket as L'Escargot. This is rue de la Harpe, which is also well-known for supposedly having been the inspiration for the story of Sweeney Todd, the murderous barber, and Mrs. Lovett, who baked the remains. In reality, the stories told about the rue de la Harpe were as much fiction as were those of Sweeney Todd.

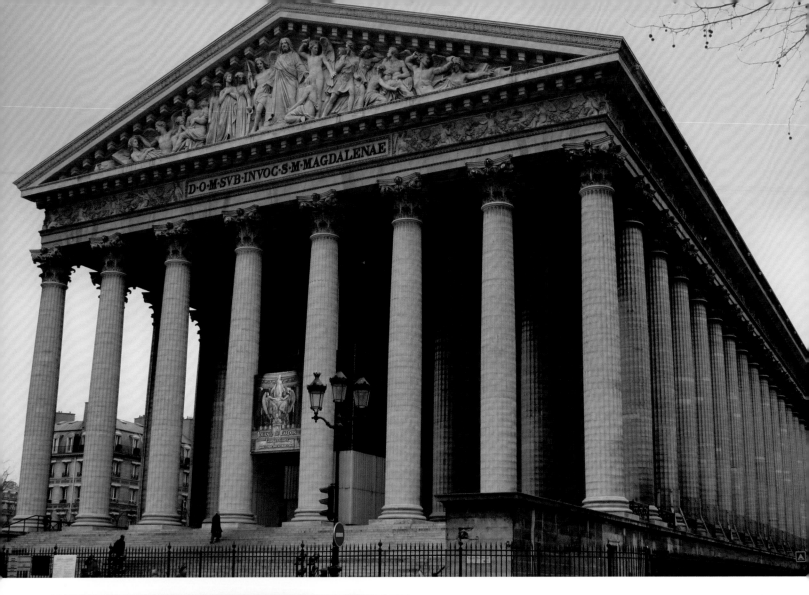

**ABOVE:** In the Place de la Madeleine in the 8th arrondissement stands L'église Sainte-Marie-Madeleine. Originally designed for Napoleon as a classical temple to celebrate his army, it was to be known as the Temple de la Gloire de la Grande Armée. But the Arc de Triomphe was built first and took that glory instead. The Madeleine was finally completed in 1842 after many changes of architect and purpose, and was consecrated as a church.

**LEFT:** Paris means fashion and haute couture and none is more redolent of style than Chanel—which has many shops in the center. Its exclusive store is found at Place Vendôme alongside the original Hotel Ritz and many other expensive couture and jewelry shops. In the Place Vendôme there is a stone column 144ft high encased in the bronze melted down from 1,250 cannons captured in 1805 at the Battle of Austerliz. Work started the following year and the column was finished in 1810. A copy of the original statue of Napoleon Bonaparte posing as Caesar stands on top—the original was irreparably damaged in 1871 during the Commune by the artist Gustave Courbet and friends.

**ABOVE RIGHT:** In the 4th arrondissement is the huge Hôtel de Ville, the political center of Paris and France. An earlier building burned during the Commune was rebuilt with funds from a national subscription and officially opened in 1882. The exterior has 30 statues representing French cities and 108 statues of famous and important Parisians. Four sculptures around the clock on the central tower represent Paris, the River Seine, Work, and Education.

**RIGHT:** Wherever you go in Paris there are large wooden doors that seem to hide secrets. Most open onto hidden courtyards, or light wells.

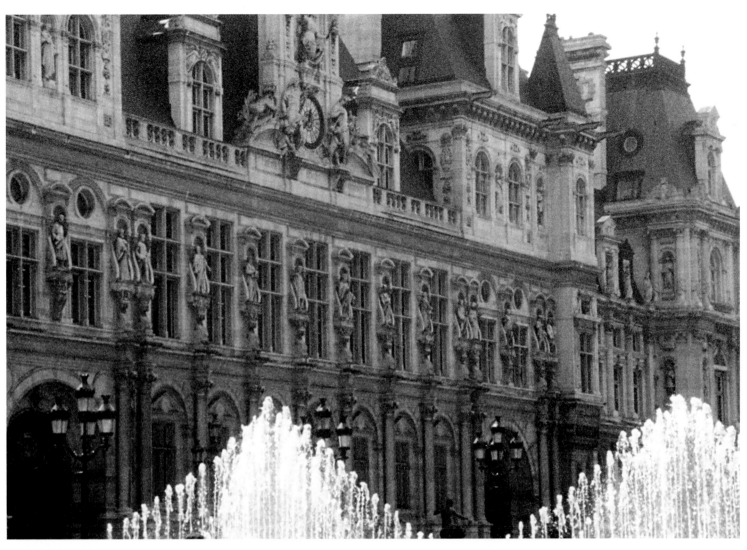

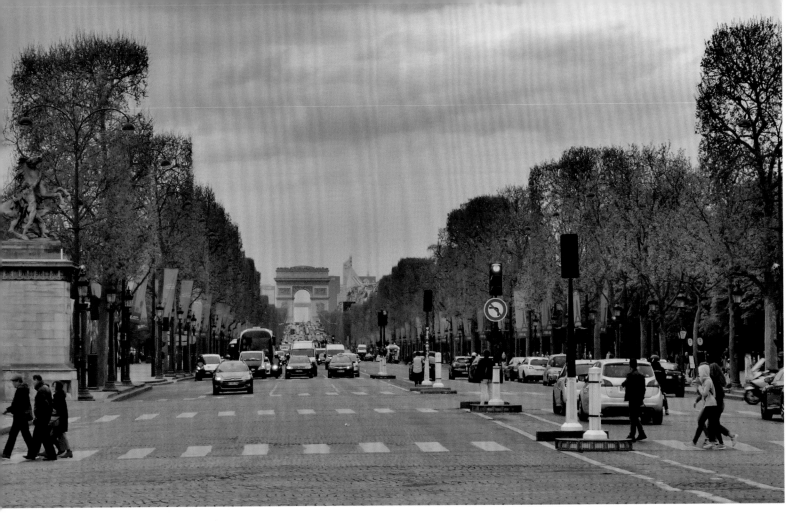

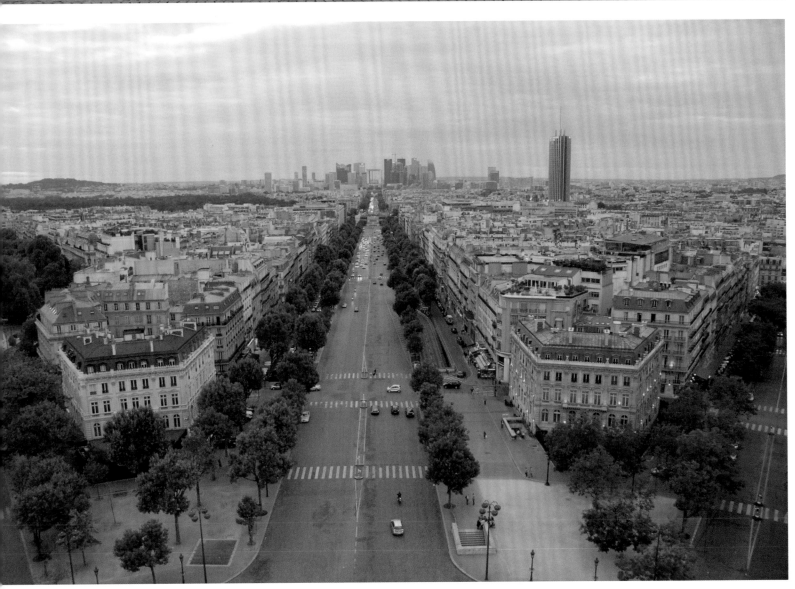

**LEFT:** Looking down the Champs-Élysées toward the Arc de Triomphe.

**BELOW LEFT:** Looking toward Neuilly and La Défense, at right the tower of the Hyatt Regency Paris Étoile hotel.

**RIGHT, BELOW, AND PAGES 66–67:** Scenes along the Champs-Élysées. Originally was a tree-lined walkway until Marie de Medici commissioned Le Nôtre to extend her view from the Tuileries. This then became a fashionable place to promenade. Over time the avenue was extended and in 1828 when it became city property, footpaths, fountains, and gas lights were added. Now it has become one of the great boulevards of the world, full of motor cars and crowds of people. Note the identification of the arrondissement on the street sign (**RIGHT**).

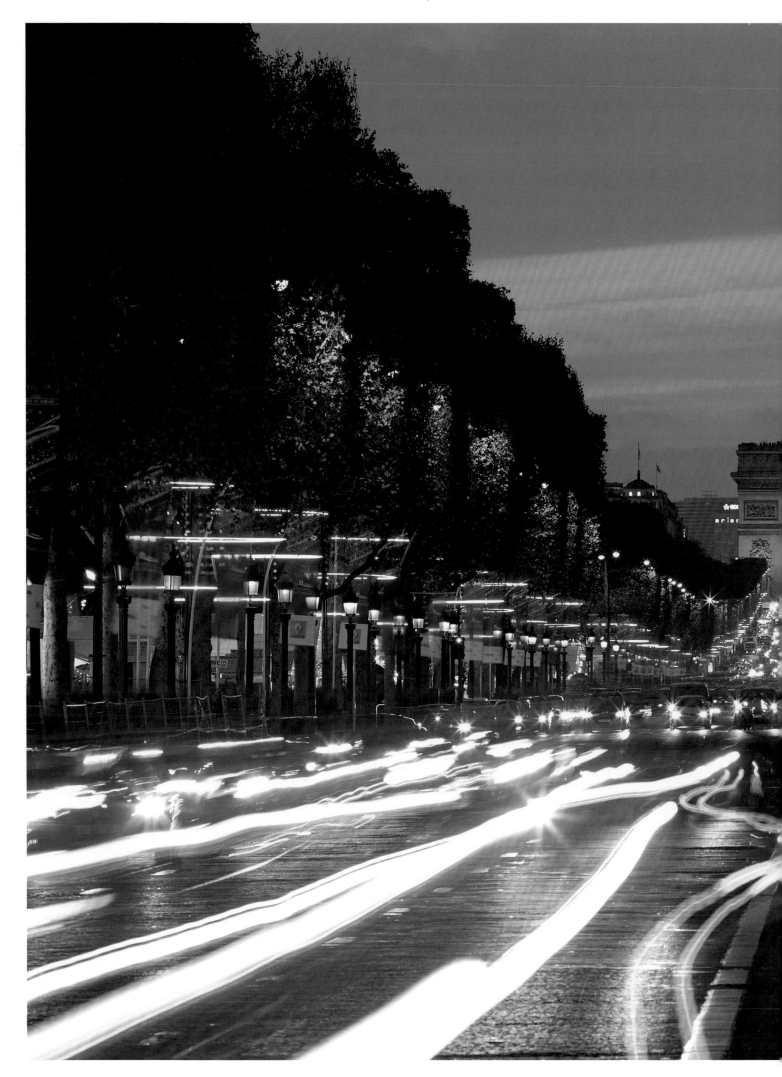

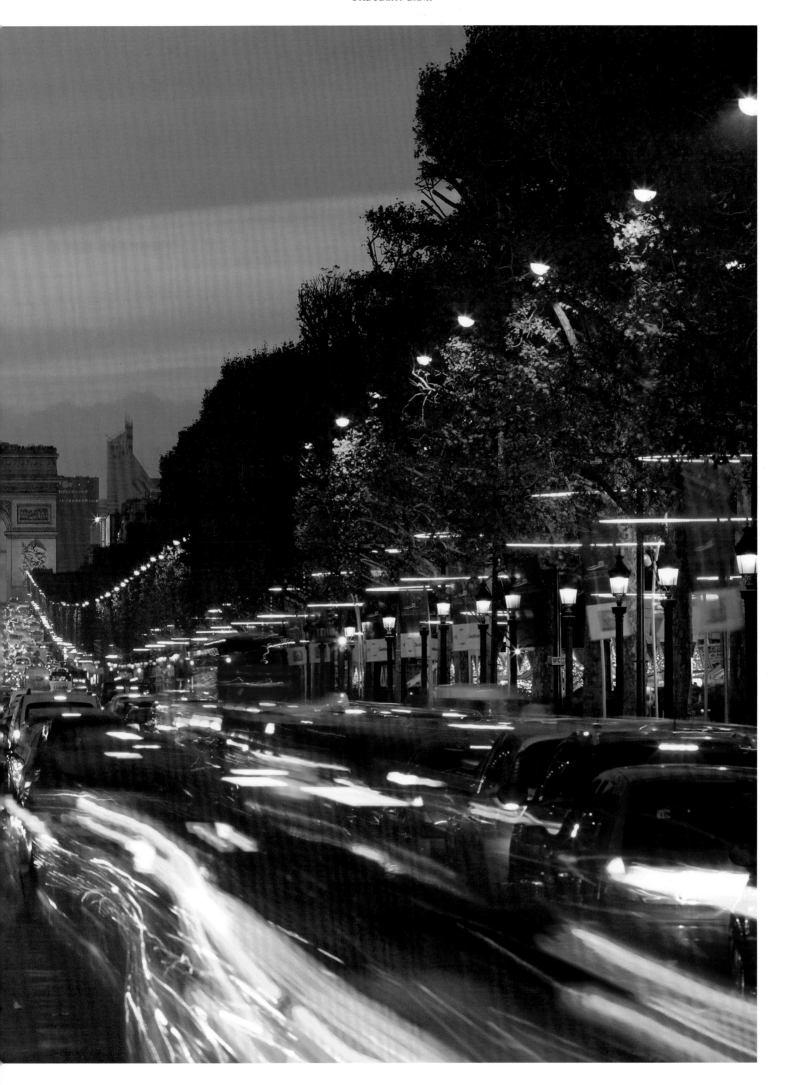

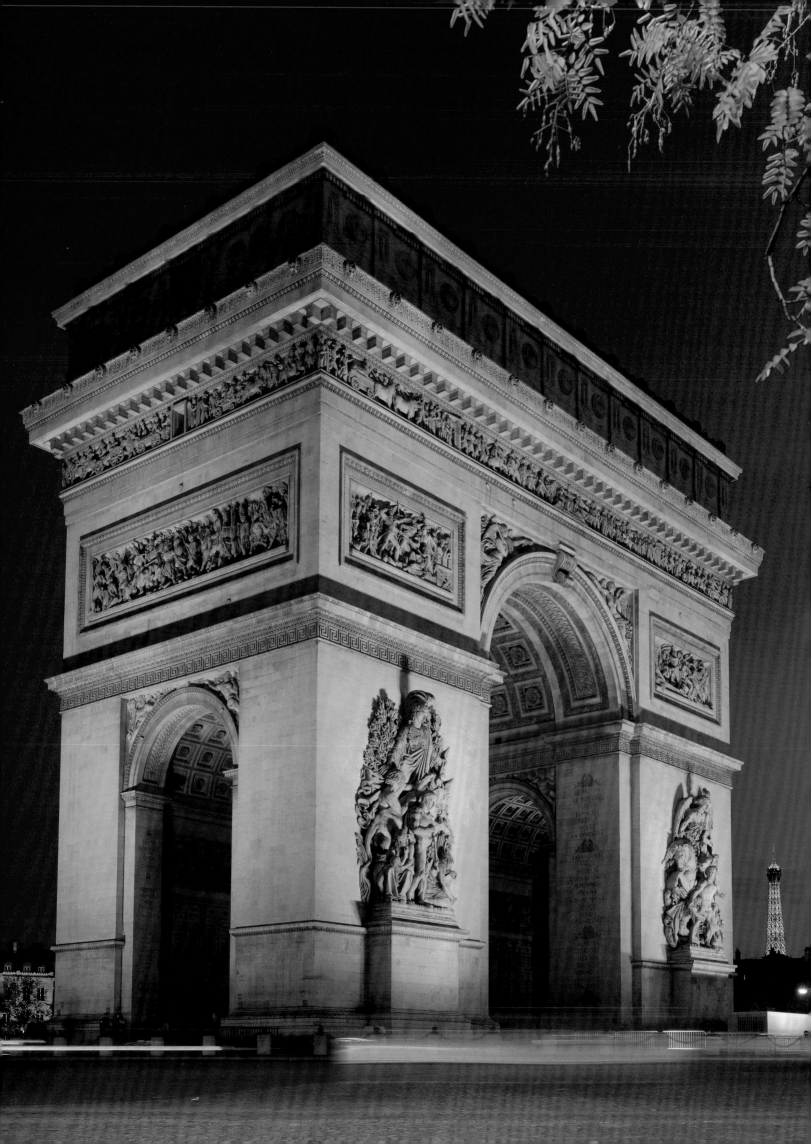

**LEFT:** The Arc de Triomphe was commissioned by Napoleon in 1806 as a triumphal monument to commemorate his victories. It was not finished until 1836, well after his death. It stands at the junction of the 8th, 16th, and 17th arrondissements and at the central roundabout of the junction of twelve great avenues and boulevards—Place Charles de Gaulle Étoile.

**RIGHT:** Detail of the Arc de Triomphe. It is decorated with sculpted reliefs depicting scenes from French history, particularly of battles, and is inscribed with the names of Napoleon's victorious generals. The battles themselves are commemorated at the top of the arch in 30 carved shields. This detail shows the most famous cartouche, the "Departure of the Volunteers of 1792" or "La Marseillaise" sculpted out of white marble in 1792 by François Rude (1784–1855).

**PAGES 72–73:** The Pompidou Center, also known as the Beaubourg, it is properly titled the *Centre National d'Art et de Culture Georges Pompidou*. The design for this huge futuristic arts center was the result of a competition won by the partnership of Renzo Piano and Richard Rogers. As the French National Museum of Modern Art it attracts about seven million visitors a year to see its changing exhibitions and permanent collection of twentieth-century artists including works by Picasso, Braque, Magritte, Chagall, Matisse, Delaunay, Kandinsky, Ernst, and Klee. It also includes a public library. The Beaubourg Plaza in front of the building constantly throngs with visitors, peddlars, and street entertainers.

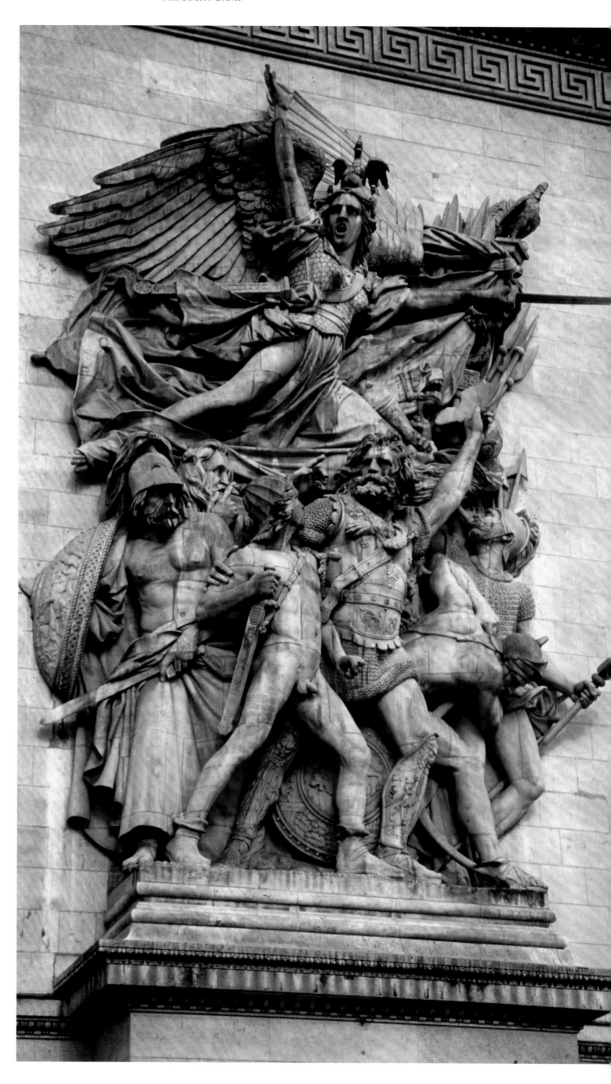

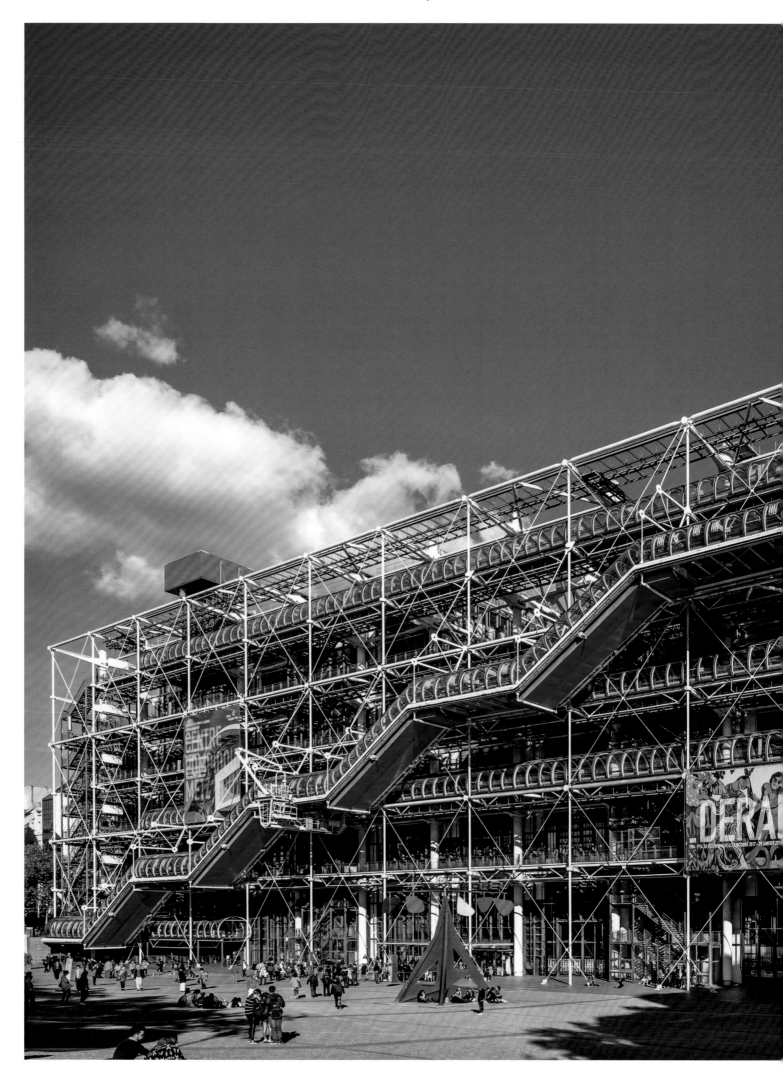

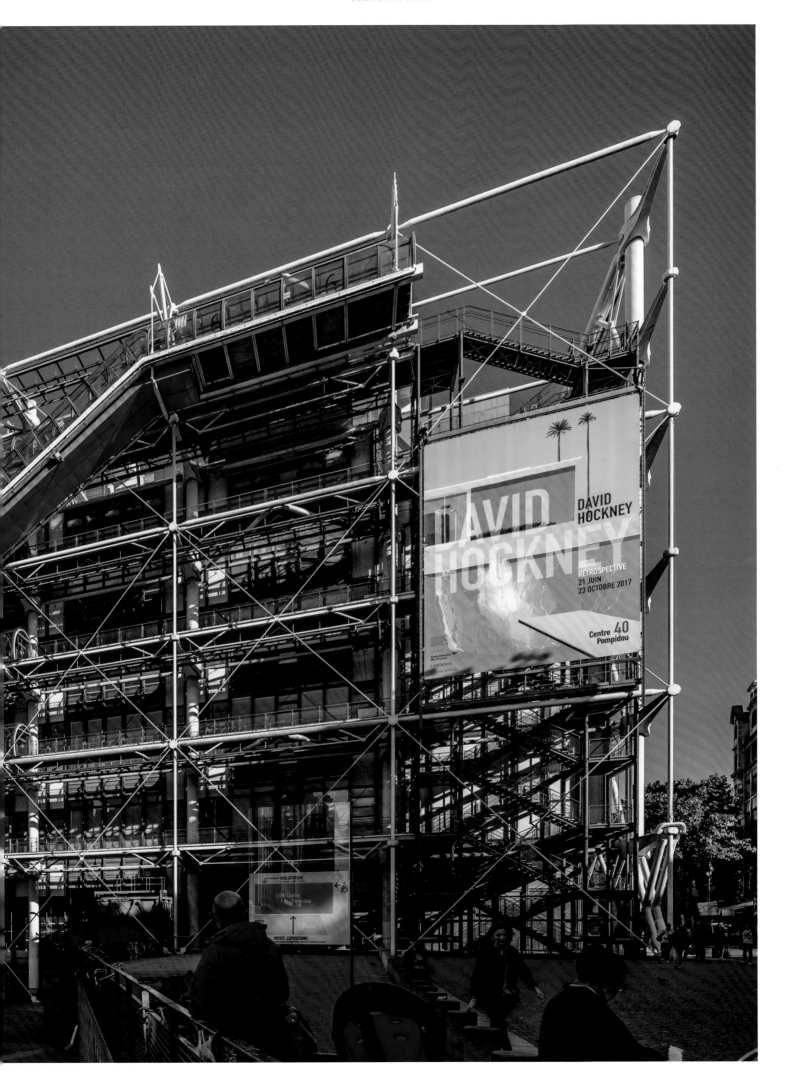

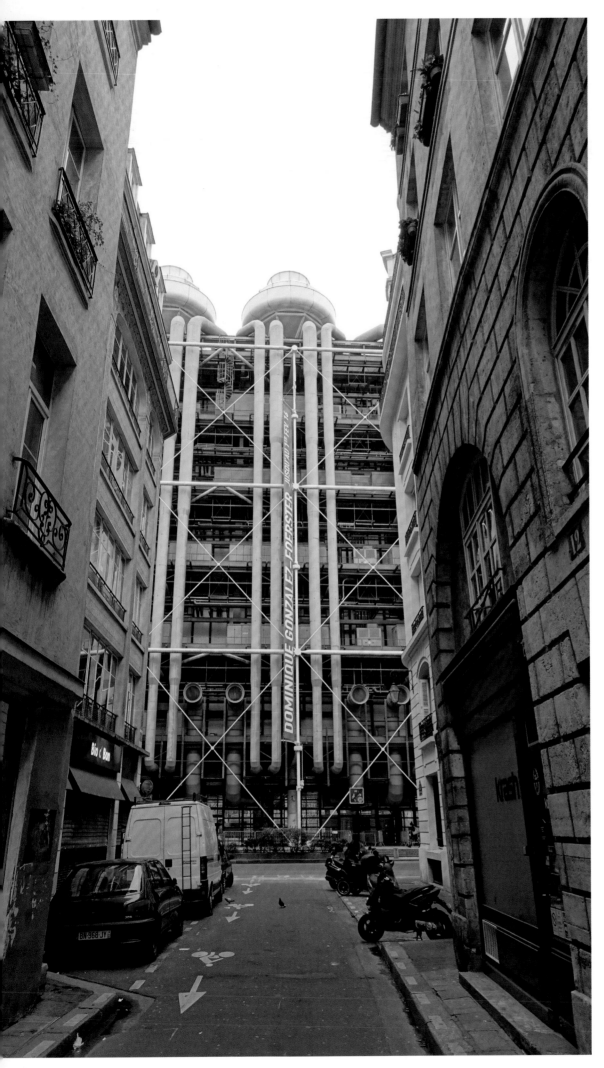

**LEFT:** Detail of the colorful pipes on the wall of the Pompidou Center. The center was the brainchild of President Georges Pompidou in 1969 as a way to bring art to the "man in the street." It took six years to build this controversial building in the old Beaubourg district in the middle of Paris.

**RIGHT:** A view of the Pompidou Center which shows the construction as essentially a giant transparent rectangular box with an exposed skeleton of colorful steel columns binding the box together.

**BELOW RIGHT:** All the pipework is external. The blue tubes carry air, the green ones are for water, and electricity is cabled within the yellow tubes. The elevators are painted red and the escalators move within clear plastic tunnels. The dragon is part of a Chinese New Year celebration.

**PAGES 75–76:** The Place de la Concorde is in the 8th arrondissement. It was constructed in 1763 when it was called the Place Louis XV. This was changed to become the Place de la Révolution when the guillotine was set up. It ended the lives of many famous victims including King Louis XVI, Marie Antoinette, Danton, and Robespierre. In addition between 1793 and 1795 a further 2,800 lesser-known victims lost their lives. The two fountains were added to the plaza in the 1830s on either side of the Luxor Obelisk which was erected in front of a crowd of 200,000 in 1836. Also a number of columns were built each decorated with the symbol of Paris—a ship's prow. The Ferris wheel—the Roue de Paris—moved from Paris to England in 2003 and has been peripatetic since, moving to the Netherlands, Belgium, Thailand, and Italy.

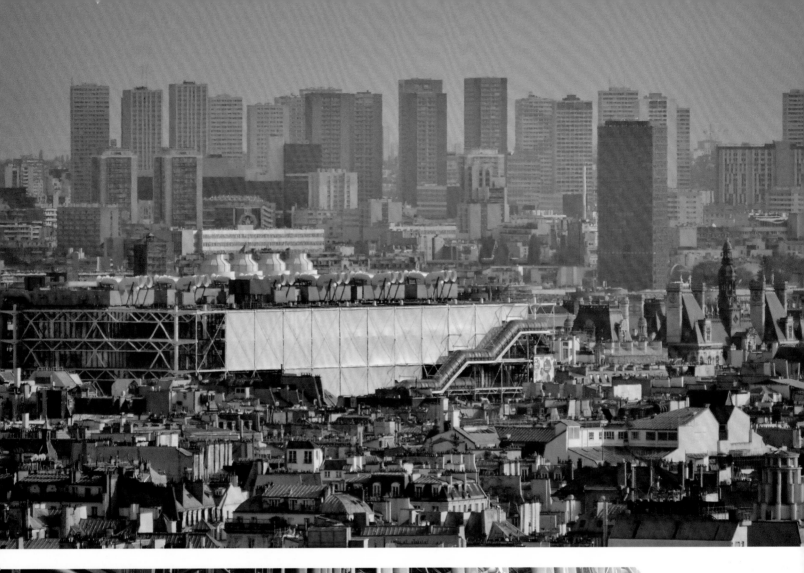

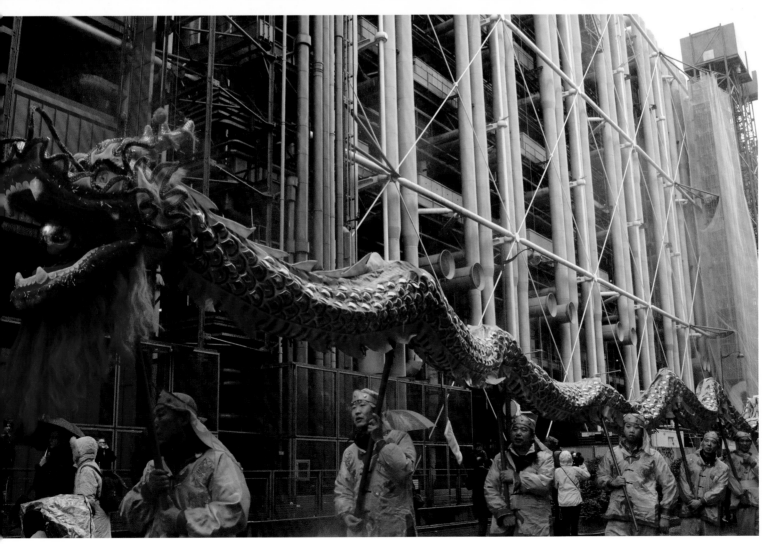

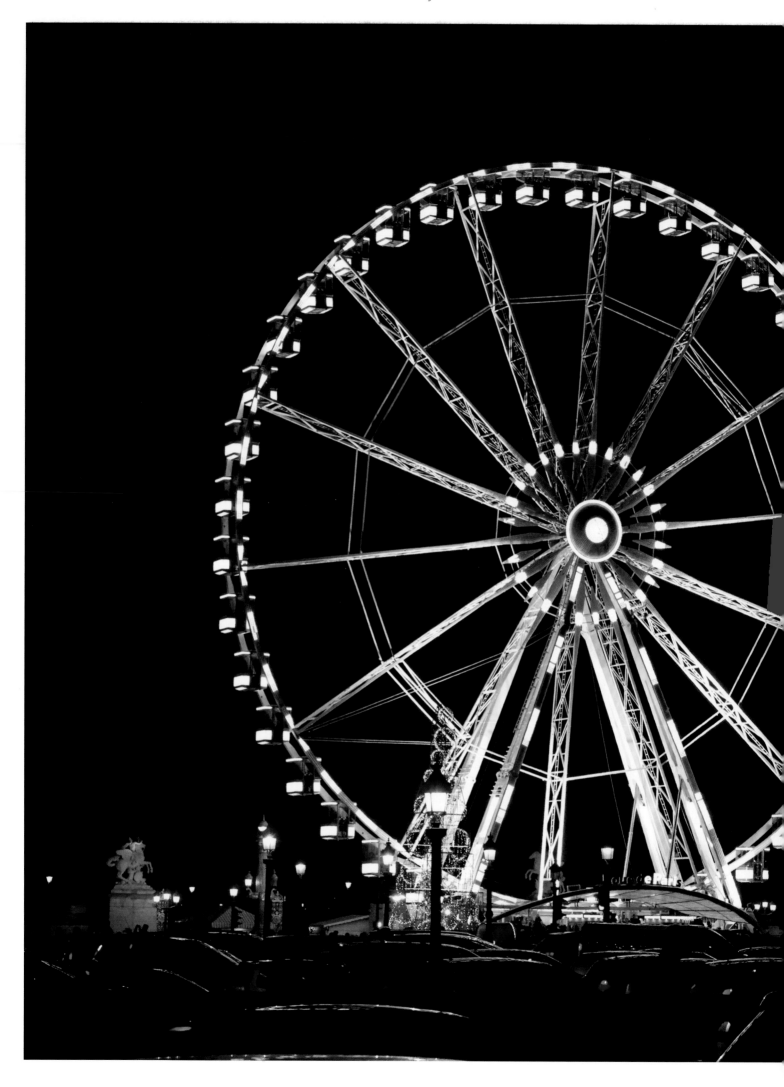

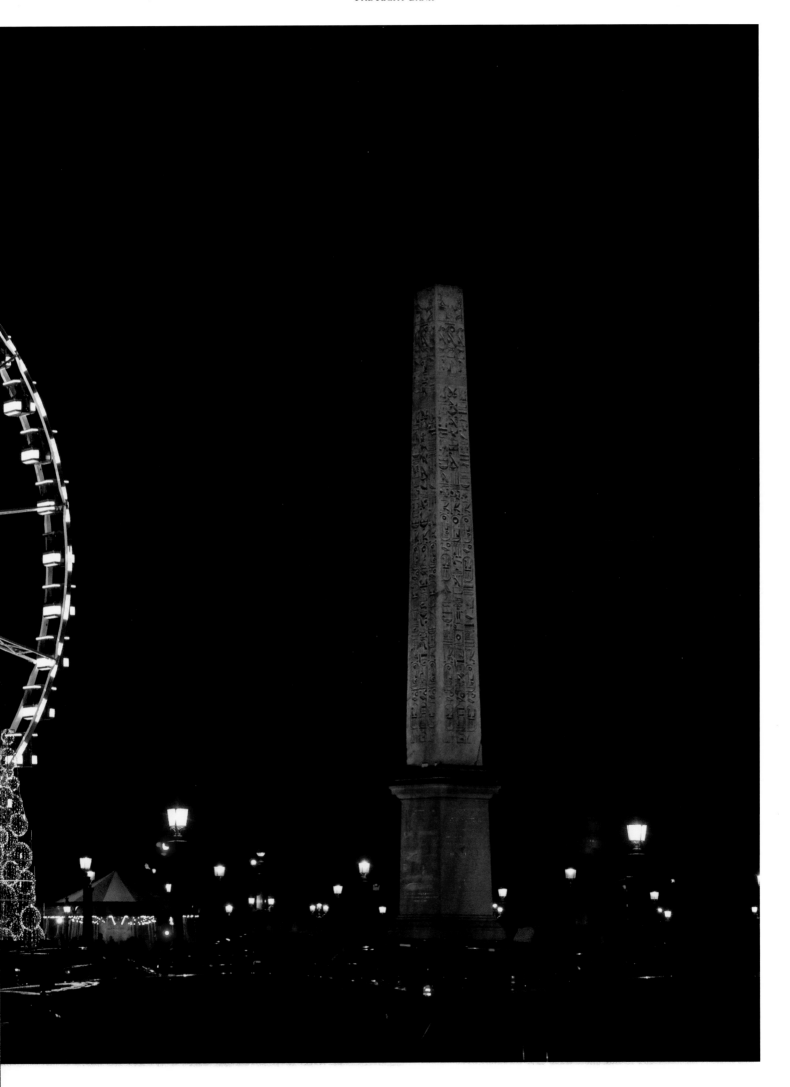

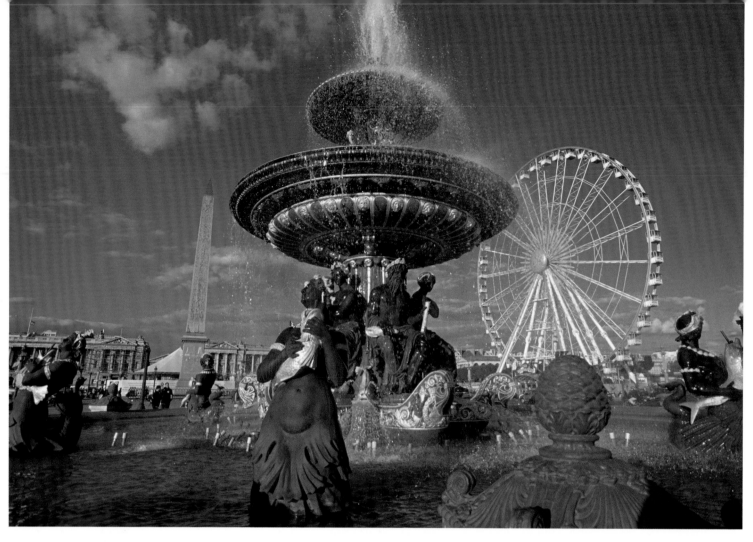

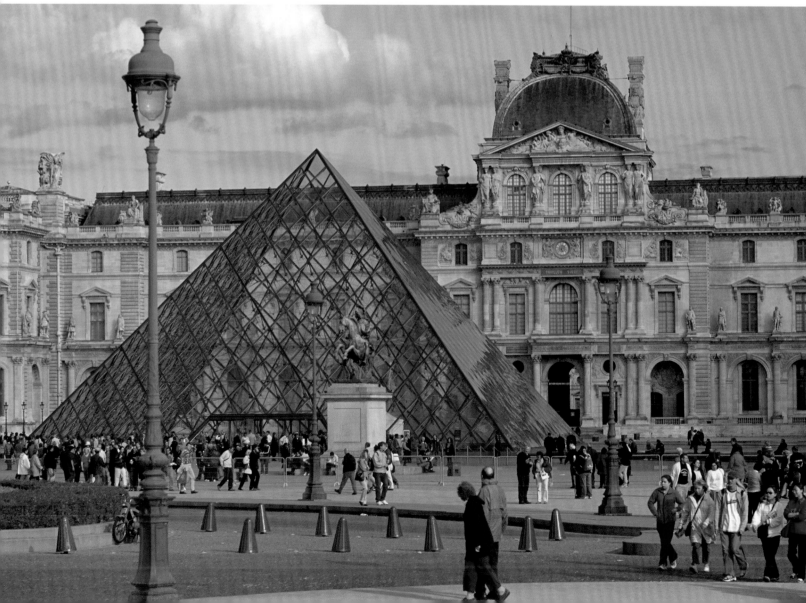

**LEFT:** Detail of a fountain in Place de la Concorde.

**BELOW LEFT:** The entrance to the Louvre Museum is down through the glass pyramid into the huge underground reception area which then leads into the Grand Louvre.

**RIGHT:** At the eastern end of the Champs Elysées stand replicas of the Horses of Marly (the original statues are in the Louvre Museum). In addition there are statues representing the great cities of France—Bordeaux, Brest, Lille, Lyon, Marseille, Nantes, Rouen and Strasbourg,

**PAGES 80 AND 81:** The Grand Louvre was renovated between 1981 and 1993. At the heart of the work is I.M. (Ieoh Ming) Pei's 71ft high glass pyramid which contains 70 triangles and 603 diamonds of glass that let streams of light into the underground reception hall. Inside hangs a reverse glass pyramid which appears to sit on top of a miniature brick pyramid. The glass pyramid—celebrated its thirtieth birthday in 2019—is lit up at night.

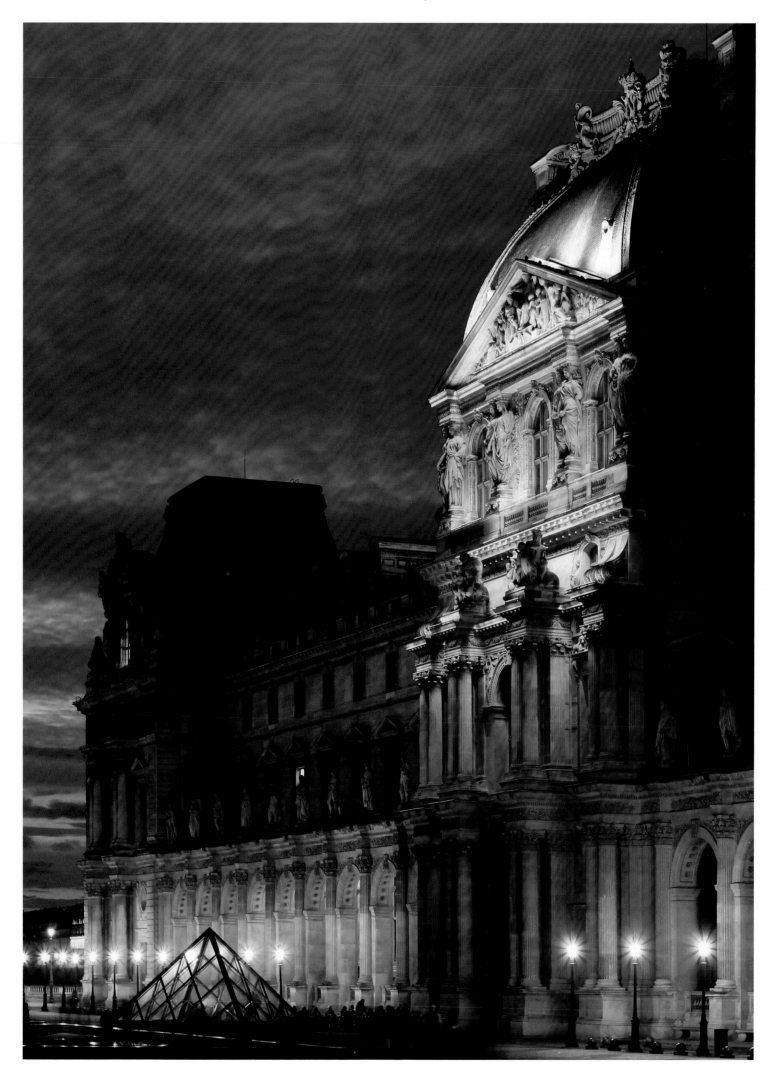

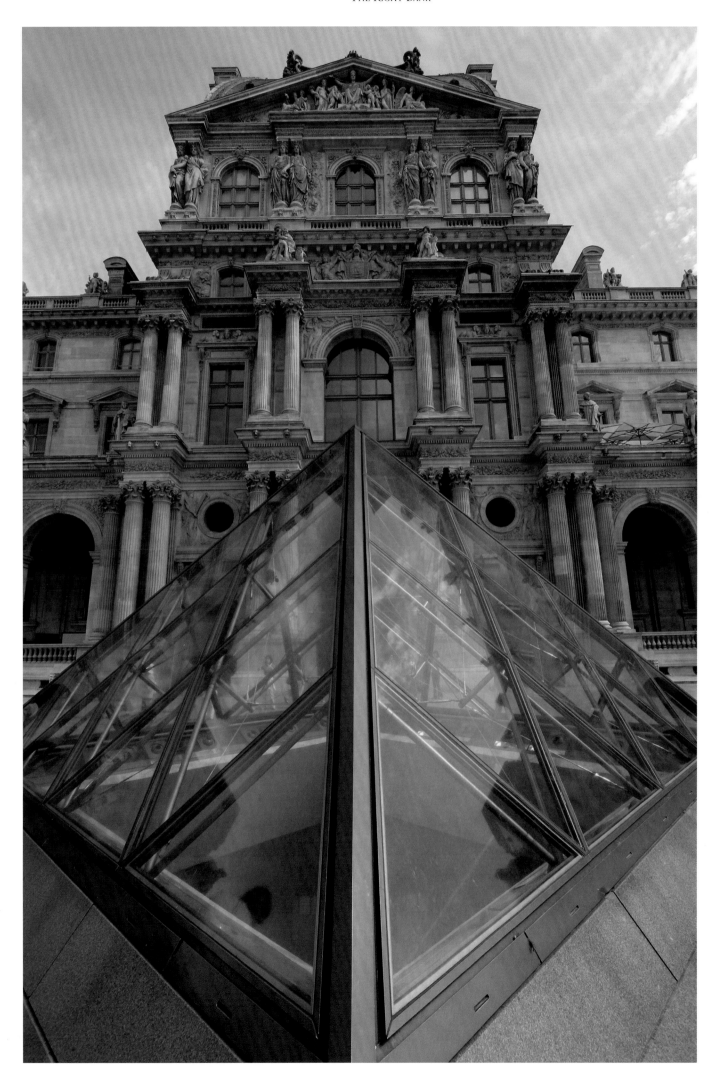

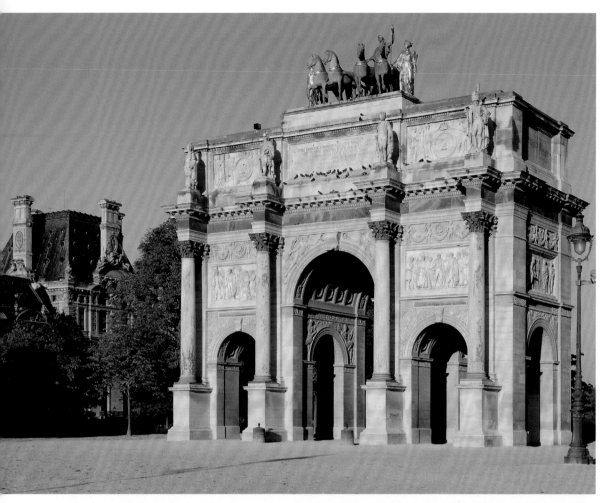

**LEFT:** The Arc de Triomphe du Carrousel was started in 1806 on Napoleon's orders. On top of it he positioned the chariot and horses that he had taken from St. Mark's in Venice. (The Venetians themselves had taken the statue, created in 300 B.C. by Lysippos, following the Fourth Crusade which sacked Constantinople in 1204.)

**RIGHT AND BELOW:** The ancient Louvre palace is in the 1st arrondissement. The first building here beside the Seine was a fortress built at the end of the twelfth century by Philippe-Auguste. It was then transformed into a royal palace starting when Charles V moved his residence here in 1358. Subsequent French monarchs extended, removed, and improved the buildings over the centuries.

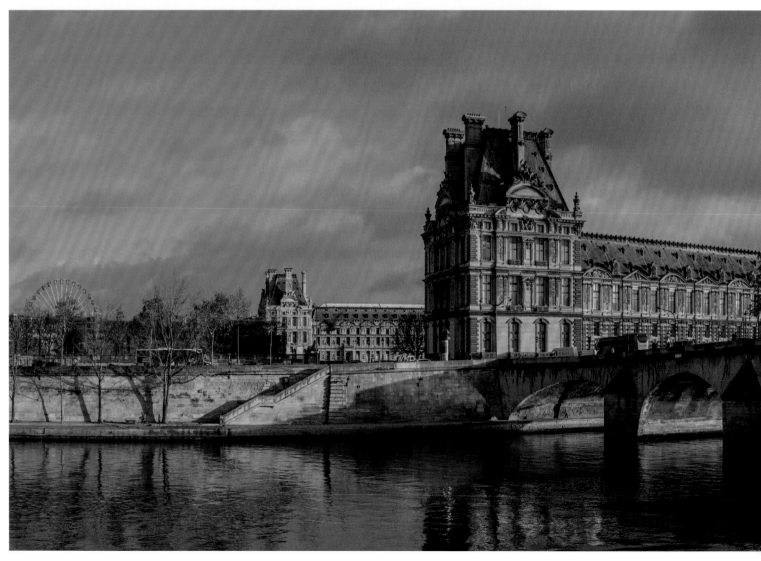

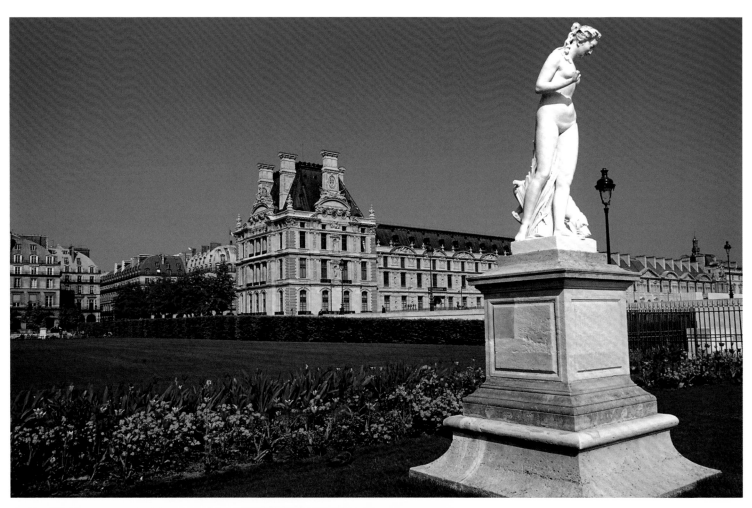

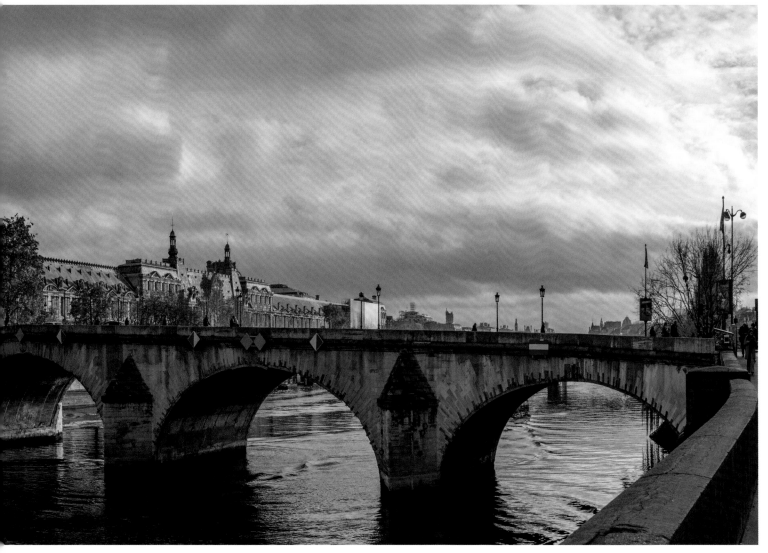

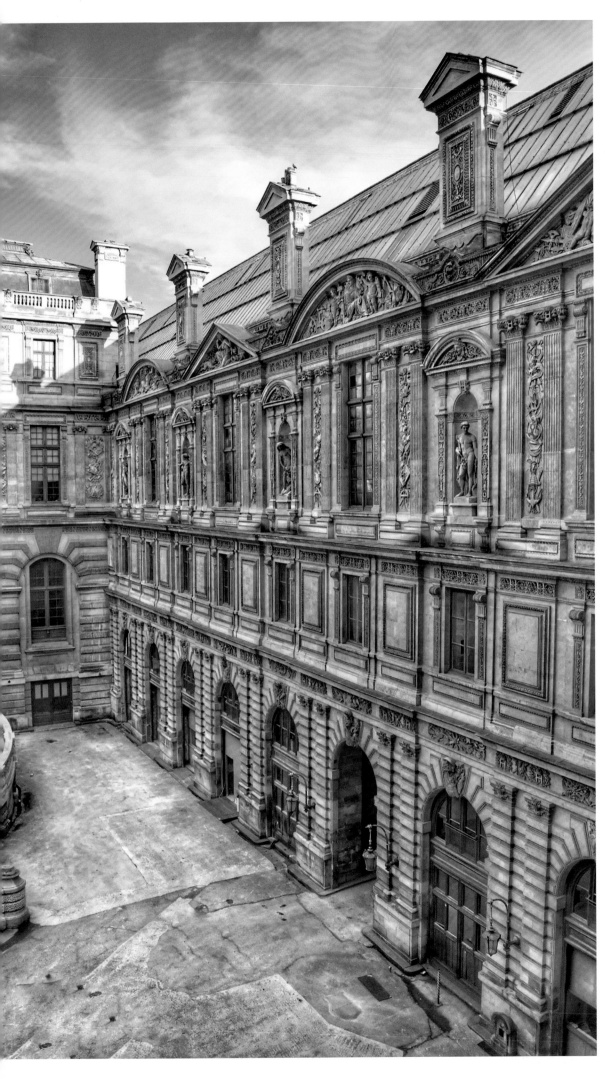

**LEFT AND RIGHT:** Two more views of the Louvre. Originally a fortress, today it is the most important art gallery in France, if not the world. It opened as a museum in 1793, becoming the Musée Napoleon in 1801. It houses artifacts in eight collections: Near Eastern Antiquities, Egyptian Antiquities, Greek, Etruscan and Roman Antiquities, Islamic Art, Sculptures, Decorative Arts, Paintings, and Prints and Drawings.

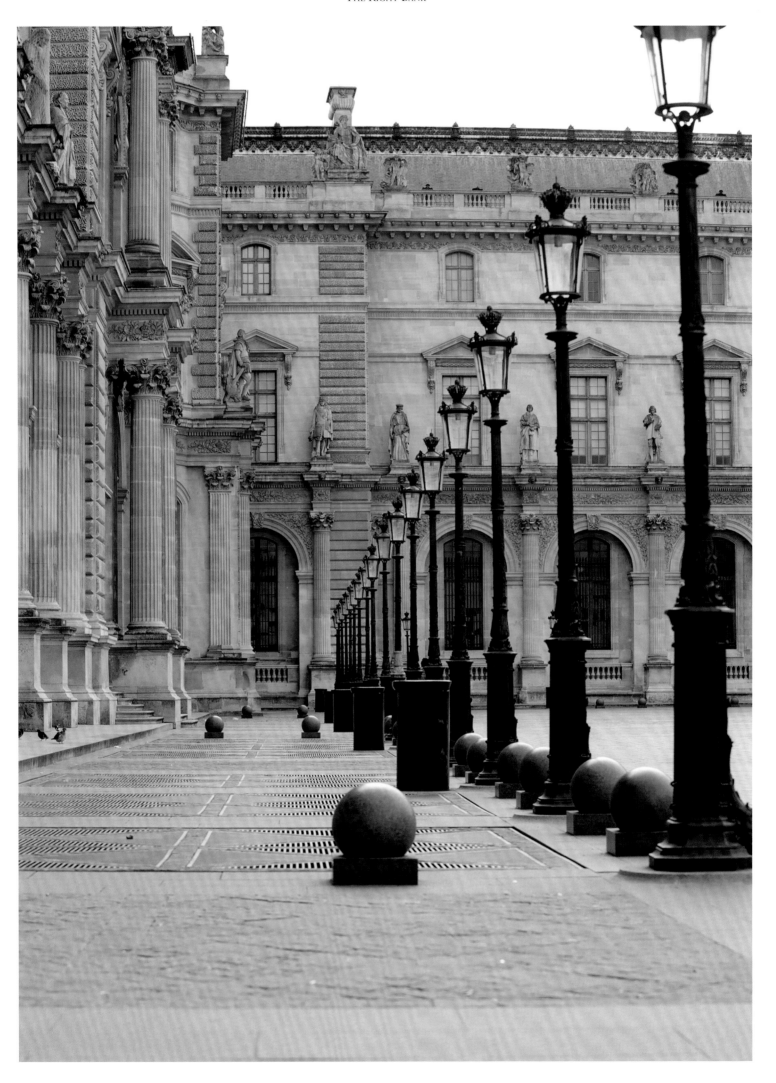

**LEFT:** The façade of the Opéra is embellished with two huge gilded statues, above a frontage comprising rose marble columns, groups of sculpture, and friezes. The elaborate interior—which can be compared in opulence with Versailles—has a maximum capacity of 2,200.

**BELOW LEFT:** The Opéra's interior is opulently accoutered.

**RIGHT AND BELOW:** Views of the Opéra looking down Avenue d'Opéra. The Académie Nationale de Musique was established under a patent granted by Le Roi Soleil, Louis XIV, in 1669 and was instrumental in making Paris a major cultural center. The building was officially renamed Palais Opéra in 1989 when the new Opéra de Paris Bastille opened.

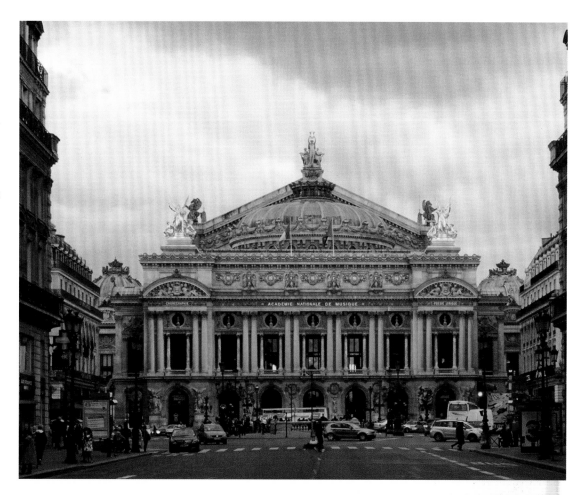

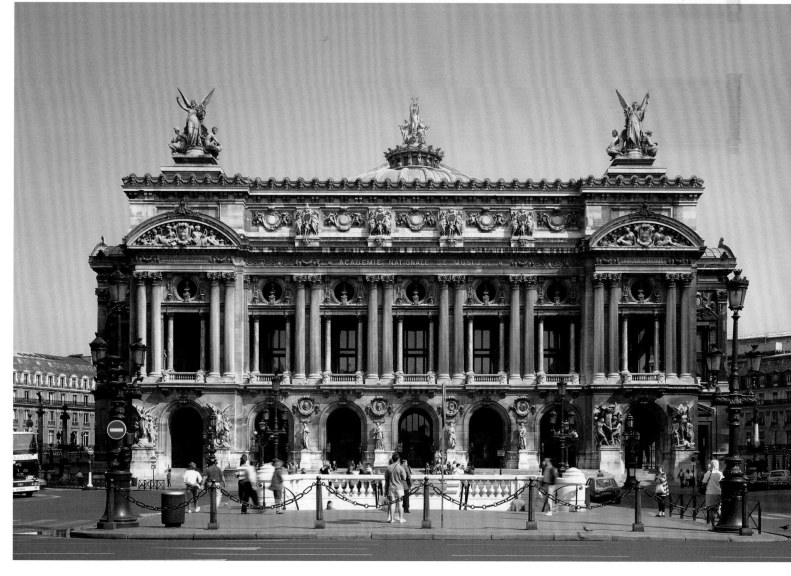

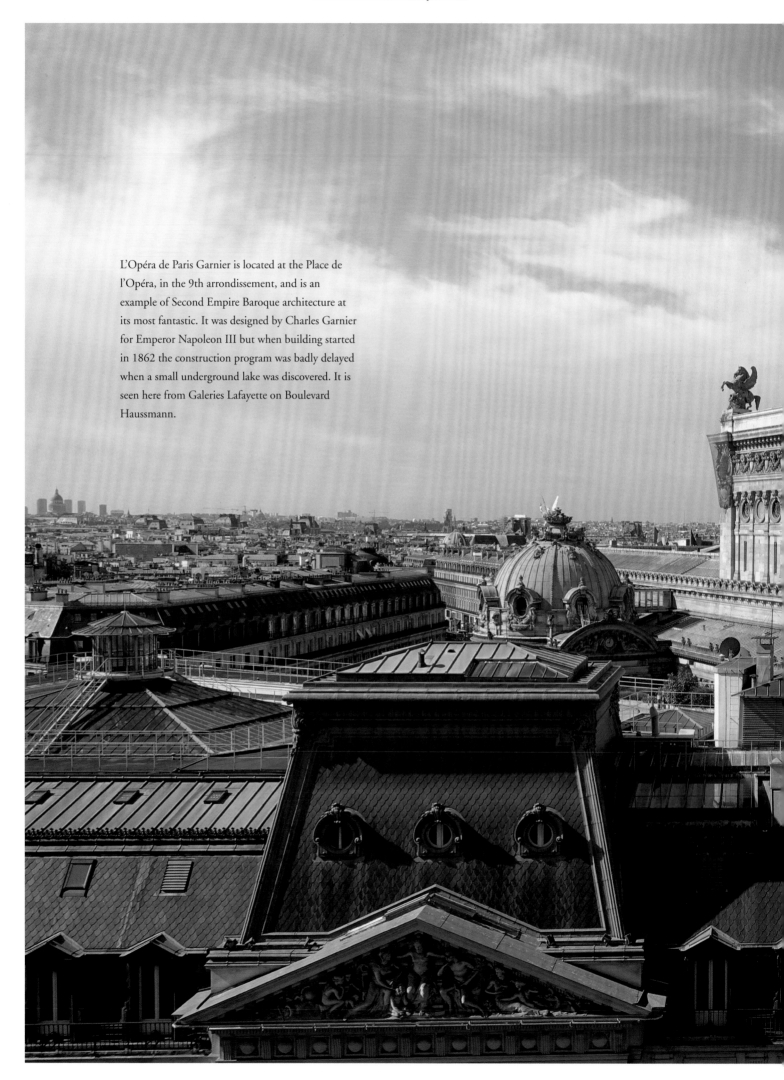

L'Opéra de Paris Garnier is located at the Place de l'Opéra, in the 9th arrondissement, and is an example of Second Empire Baroque architecture at its most fantastic. It was designed by Charles Garnier for Emperor Napoleon III but when building started in 1862 the construction program was badly delayed when a small underground lake was discovered. It is seen here from Galeries Lafayette on Boulevard Haussmann.

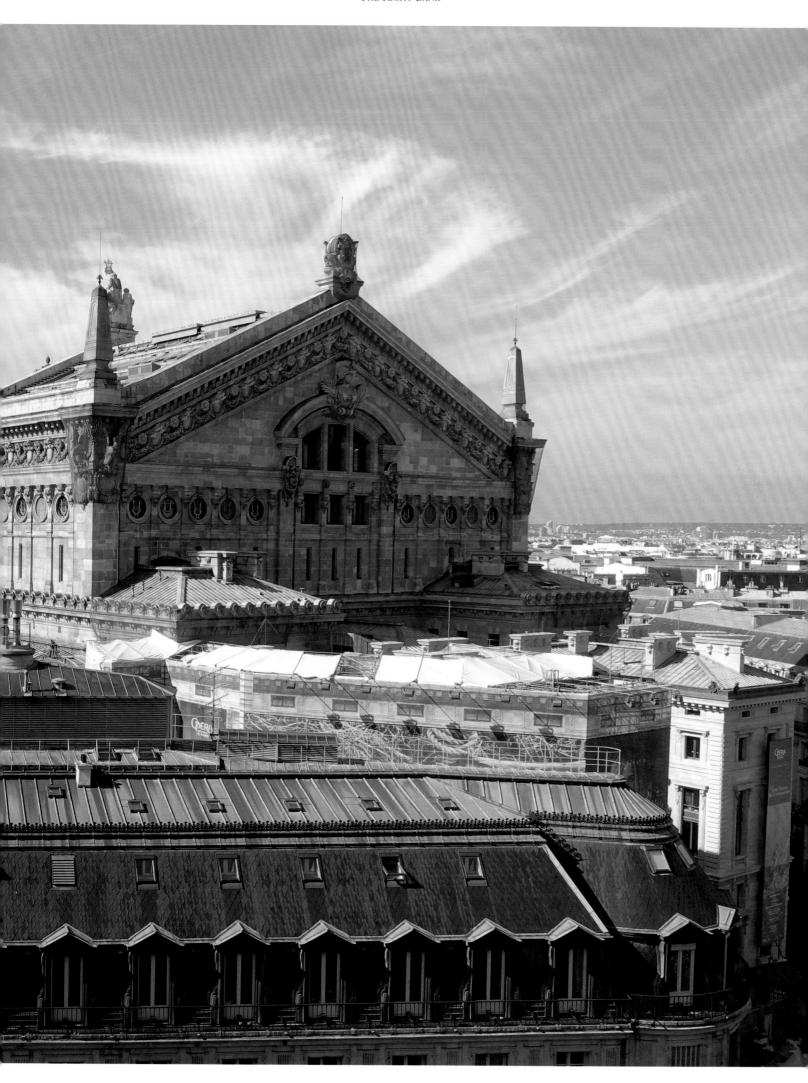

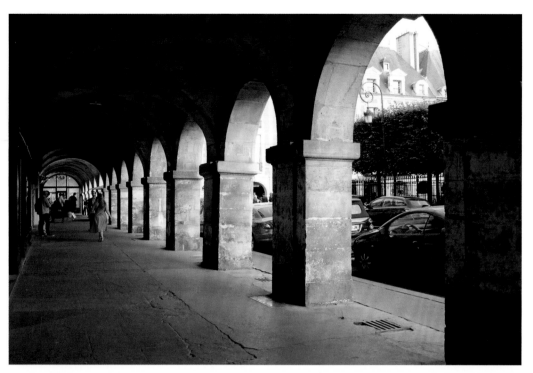

**LEFT AND RIGHT:** The Place des Vosges was established by Henri IV when it was called Place Royale. The name was changed by Napoleon in 1800 as a reward for the Département of Vosges which was the first to pay taxes that year.

**BELOW:** Above the arcades of the Place des Vosges are 39 houses and apartments that have given shelter to many celebrated residents including Victor Hugo in 1832–1838 during which time he wrote most of *Les Miserables*.

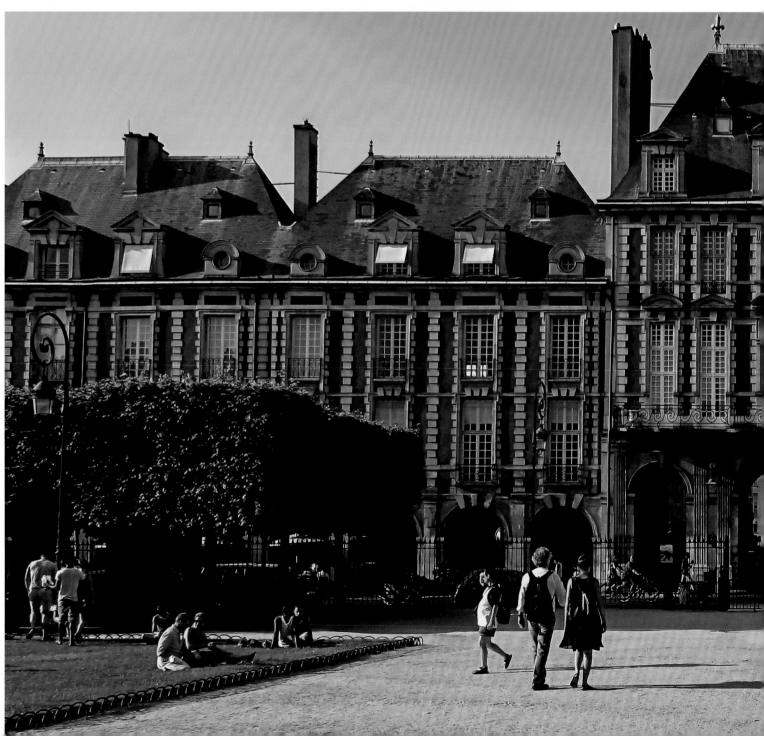

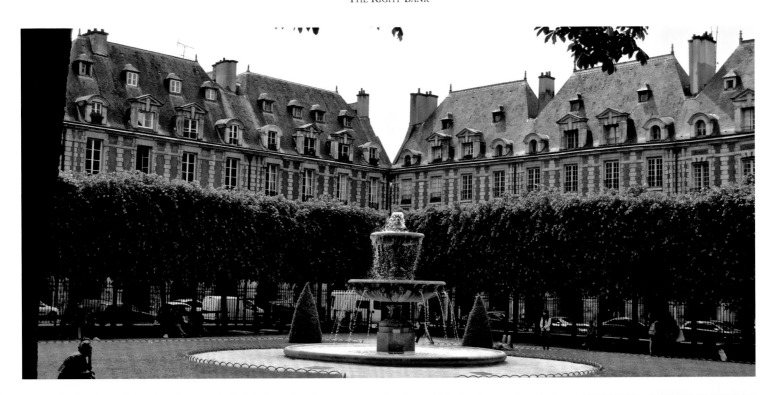

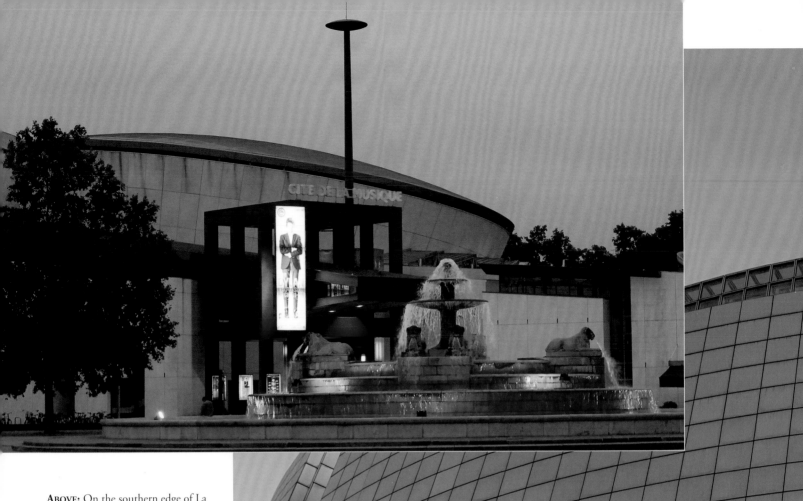

**ABOVE:** On the southern edge of La Villette park lies the Cité de la Musique designed by Christian de Portzamparc, one of France's leading contemporary architects. The building is dedicated to bringing alive the French national collection of music instruments which visitors' can listen to through infrared headphones as they view the collection. The complex includes a concert hall and the French national conservatory of music.

**RIGHT:** The Opéra de la Bastille was completed in 1990 in time to celebrate the bicentennial of the French Revolution.

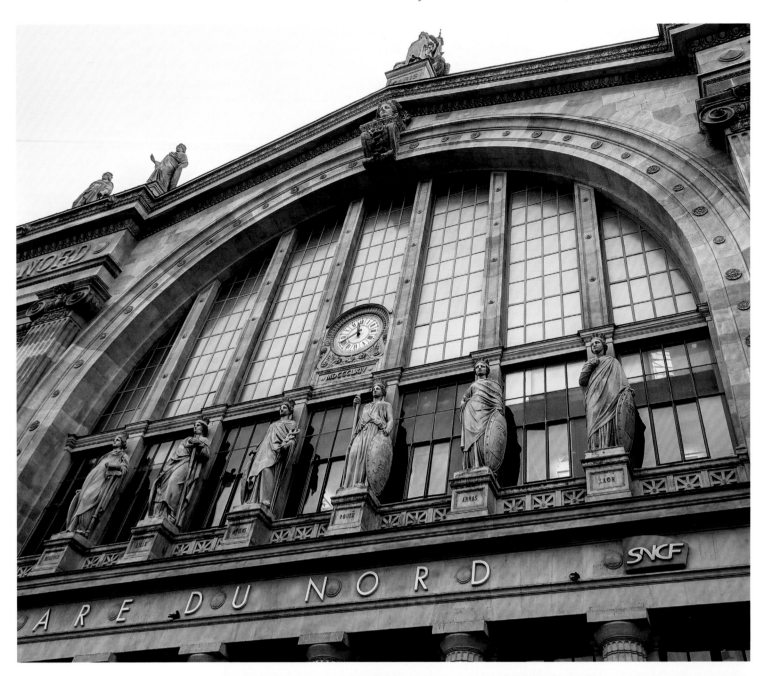

**ABOVE:** The Gare du Nord is the terminus for trains from north Germany, the United Kingdom (with the Channel Tunnel service), Scandinavia, the Netherlands and Belgium. In addition it serves the regions of Picardy and the Pas de Calais. Construction started in 1861 and the first trains operated from here in 1864 although the work was not completed until 1866.

**OPPOSITE, TOP RIGHT:** The neo-Corinthian façade of the Gare du Nord is surmounted with statues representing important northern European towns and French cities.

**RIGHT:** The business end of the Gare du Nord.

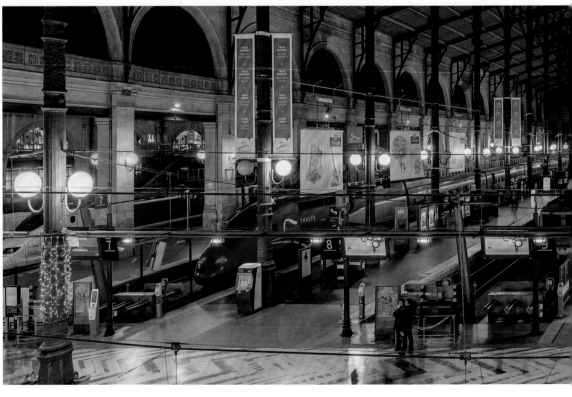

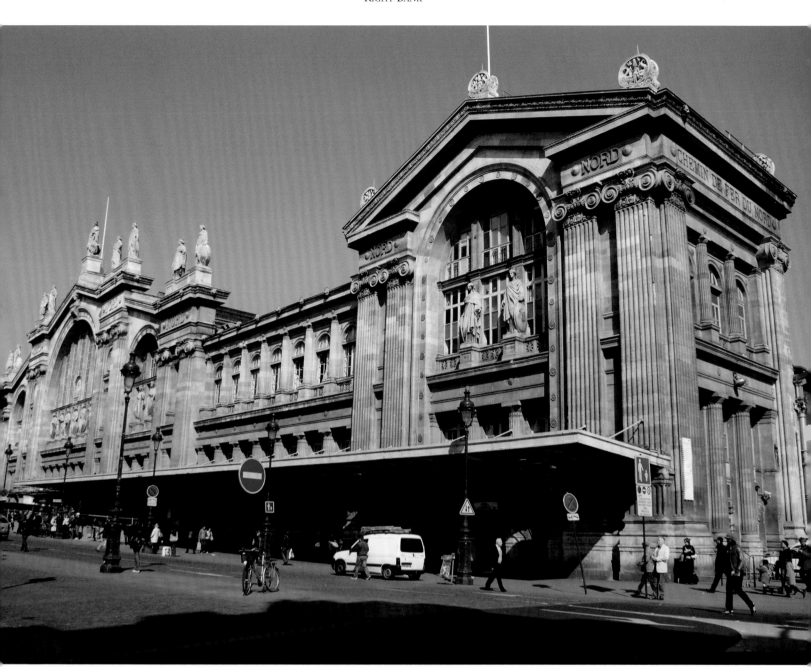

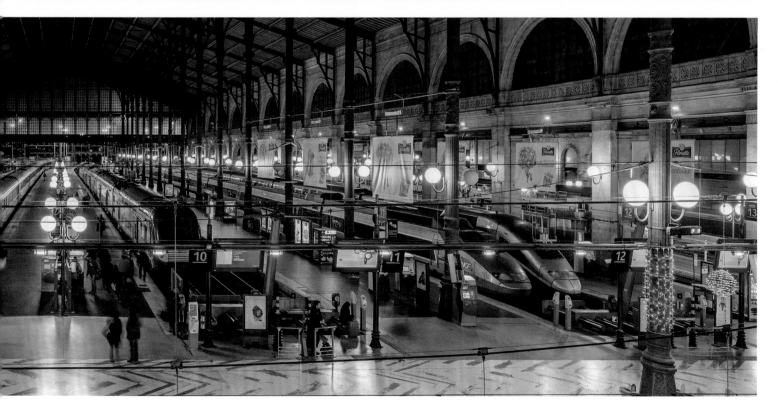

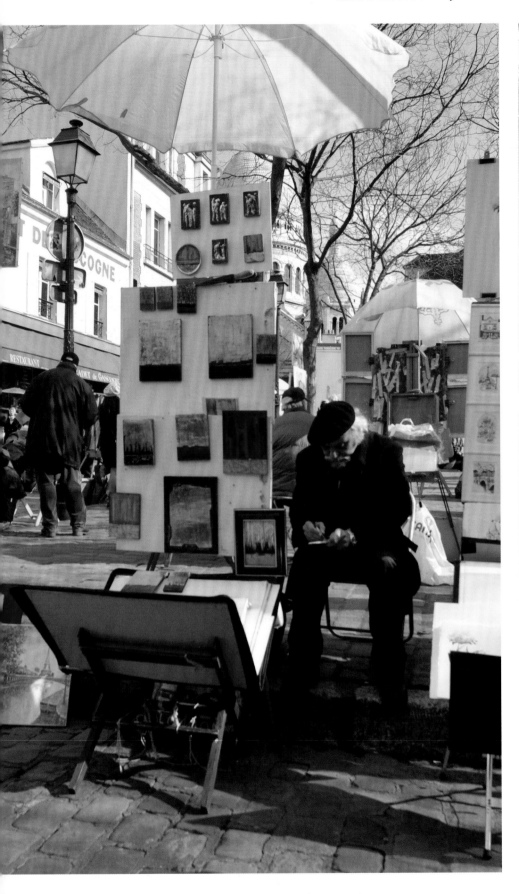

**ABOVE:** Many Montmartre artists make a living from tourists by drawing on the spot portraits.

**ABOVE:** The easiest way to get up the steep hill to Sacré-Coeur is to take the funicular railway from the base of the Butte de Montmartre (the Hill of Martyrs); the reward is one of the best views across Paris. Otherwise climb up the steps. The funicular is part of the Métro system although it is not joined up to it.

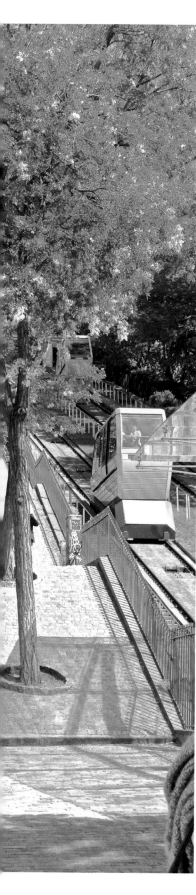

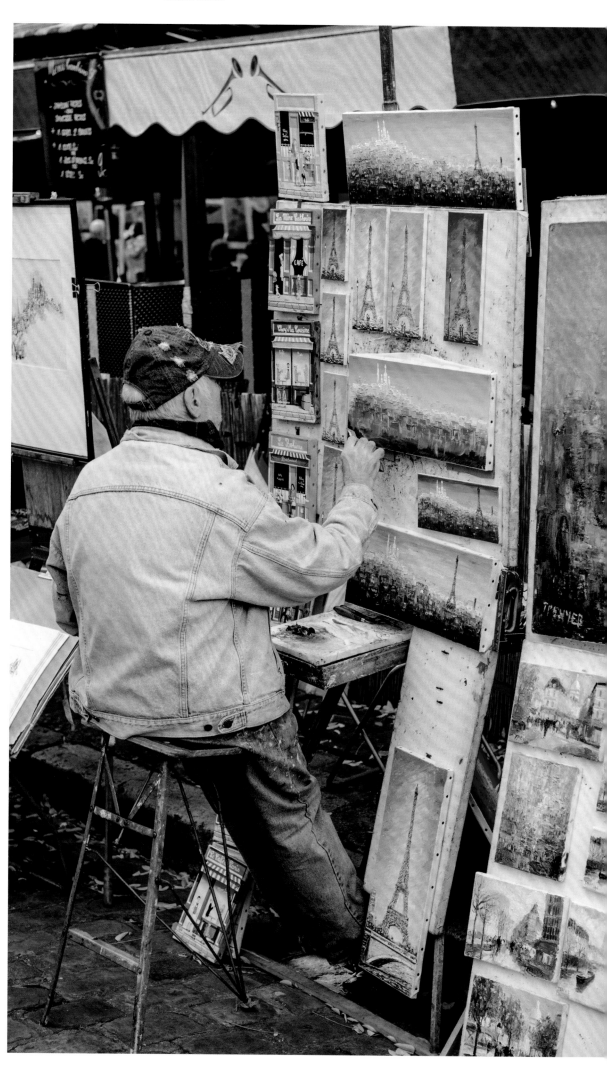

**RIGHT:** The Place du Tertre is surrounded by restaurants and cafés catering for the numerous tourists who throng the surrounding streets. In the center of the place itself numerous artists set up their easels and make their living from painting or sketching quick portraits.

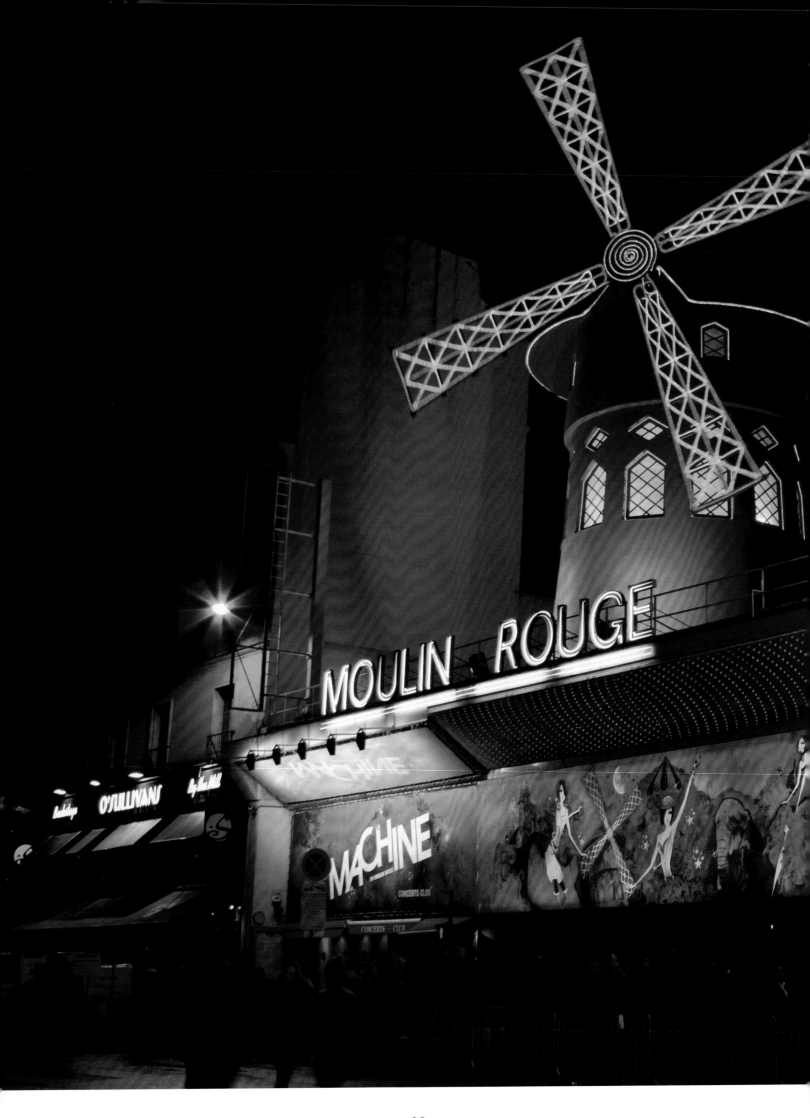

The famous Moulin Rouge in the Pigalle area of night clubs.

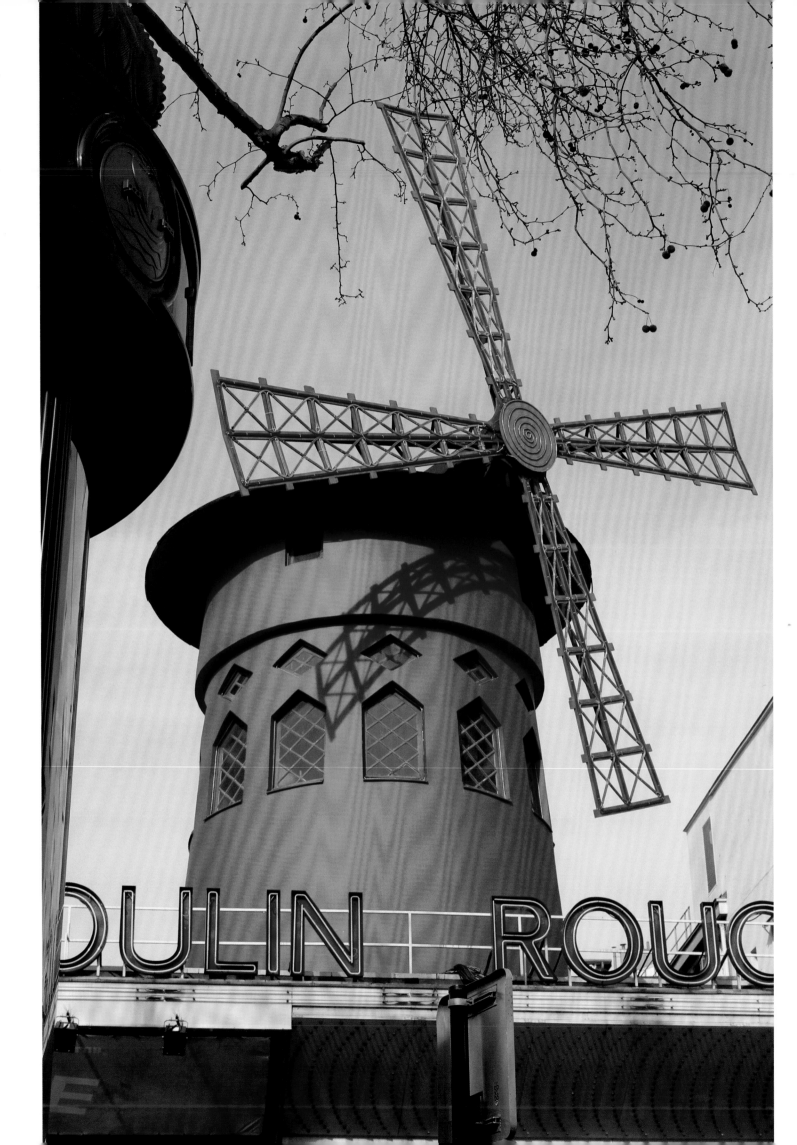

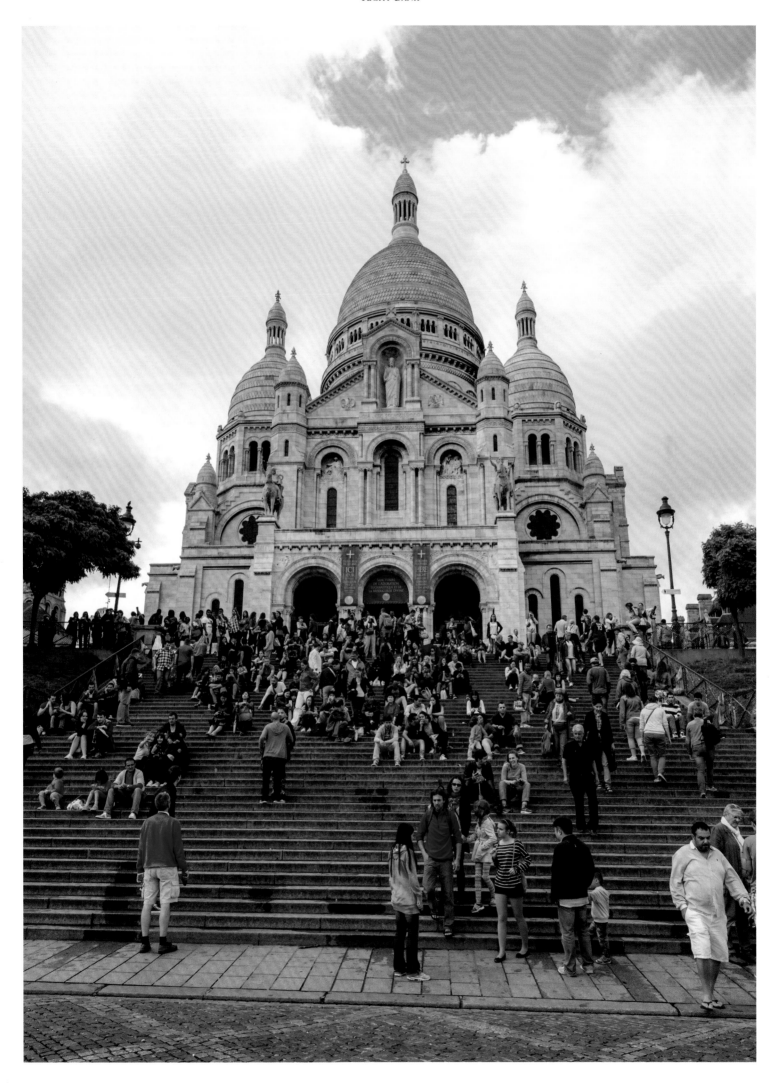

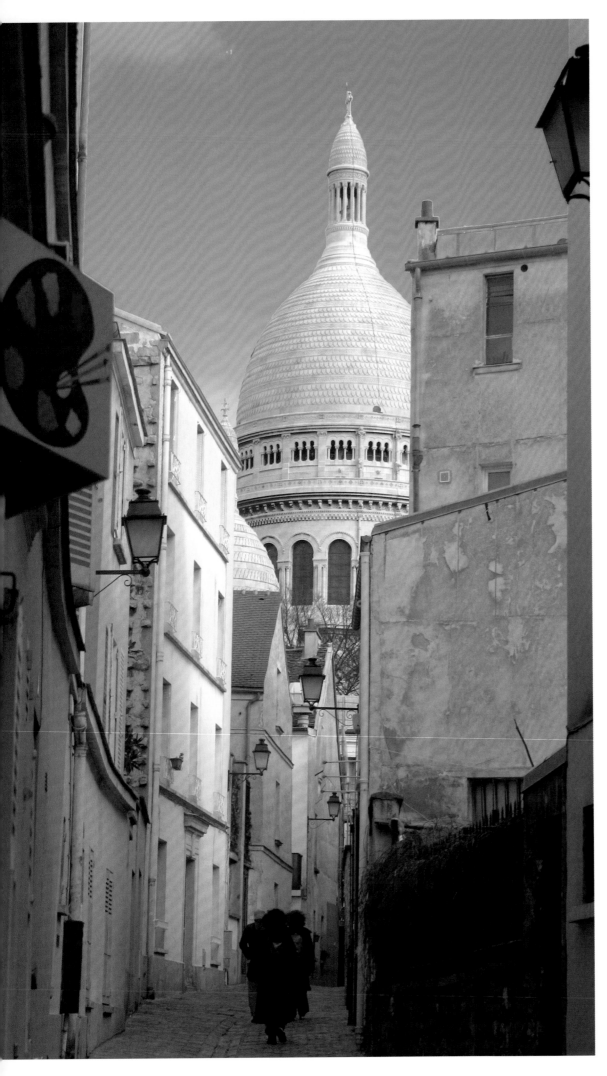

**PAGE 100:** The Moulin Rouge is the legendary nightclub of dubious repute where the Can-Can dance is claimed to have been devised. The original nolonger exists. At one time there were over 40 windmills on the Bute Montmartre, now only three are left in the area, two of these on the Rue Lepic are modern replicas and none of them work.

**PAGE 101:** The gleaming white basilica of Sacré Coeur built in Roman-Byzantine style dominates this side of Paris. Construction began in 1877 and took forty years to complete (1914). It was designed by the architect Paul Abadie, but he died in 1884 long before construction was complete.

The interior contains one of the largest mosaics in the world, designed by the French architect Luc Olivier Merson—it shows Christ with outstretched arms. In the bell tower hangs one of the heaviest bells in the world, the Savoyarde, which was cast in Annecy in 1895 and weighs 19 tons.

**LEFT AND RIGHT:** More views of Sacré-Coeur.

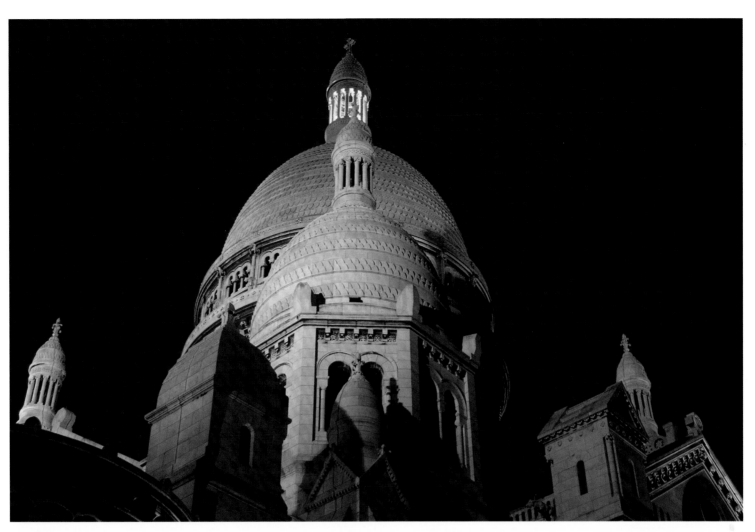

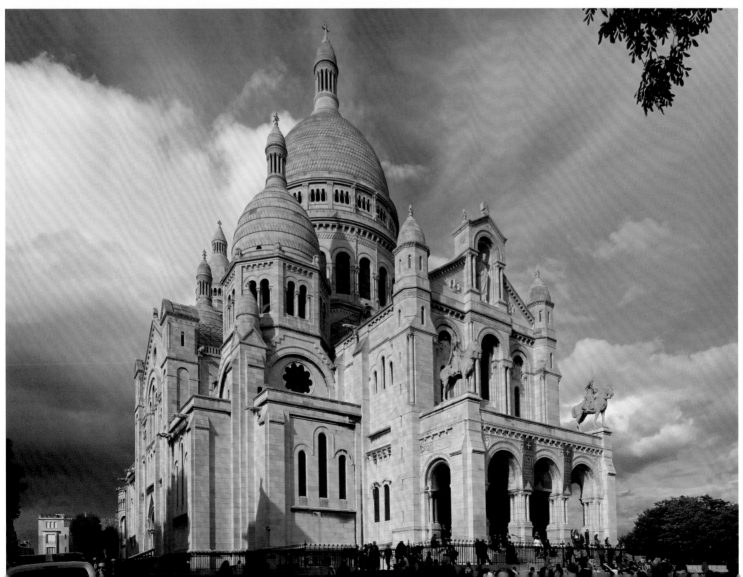

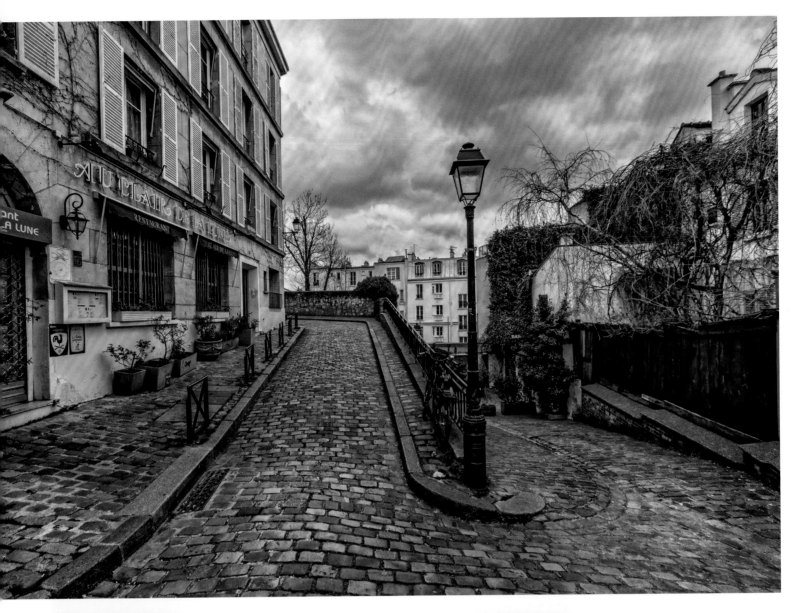

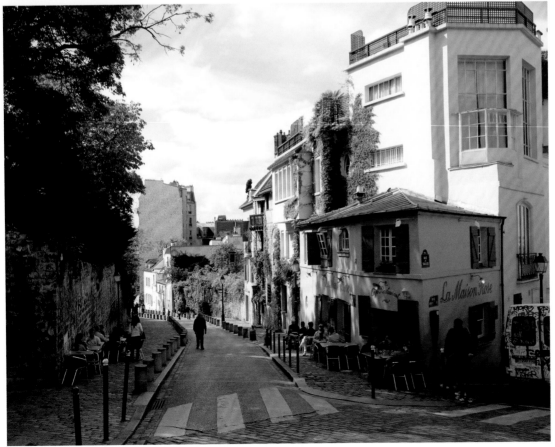

**ABOVE AND LEFT:** The winding cobbled streets of Montmartre—the hill is only 430ft high, but it dominates the city. It became part of Paris in 1860 but has still managed to retain its feeling of being a village.

**RIGHT:** *Le Bateau Lavoir*—meaning The Laundry-Boat—in Montmartre was a squalid block of buildings which became famous thanks to its artistic tenants. 13 rue Ravignan contained a number of artists' studios, one of whose tenants was Pablo Picasso who is said to have devised Cubism here (along with Georges Braque) and painted one of his finest works, *Les Demoiselles d'Avignon*. Many famous names were visitors including Stein, Braque, Modigliani, Matisse, Cocteau, Apollinaire, and Rousseau for whom Picasso organized a celebration banquet in 1908 in his studio.

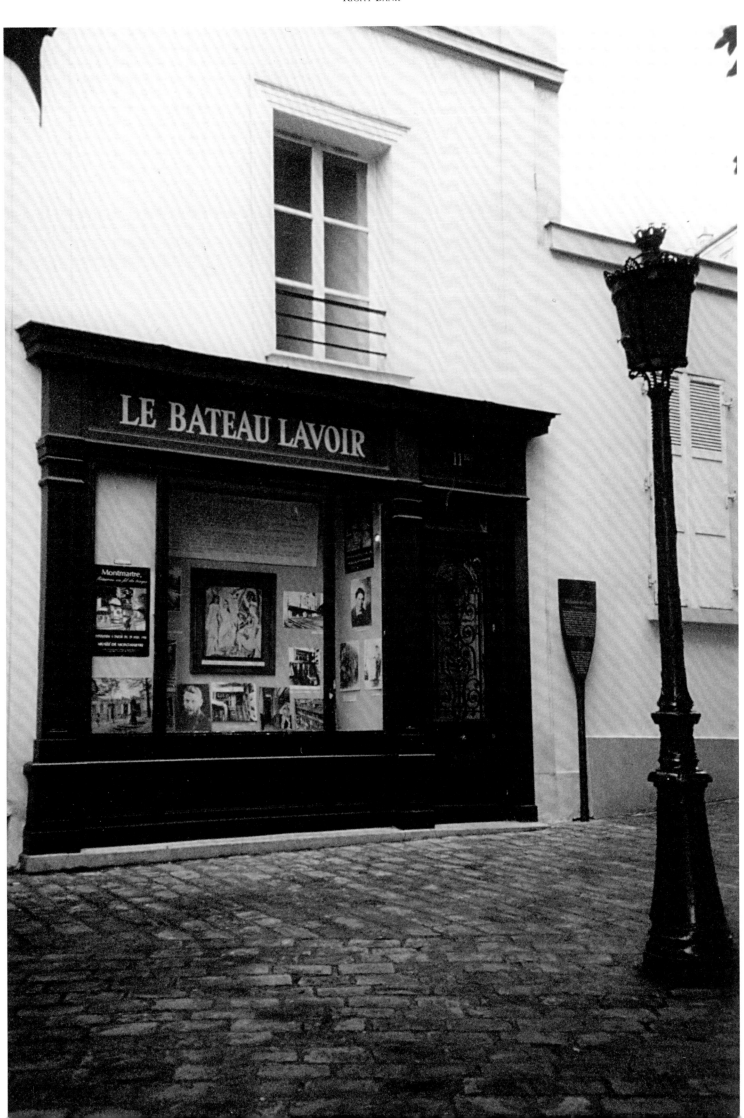

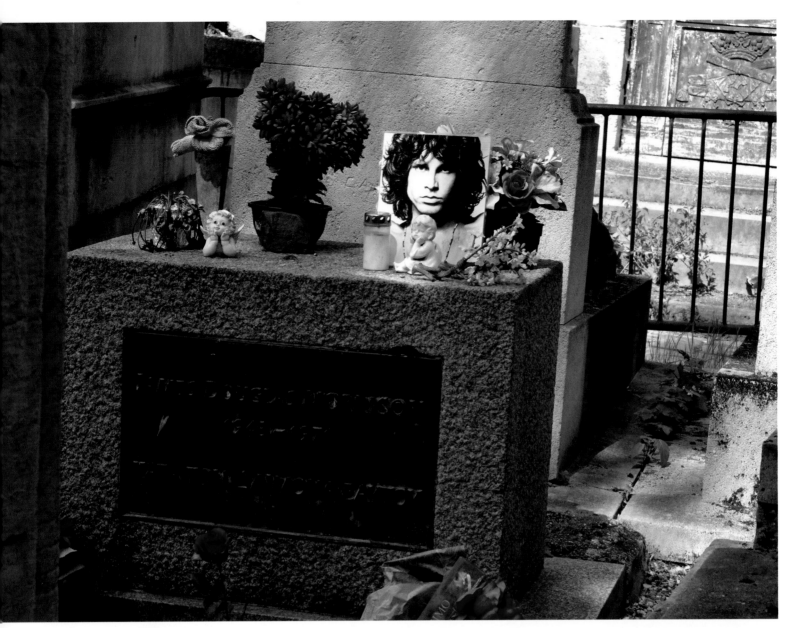

**LEFT:** Jim Morrison was the lead singer and song writer with the legendary American Sixties rock group The Doors. He moved to Paris where he died on July 3, 1971, and was buried in Pére-Lachaise cemetery five days later. His is the most visited grave in the entire cemetery, giving cause for concern as many people leave tributes and graffiti around the grave site.

**BELOW LEFT:** There are many touching effigies and tributes in Père Lachaise. The cemetery is named after Louis XIV's Jesuit confessor, Père François de la Chaise (1624–1709). The ground was bought by Paris in 1804 and the first bodies interred here belonged to the play-wright Molière and poet Jean de la Fontaine. This is André Gill by sculptor Laure Coutan from 1887.

**RIGHT:** The Raspail family mausoleum. The grave contains François Raspail (1794–1878), a chemist and French Republican politician.

**PAGE 108:** Père-Lachaise in eastern Paris is one of the city's oldest and most prestigious cemetaries and contains the remains of many famous people including, Chopin and Oscar Wilde. One of the most revered graves belongs to the French chanteuse Edith Piaf who was known as La Môme Piaf—"The Little Sparrow"—to her many fans. When she died her funeral procession was attended by hundreds of thousands of mourners who lined the streets of Paris on the route to Père Lachaise. Even the ceremony at the cemetery was attended by forty thousand grieving fans.

**PAFE 109:** This is Dominique Vivant, Baron Denon as sculpted by Pierre Cartellier. Denon, the first director of the Louvre, died in 1825.

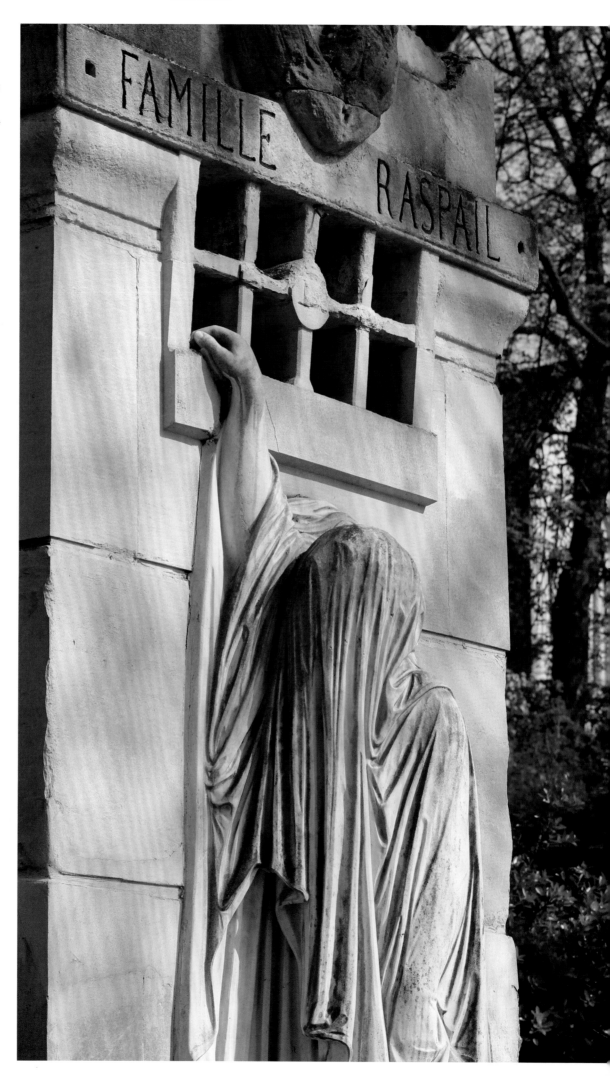

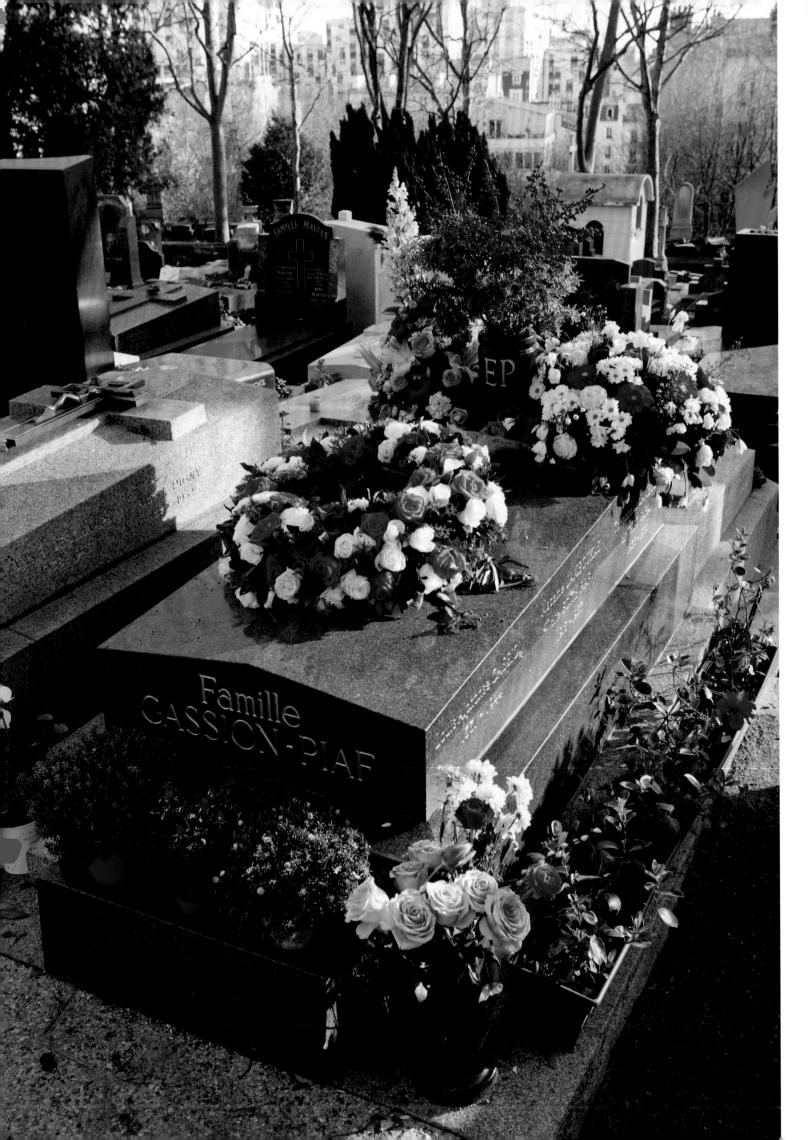

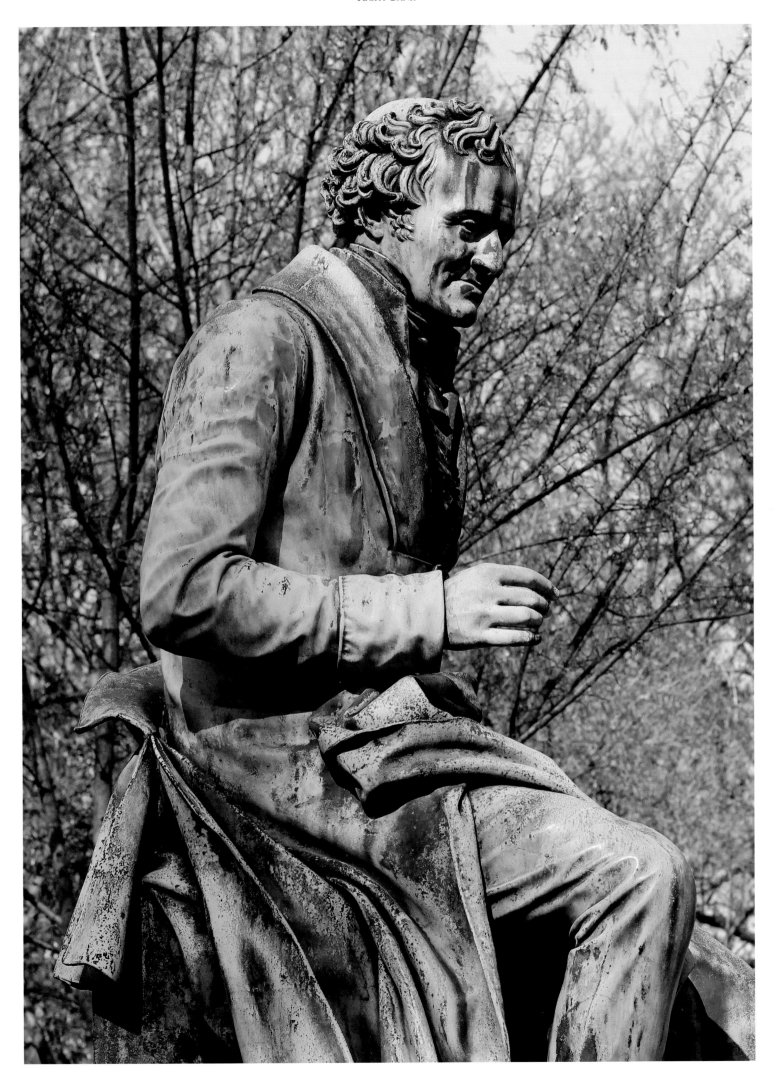

**LEFT:** La Rotonde de la Villette was built 1784–89 in the 19th arrondissement and was one of four tollhouses designed by Nicolas Ledoux for the Saint-Martin canal. At that time it formed part of the city Farmer-General wall around Paris. In 1867 a huge cattle market was built nearby which could handle 1,300 head of cattle a day. Slaughterhouses and butchers moved in but they were shut down in 1974 and the area was redeveloped as the City of Science and Technology.

**PAGE 112, ABOVE:** The Cité des Sciences et de l'Industrie opened in March 1986 in the Parc de la Villette in northeastern Paris. One of the most spectacular exhibits is the Géode, a 120ft diameter sphere made out of 6,433 triangles of polished stainless steel. Inside it houses a movie theater with the largest hemispherical screen in the world.

**PAGE 112, BELOW:** The Colonnades at Parc Monceau. The garden was created in the late eighteenth century in the anglo-chinois style and became very fashionable. It was designed by the architect Louis de Carmontelle.

**PAGE 113:** The Tour EDF at La Défense rises into the sky of the 21th arrondissement for 41-stories in a carved prow shape. The area started development as the business sector of Paris in the 1950s and has grown ever since with increasingly futuristic buildings.

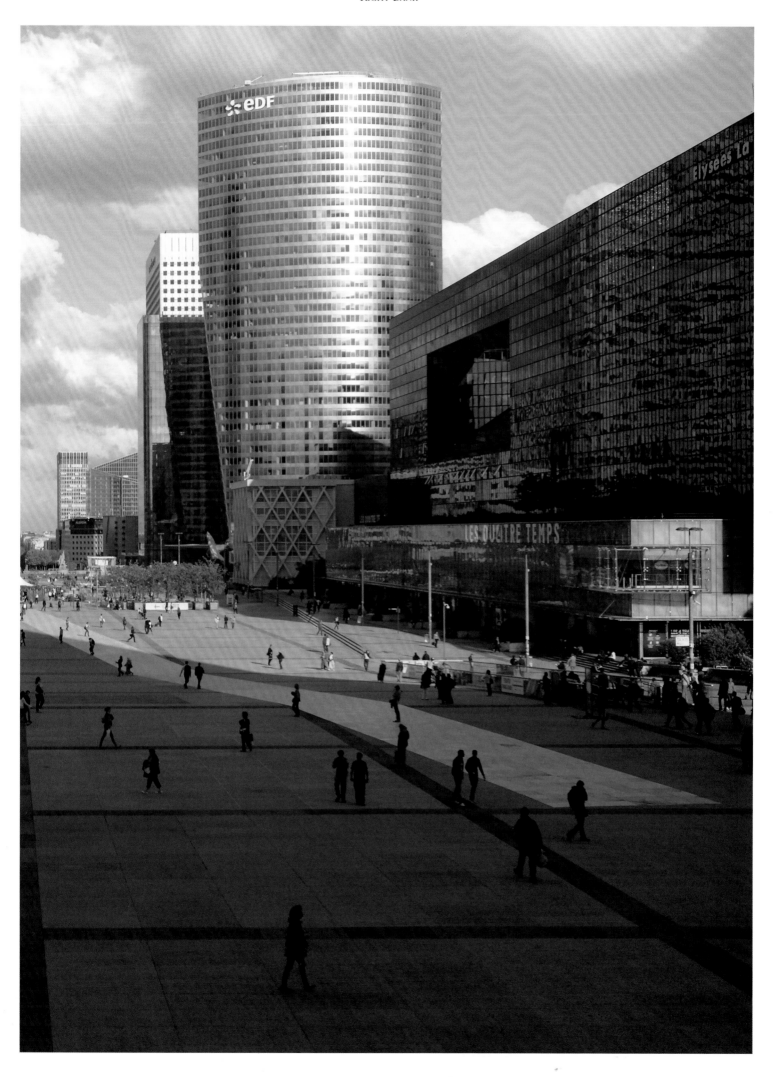

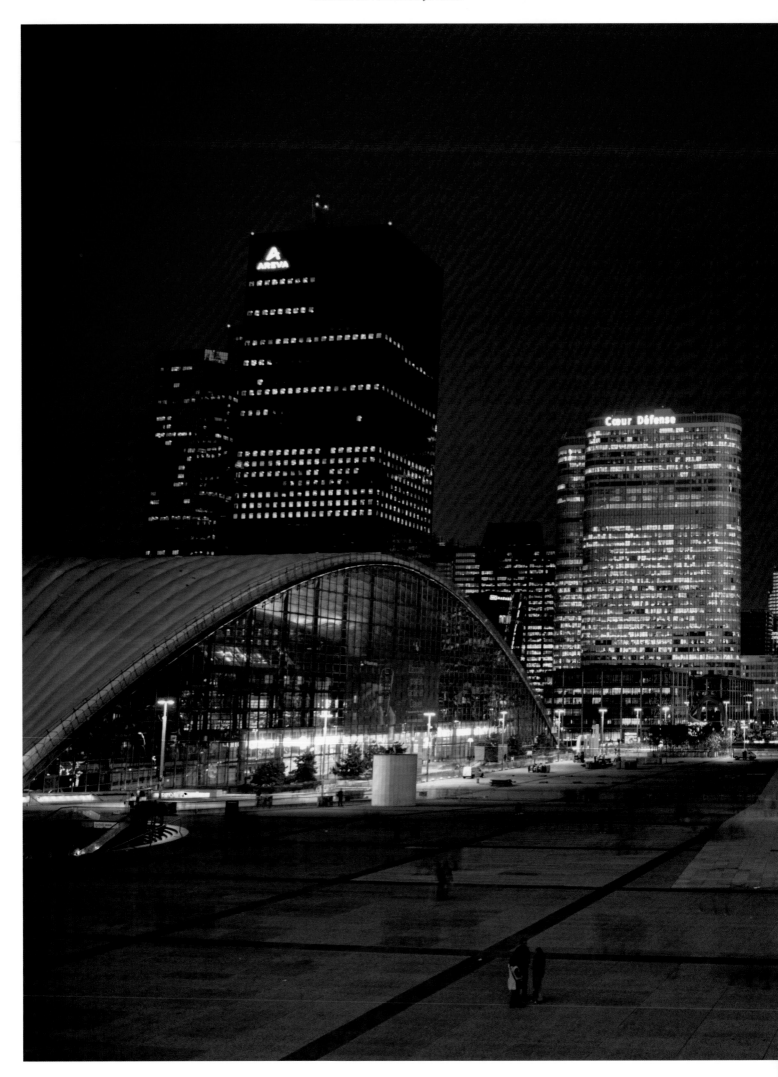

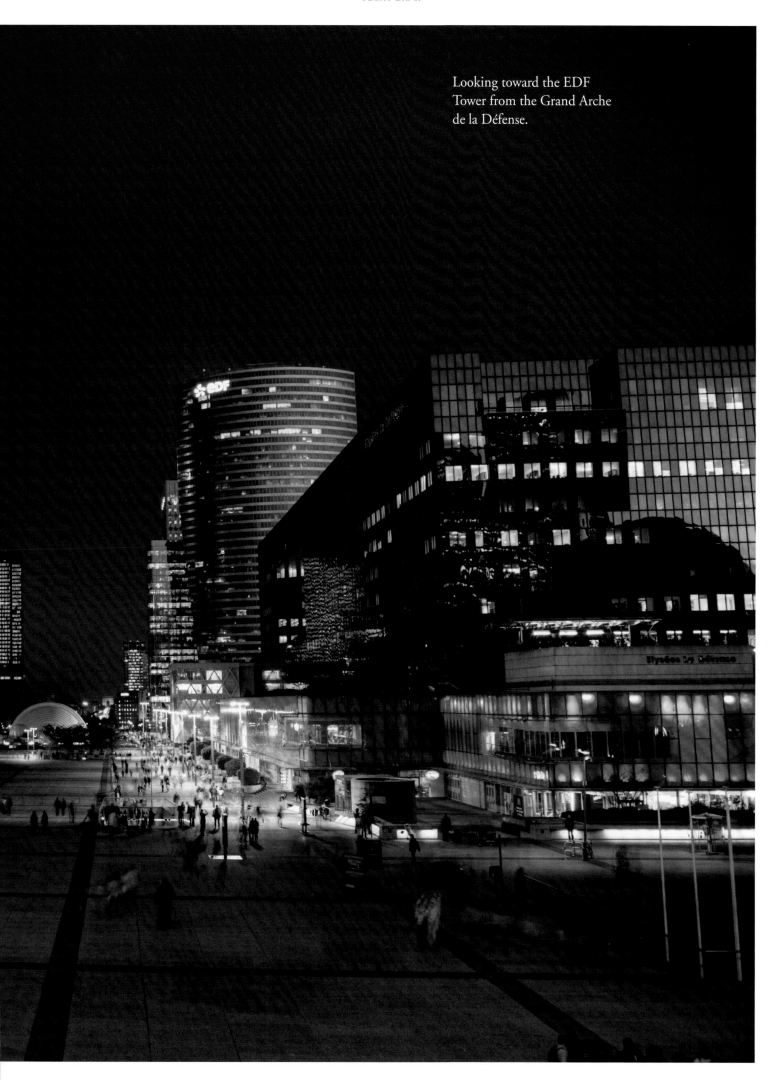

Looking toward the EDF
Tower from the Grand Arche
de la Défense.

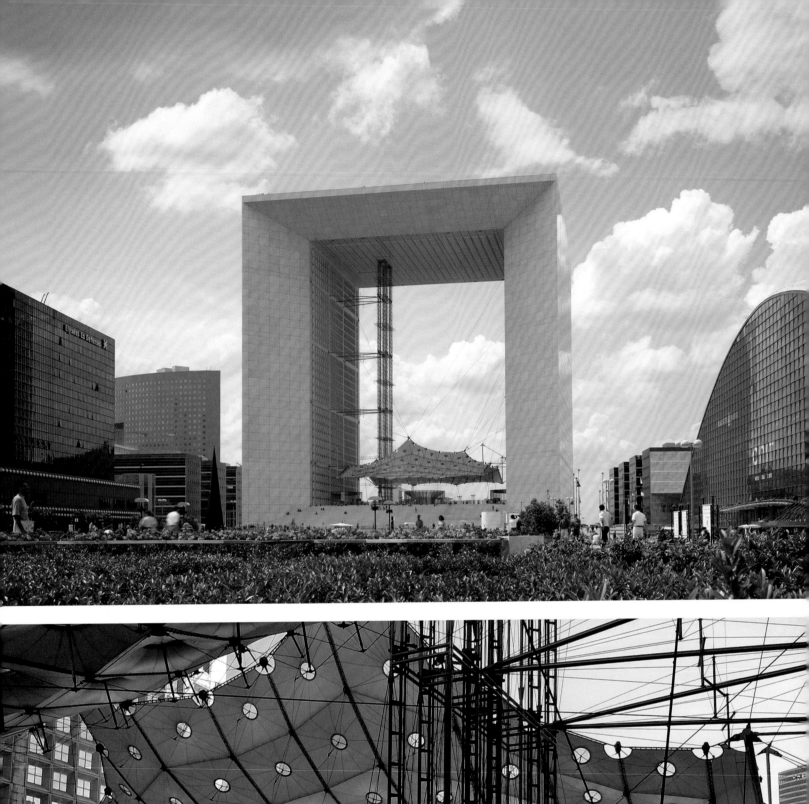

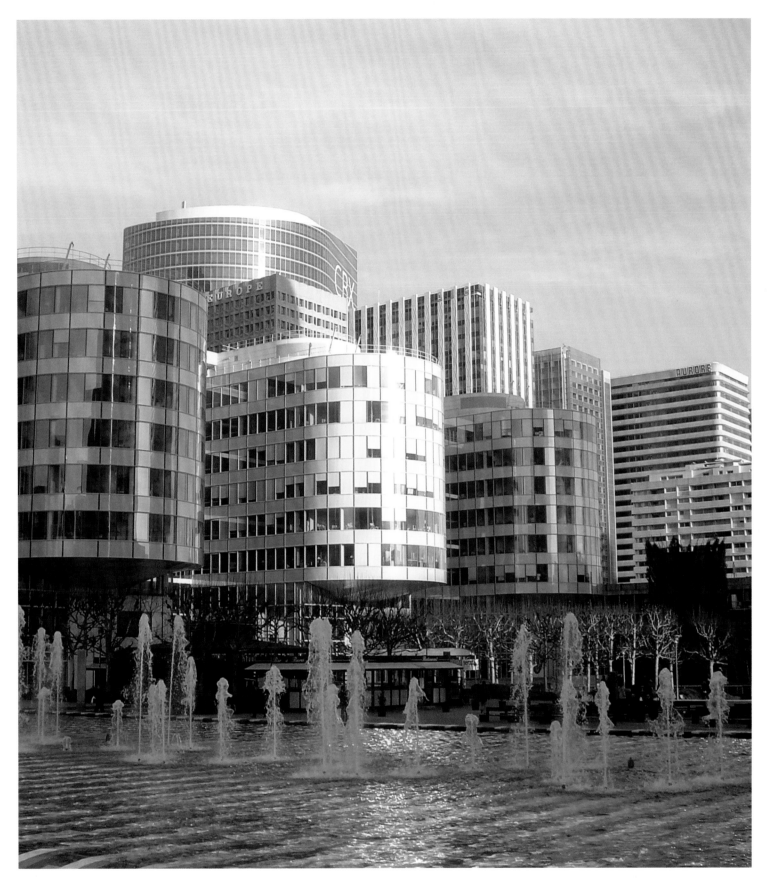

**LEFT, ABOVE AND BELOW:** Plans to create a *Voie Triumphale* (Triumphal Way) between the Arc de Triomphe and La Défense had been drawn up since the 1920s but despite plenty of ideas—especially from the modernist architect Le Corbusier—no designs could be agreed upon. Finally President Mitterand declared that he wanted a twentieth century Arc de Triomphe and made it one of his "*Grande Projects.*" So plans for the Grande Arche de la Défense were drawn up. The arch is a marble-clad French government building with offices in the sides designed by Otto von Spreckelsen and took eight years to build. It was completed in 1990. Photos show exterior

**ABOVE:** La Défense was named after a commemorative monument to the war of 1870 which was erected on this site in 1883 and called La Défense de Paris.

# The Seine

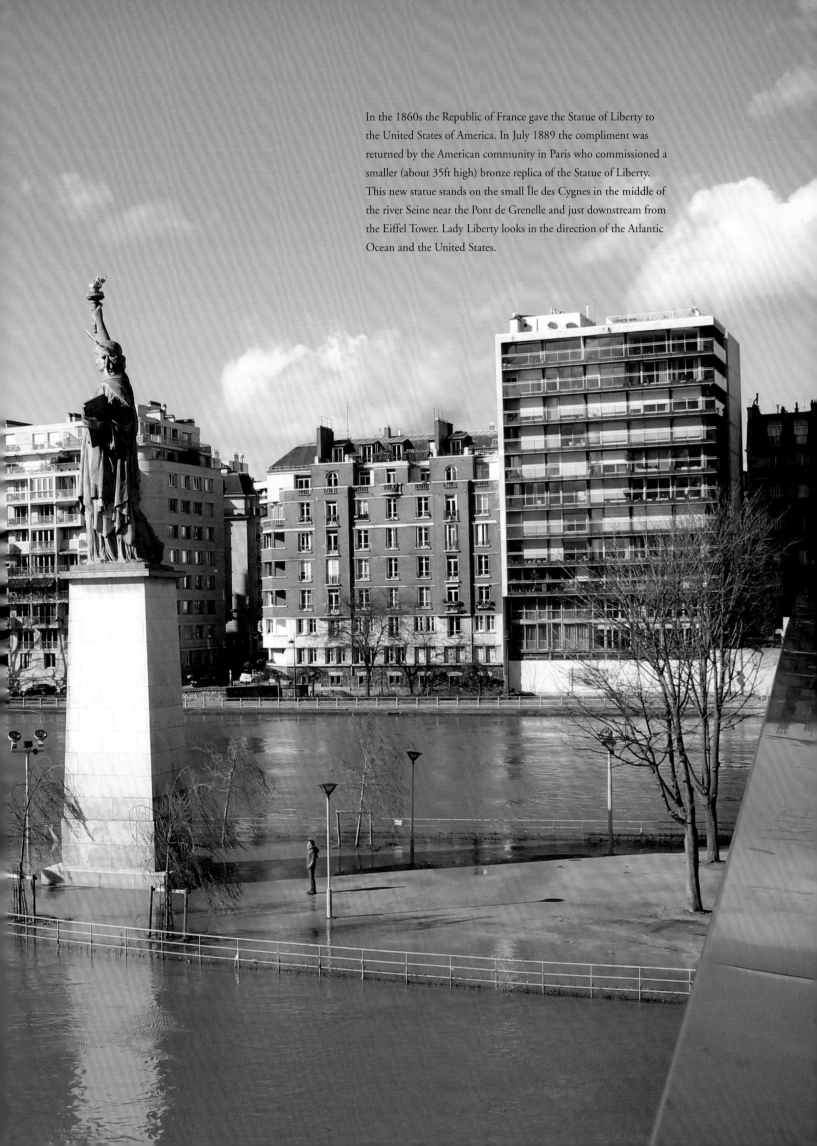

In the 1860s the Republic of France gave the Statue of Liberty to the United States of America. In July 1889 the compliment was returned by the American community in Paris who commissioned a smaller (about 35ft high) bronze replica of the Statue of Liberty. This new statue stands on the small Île des Cygnes in the middle of the river Seine near the Pont de Grenelle and just downstream from the Eiffel Tower. Lady Liberty looks in the direction of the Atlantic Ocean and the United States.

**RIGHT:** The bateaux-mouches are designed with shallow hulls for cruising rivers such as the Seine. Quite how their name came about is the subject of much heated debate and completely inconclusive. The most plausible is that "mouche" was once slang for "spy" and in the early nineteenth century this term was applied to small warships. The first and biggest company to work such vessels on the Seine was la Compagnie des Bateaux-Mouches and subsequently all tourist boats have been labeled bateau-mouche. The bateaux-mouches vary considerably in size and grandeur. Most of them carry a maximum of between 200 and 350 passengers and the modern boats are either twin or triple hulled. Most of them have glass-covered decks so that bad weather will not spoil the river trip. This one is coming up to the Pont Alexandre III.

**BELOW:** The Seine runs through the heart of Paris. The river rises in Burgundy and flows through Troyes before reaching Paris where it is contained between high stone embankments. The bank on the south side is known as the Rive Gauche (Left Bank) while on the north it is called the Rive Droite (Right Bank) this is because when facing the direction of flow they are correspondingly on the left and right hand side. The banks of the Seine in Paris became a UNESCO World Heritage Site in 1991. The Seine is navigable for 350 miles and used to have a tidal bore (*le mascaret*) but this was eliminated by dredging in the 1960s. For centuries barges along the Seine were towed by horses or men along the towpath on the Right Bank which was specifically kept clear of any obstructions. Even today Paris remains the main river port in France and commercial barges plough along with cargoes of sand, gravel, and grain. The Seine passes through 10 of the 20 arrondissements of Paris. In the city the river is enclosed within high embankments and is only 80ft above sea level. The river still supplies as much as half of the water used in the Paris region. The Seine has a number of important tributaries including the rivers Marne, Aube, Loing, and Oise. Furthermore, it is linked to the other great rivers Rhine, Rhône, and Loire by a network of canals. The bridge shown here is the Pont du Carrousel.

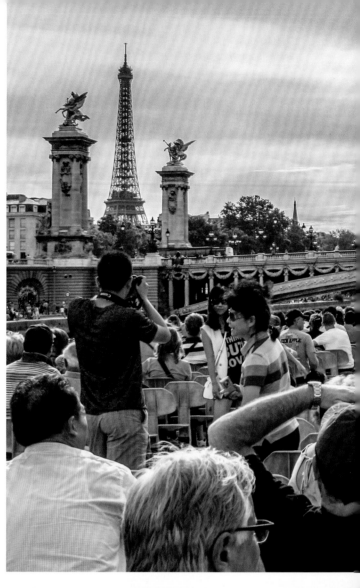

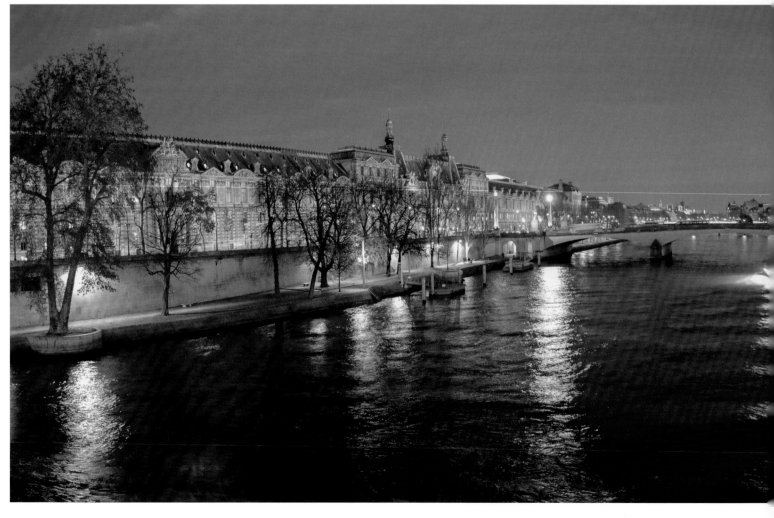

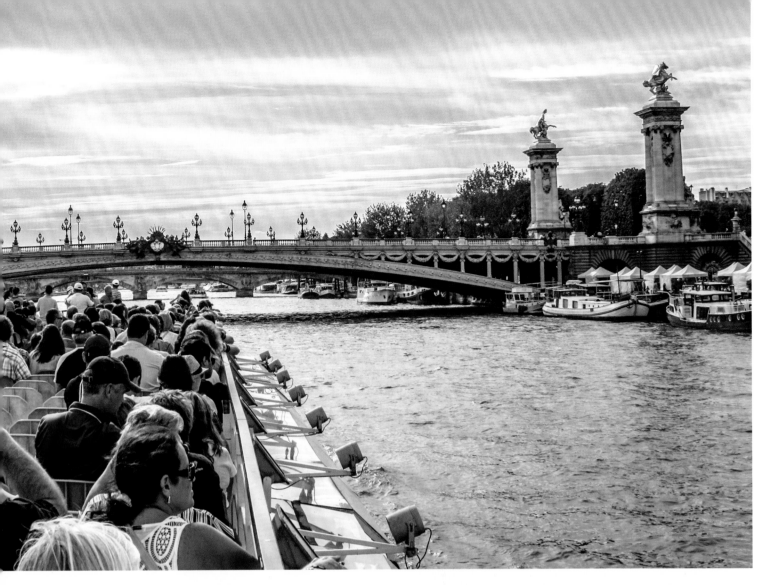

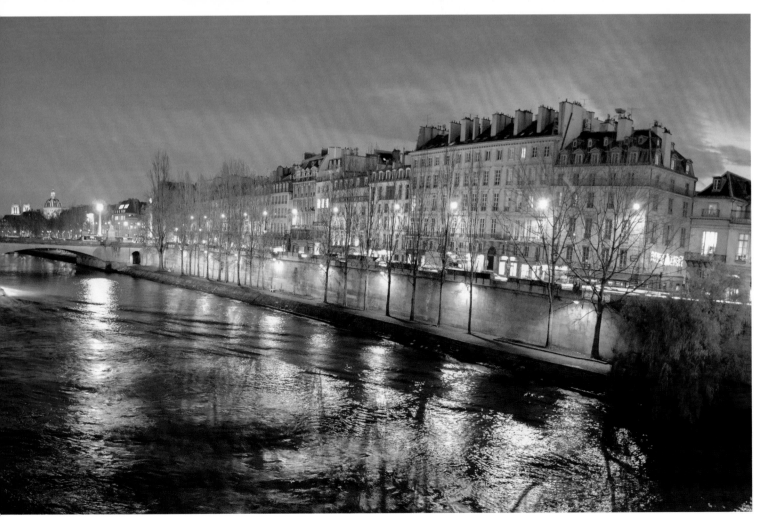

**ABOVE:** Early evening, when the sun is setting is a magical time to wander around Paris. The details of the buildings are lost but the intricate silhouettes of the rooftops and trees show a different aspect of Paris.

**RIGHT:** The locals find the bateaux-mouches annoying but for visitors they really are one of the best ways of discovering the city. This boat is about to pass under Pont des Arts, a footbridge built in 1802–1804 during the reign of Napoleon. Note the Saint-Jacques Tower on the left.

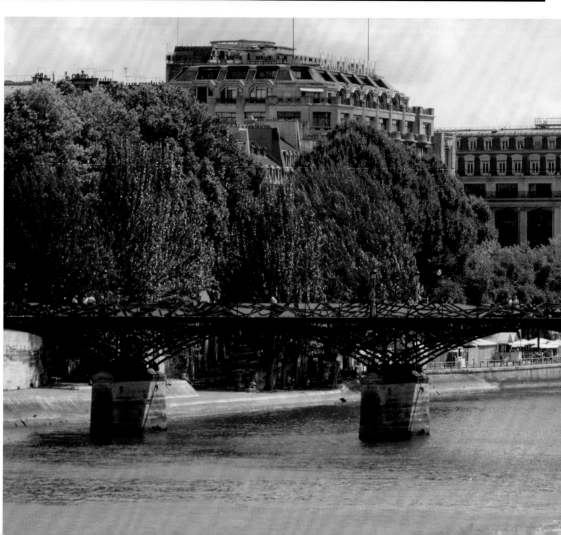

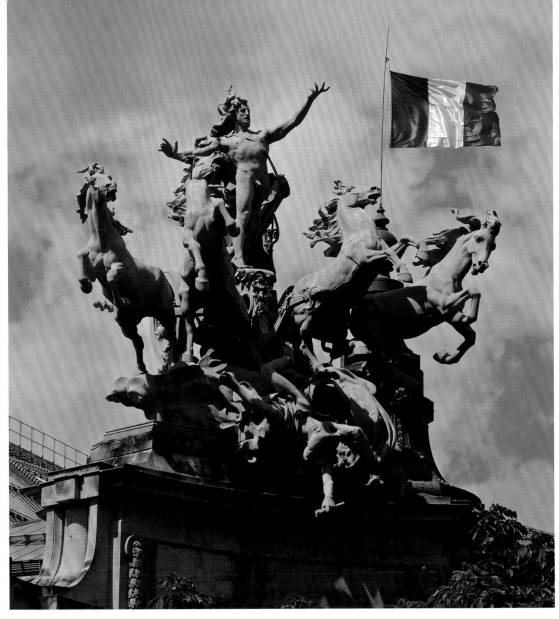

**LEFT:** A view from the river of the rooftop of the Grand Palais with two of the most ubiquitous sights in Paris—an elaborate statue and the French Tricolor.

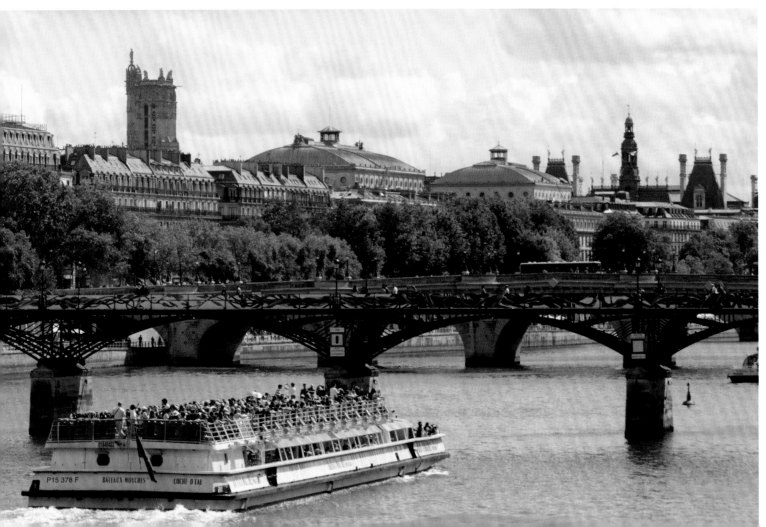

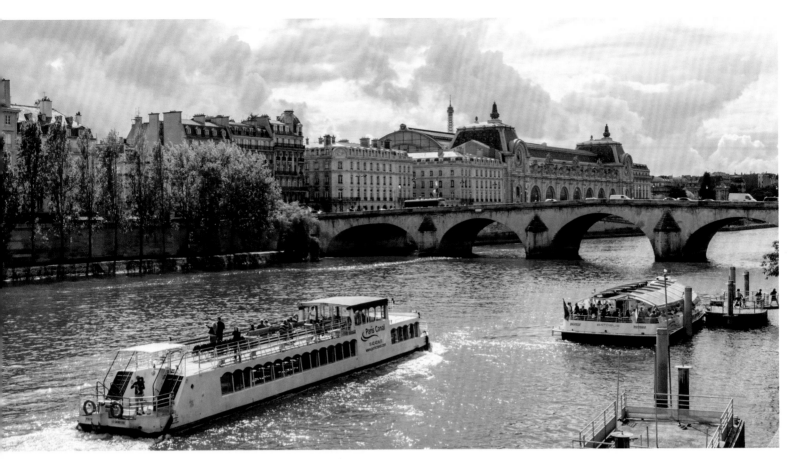

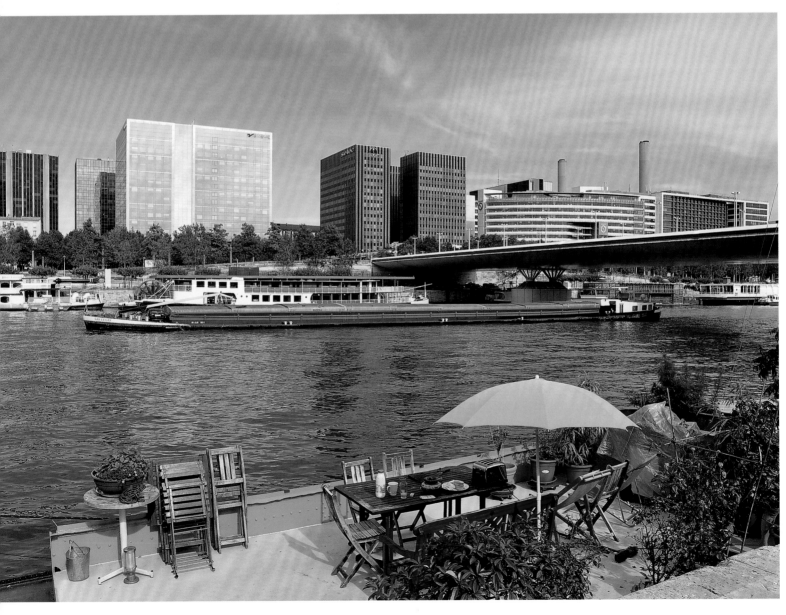

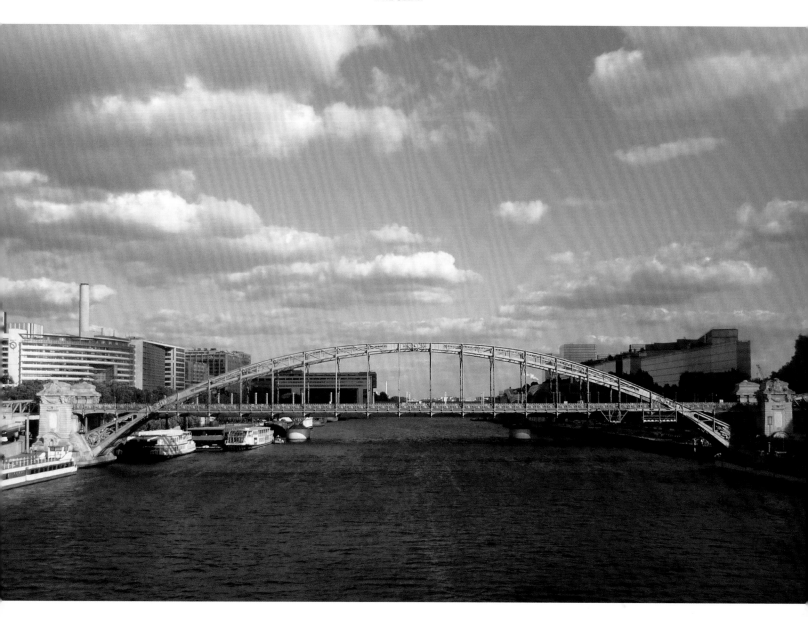

**LEFT AND ABOVE:** The Seine is criss-crossed by a series of magnificent bridges that have been built over the centuries uniting the left and right banks. The oldest remaining bridge is the stone-built Pont Neuf on the Île de France, built for Henri IV between 1578 and 1607. The principal bridges, going from west to east are:

- Pont Mirabeau (opened 1897)—a good view of the Statue of Liberty
- Pont de Grenelle (opened 1968)
- Pont de Bir-Hakeim light rail and road bridge (completed 1900), originally called the Passy Viaduct—renamed in 1949 in honor of General Koening's June 1942 victory in Libya
- Pont d'Iéna (opened 1813)—the first bridge to be built after Napoleon's victory at Jena in 1806 and named to commemorate the event. After Napoleon's fall it was briefly renamed Pont d'École Militaire but was changed back again
- Pont de l'Alma (opened 1854)
- Pont des Invalides (opened 1855)
- Pont Alexandre III (opened 1900)—many consider this to be the most beautiful of all the Parisian bridges. It is named after the Russian czar who laid the cornerstone in October 1896
- Pont de la Concorde (opened 1791)—widened in 1930–1932, it was renovated in 1783
- Passerelle Léopold-Sédar-Senghor (opened 1999)—a footbridge that had was called the Passerelle de Solférino until 2006

- Pont Royal (**ABOVE LEFT**)—the ancient bridge was lost in 1684. This one opened in 1689 and was reconstructed in 1850
- Pont du Carrousel—dates back to 1831, major restoration 1906
- Pont des Arts (opened 1802)—the first iron bridge in Paris (now changed to steel)
- Pont Neuf (completed 1606)—at the point of the Île de France, Paris's oldest bridge, majore restoration 1848–1855, 1994–2007
- Pont Saint-Michel (opened 1857)—links Rive Gauche and the Île de la Cité; the Pont au Change links with the Rive Droite
- Petit Pont—there have been some thirteen bridges here since antiquity, the most recent opening in 1853; the northern bridge is the Pont Notre-Dame (opened 1853)
- Pont au Double (opened 1833); Pont d'Arcole (opened 1856)
- Pont de l'Archevêché (opened 1828)
- Pont Saint-Louis links the Île de France to the Île Saint-Louis which in turn is linked to the northern bank by the Pont Louis-Philippe, Pont Marie (completed 1630) and named after its designer-engineer Christophe Marie. To the south, there are the Pont de la Tournelle (completed 1645) and the Pont Sully across the tip of the island
- Pont d'Austerlitz (**ABOVE**)—the original bridge opened 1805 but was rebuilt 1884–1885
- Pont Charles-de-Gaulle (opened 1997) (**LEFT**)
- Pont de Bercy (opened 1864)—major changes in 1904 and doubled 1889–1992

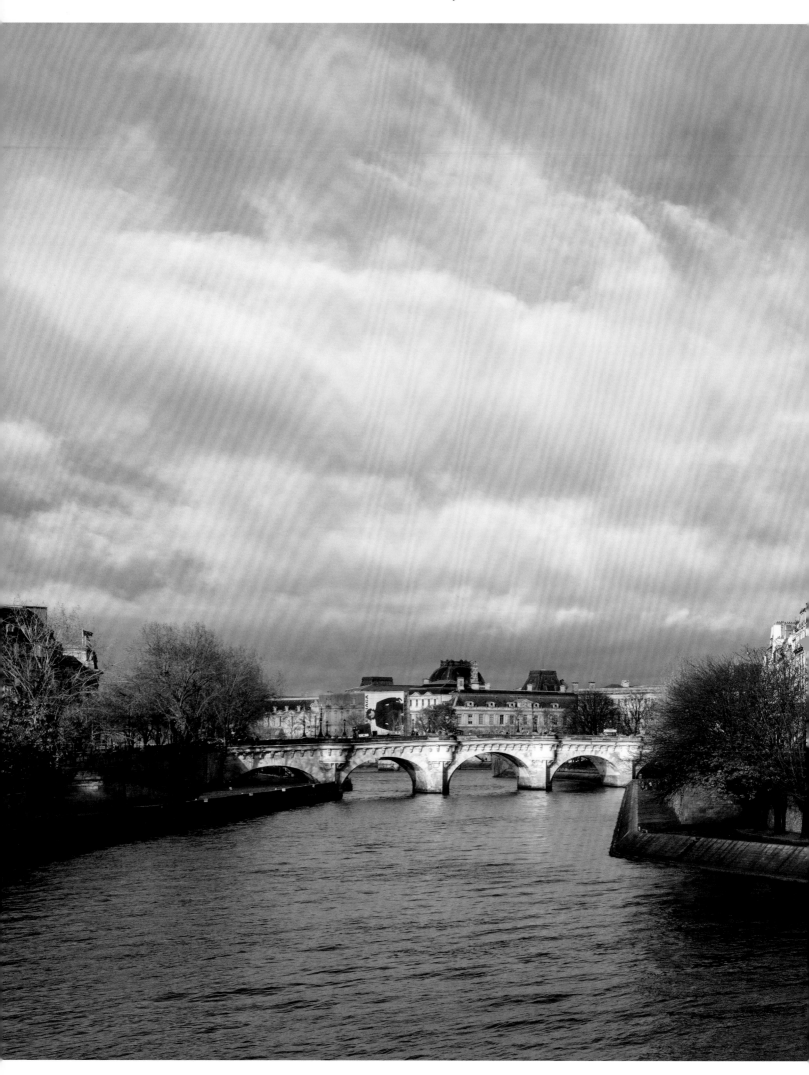

Coming up to the Pont Neuf.

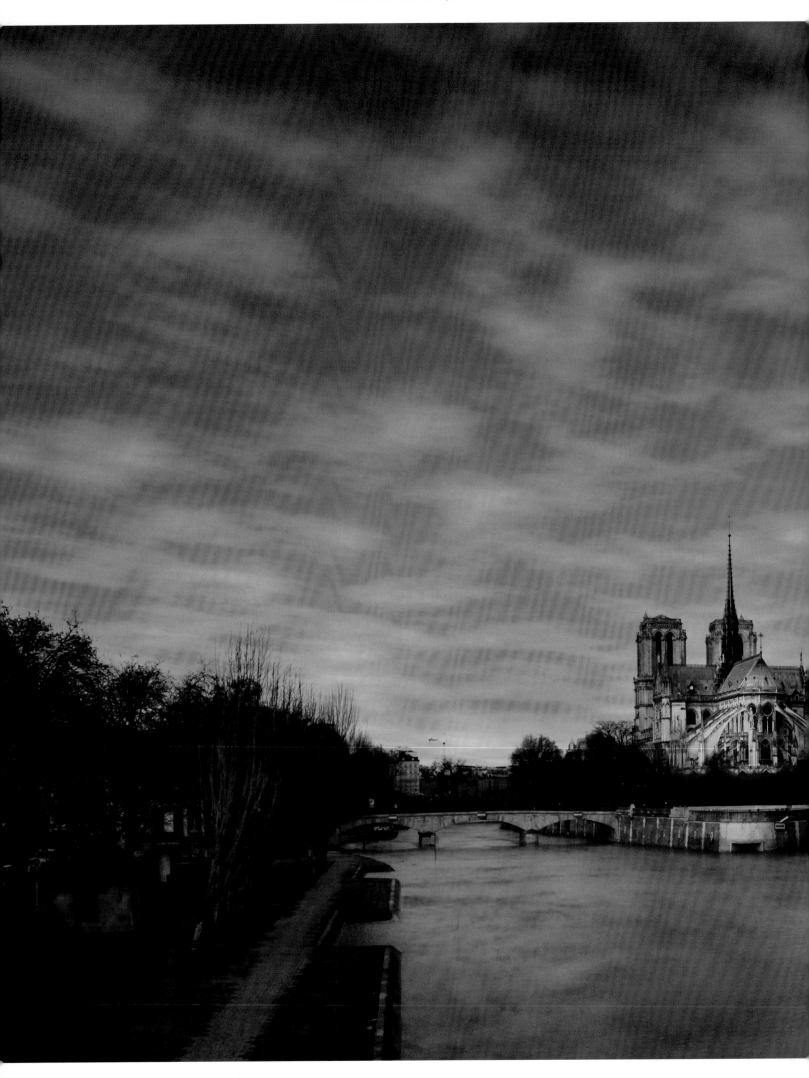

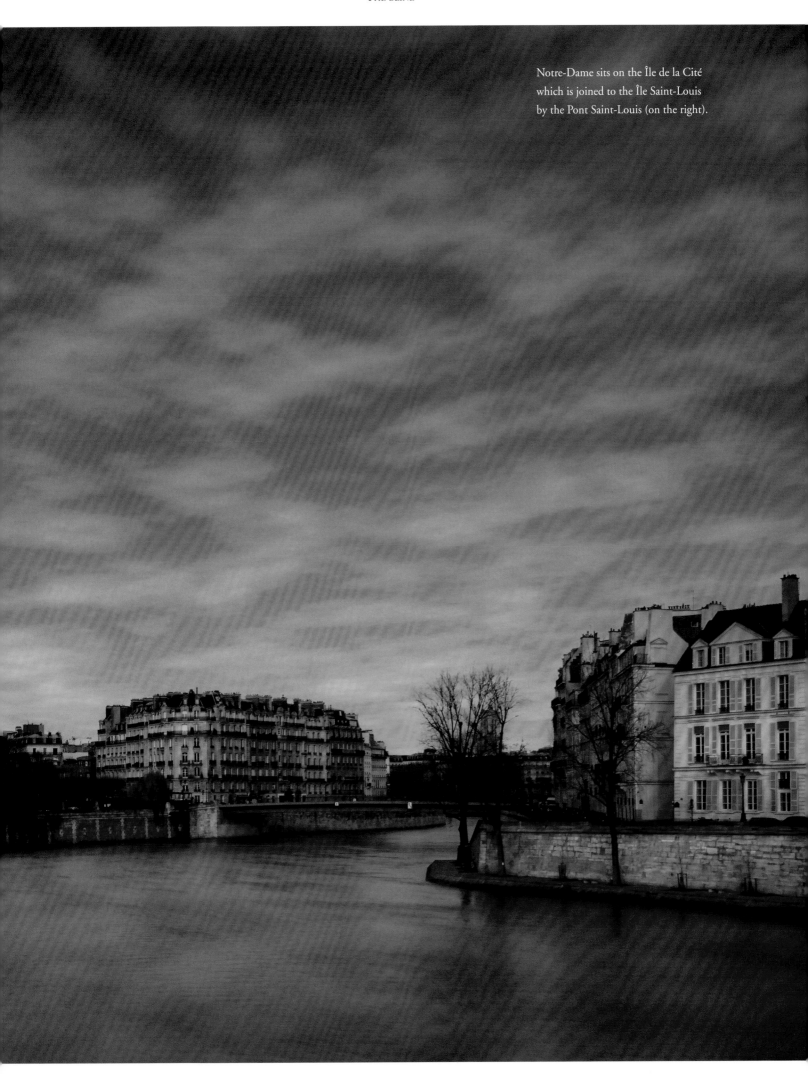

Notre-Dame sits on the Île de la Cité
which is joined to the Île Saint-Louis
by the Pont Saint-Louis (on the right).

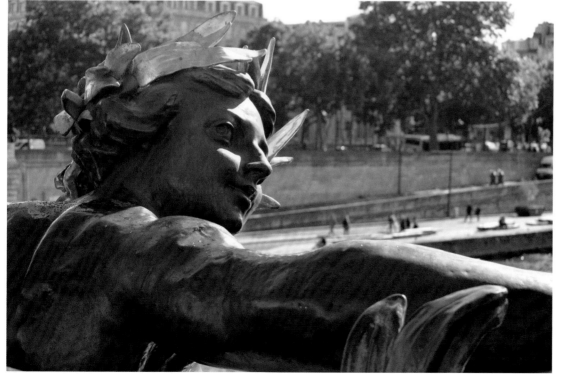

Le Pont Alexandre III is classified as a "Monument historique." Building work started in 1897 and it was completed in time for the opening of the 1900 Universal Exposition. The bridge is named after Czar Alexander III of Russia to mark the latest Franco-Russian alliance. The magnificent candelabra (**OPPOSITE**) are replicas of the lamps on Trinity Bridge in St. Petersburg. Elsewhere on the bridge there are decorations of nymphs representing the rivers Seine and Neva (**LEFT**). On the north bank of the Seine the bridge leads onto the Avenue Winston Churchill, flanked by the Grand and Petit Palais (**ABOVE**). The two palaces were also built for the 1900 Universal Exposition.

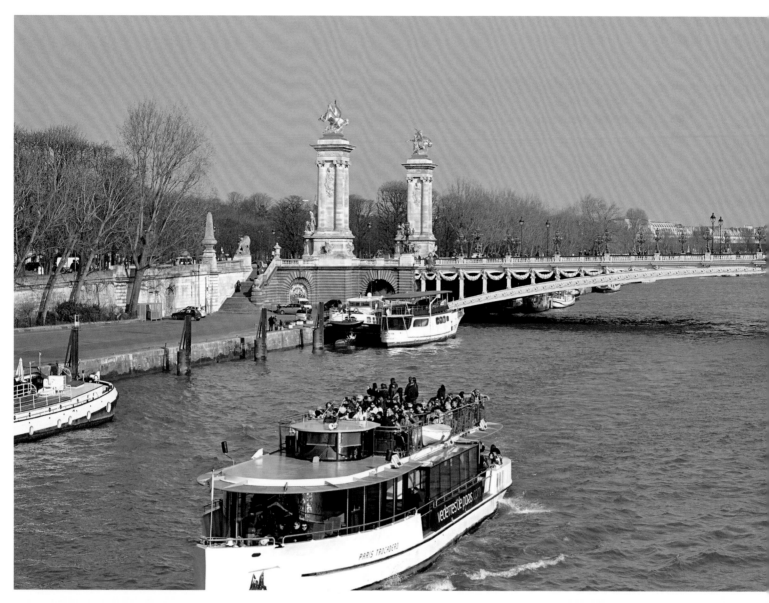

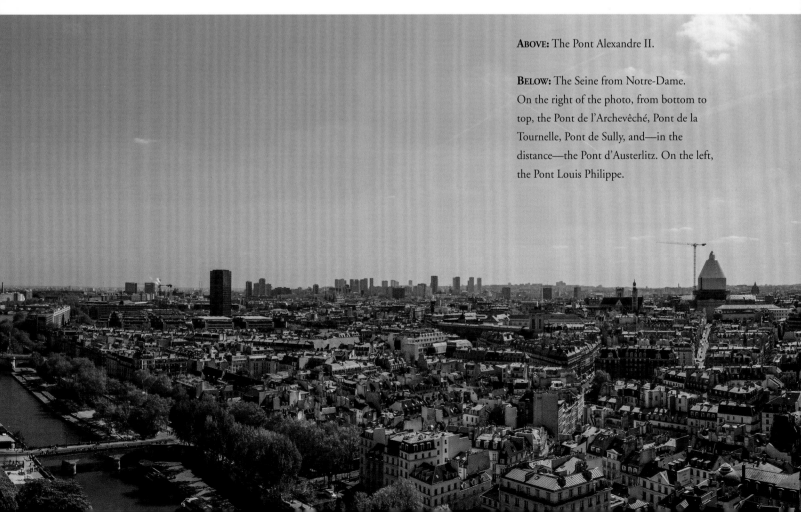

**ABOVE:** The Pont Alexandre II.

**BELOW:** The Seine from Notre-Dame.
On the right of the photo, from bottom to
top, the Pont de l'Archevêché, Pont de la
Tournelle, Pont de Sully, and—in the
distance—the Pont d'Austerlitz. On the left,
the Pont Louis Philippe.

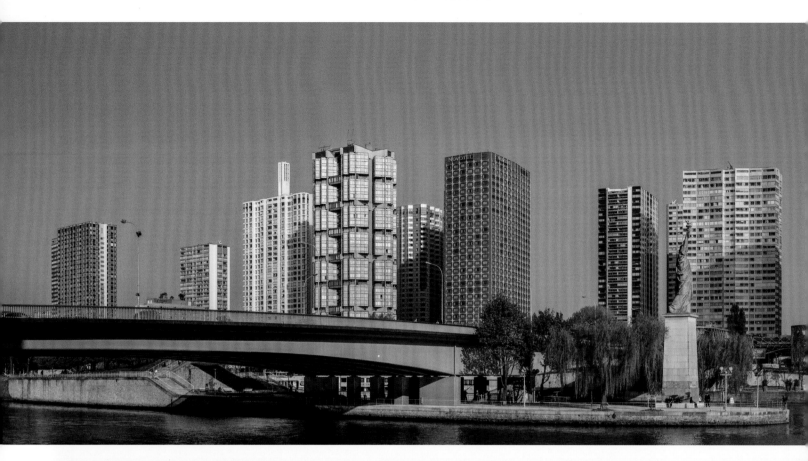

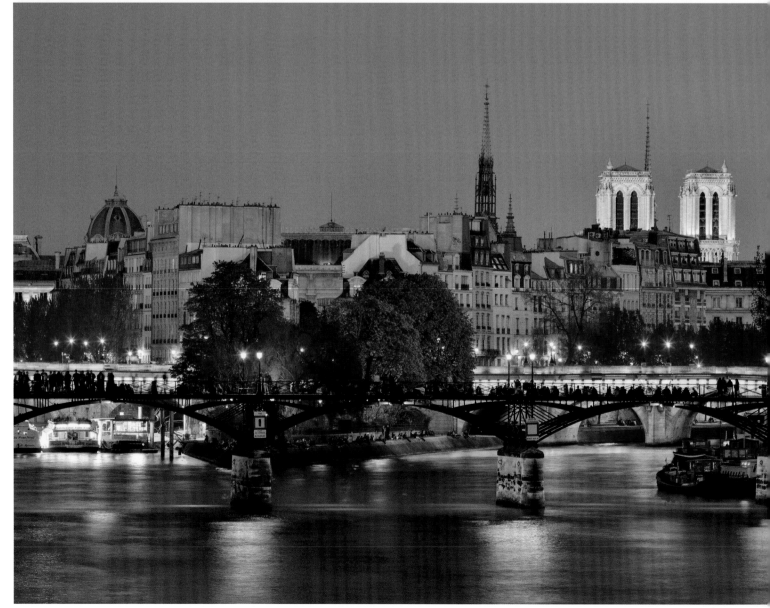

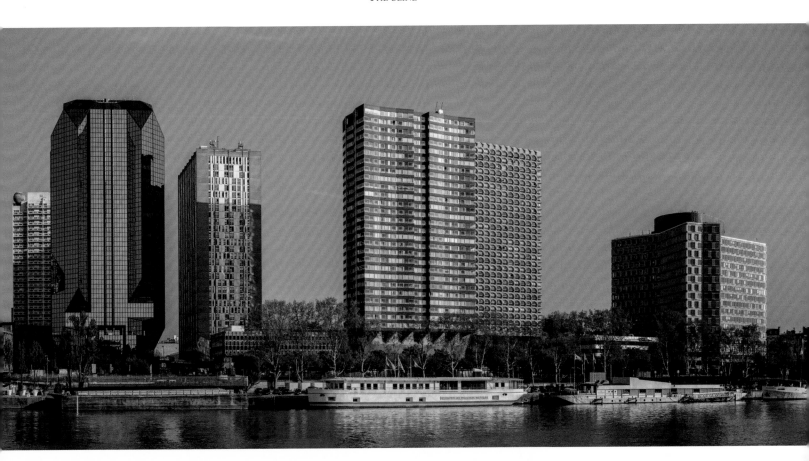

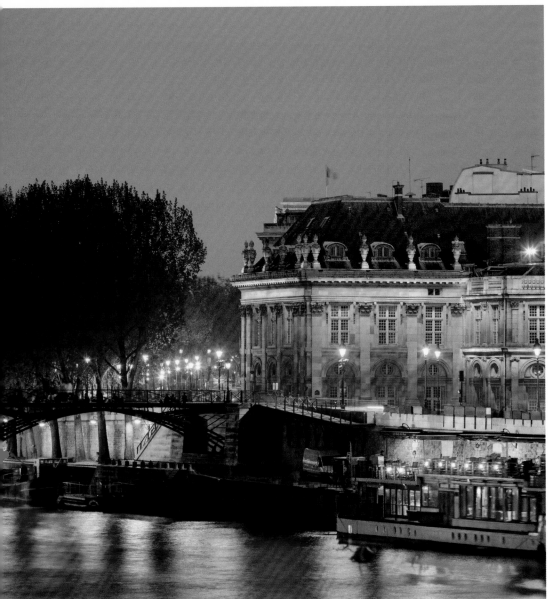

**ABOVE:** The Pont de Grenelle and Lady Liberty (see also pages 118–119).

**LEFT:** One of the best ways to enjoy the river is at night when the lights of the city create a magical atmosphere. This view is looking east toward the Pont des Arts and Notre-Dame. The dome at left is that of the Tribunal de Commerce. The spire to the left of Notre-Dame belongs to the Gothic Sainte-Chapelle, whose stunning stained glass shows over a thousand scenes from both testaments of the Bible.

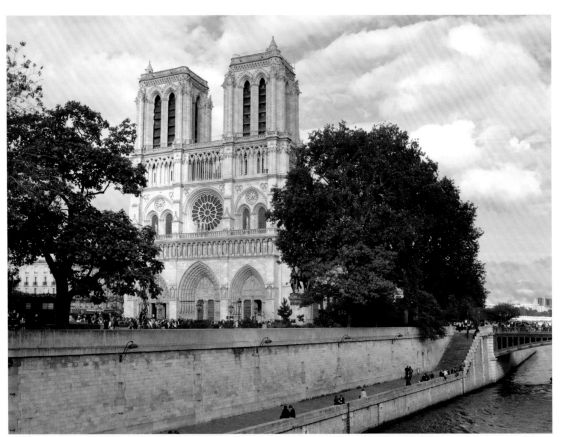

**LEFT AND BELOW:** The great old Gothic cathedral of Notre-Dame stands on the Île de la Cité in the middle of the River Seine. It has stood here since 1163 and the time of Louis VII when the first foundation stones were laid by Pope Alexander III. Work lasted for centuries: by 1183 the choir was finished and work on the nave started. It was completed by the turn of the century. The cathedral was finally completed by 1345 but has undergone extensive changes since. The equestrian statue (**BELOW**) is of Charlemagne, King of the Franks.

**RIGHT:** Much of the ceiling of the nave was destroyed by fire on April 15, 2019.

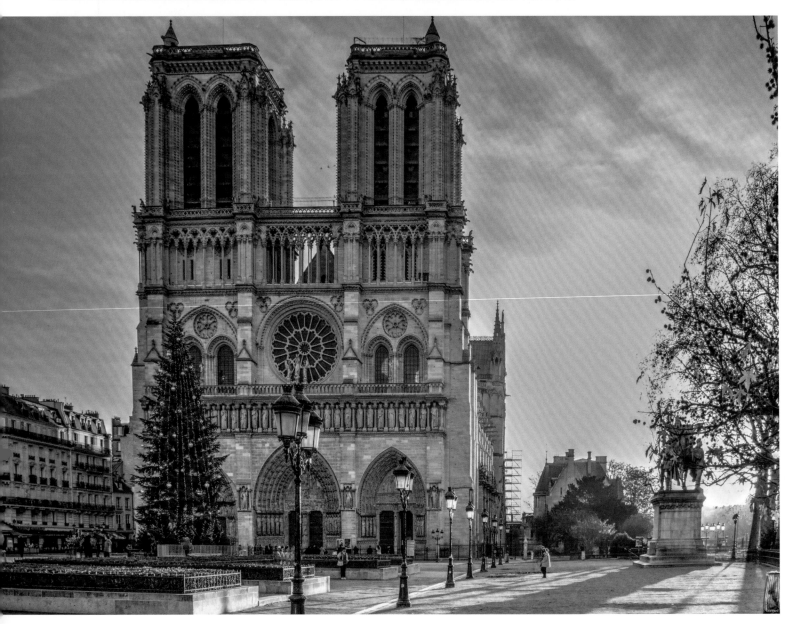

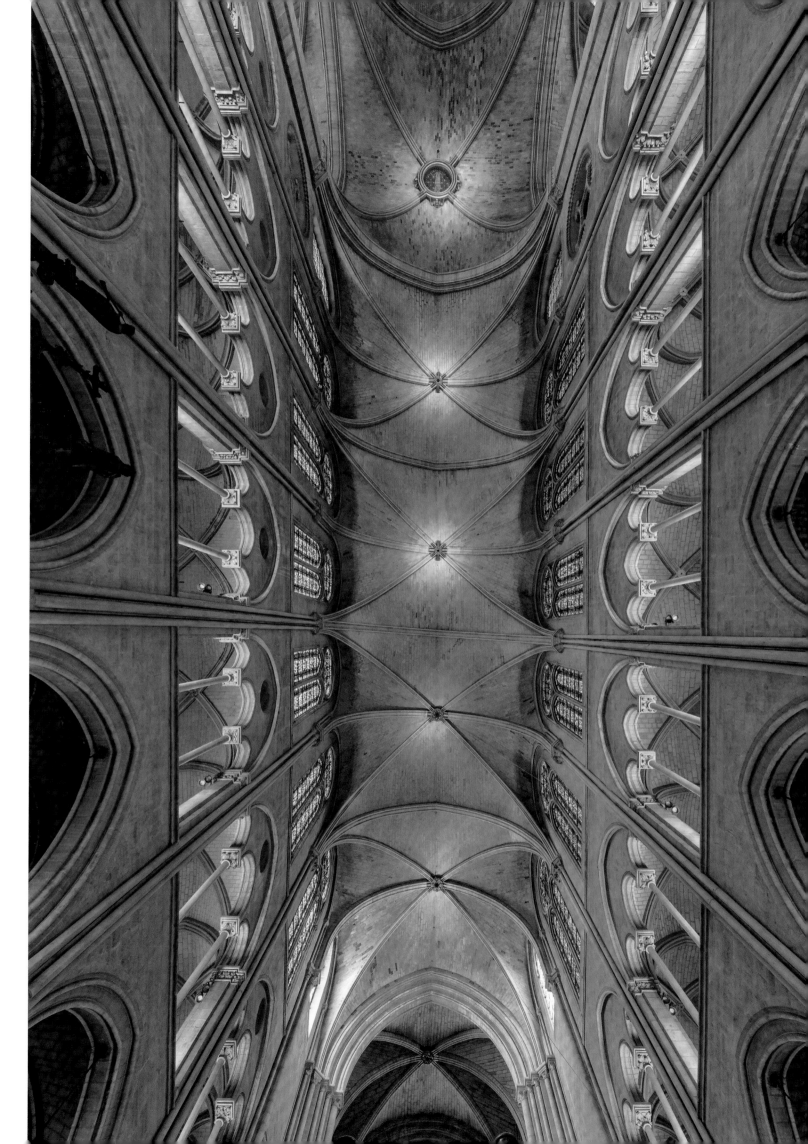

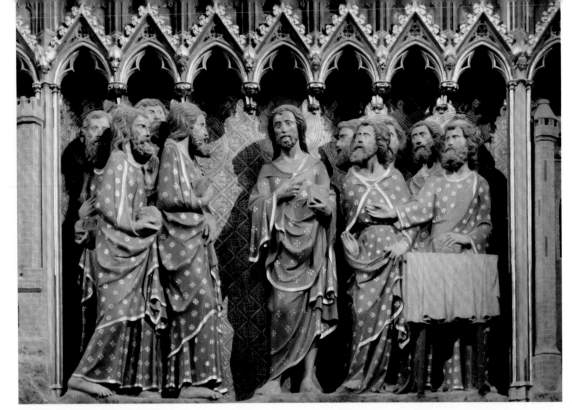

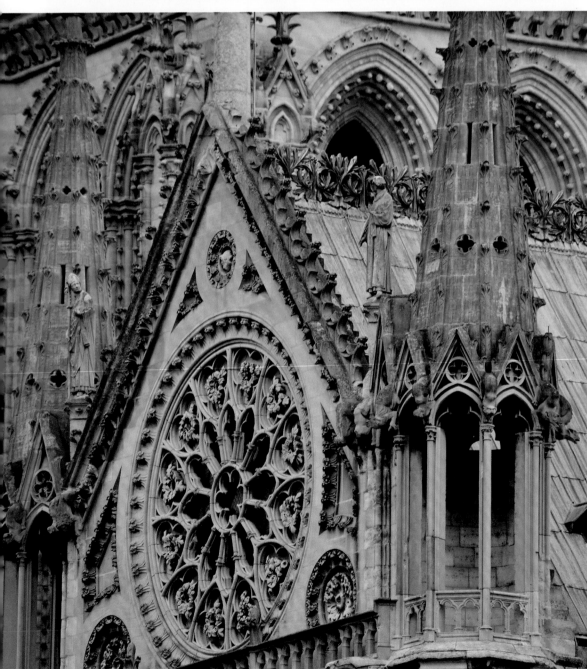

**LEFT:** A chancel screen in Notre-Dame. It shows various scenes of the appearances of the Risen Christ, this one being "Appearance to the Apostles in the Upper Room."

**RIGHT:** The cathedral's rose windows were originally engineered in the thirteenth century, but most of the glass was replaced during nineteenth-century restoration. This is the north window, originally created around 1250–1260. Most of the medieval glass is intact but heavily restored.

**BELOW LEFT:** External view of the South Rose Window, also known as the "Rose du Midi," which was presented to the cathedral by Saint Louis—Louis IX. Many kings and queens of France were crowned in Notre-Dame cathedral. Other notable coronations were the crowning of Henry VI of England and the crowning of the young Mary Stuart as queen of France. The most audacious act of all was when Napoleon Bonaparte crowned himself Emperor of France and then his wife Josephine as empress. During the French Revolution the cathedral was looted and many great treasures were lost—undoubtedly much of the gold and plate was melted down and lost forever. At that time the nave was used as a warehouse for grain and food among other things. After the Revolution the great cathedral was in a sad state and desperately in need of the restoration work which started in 1845 with the construction of the spire. Much of the South Rose's glass was replaced at this time and during many restorations the configuration of the panels have changed. It was damaged in the 2019 fire but not disastrously.

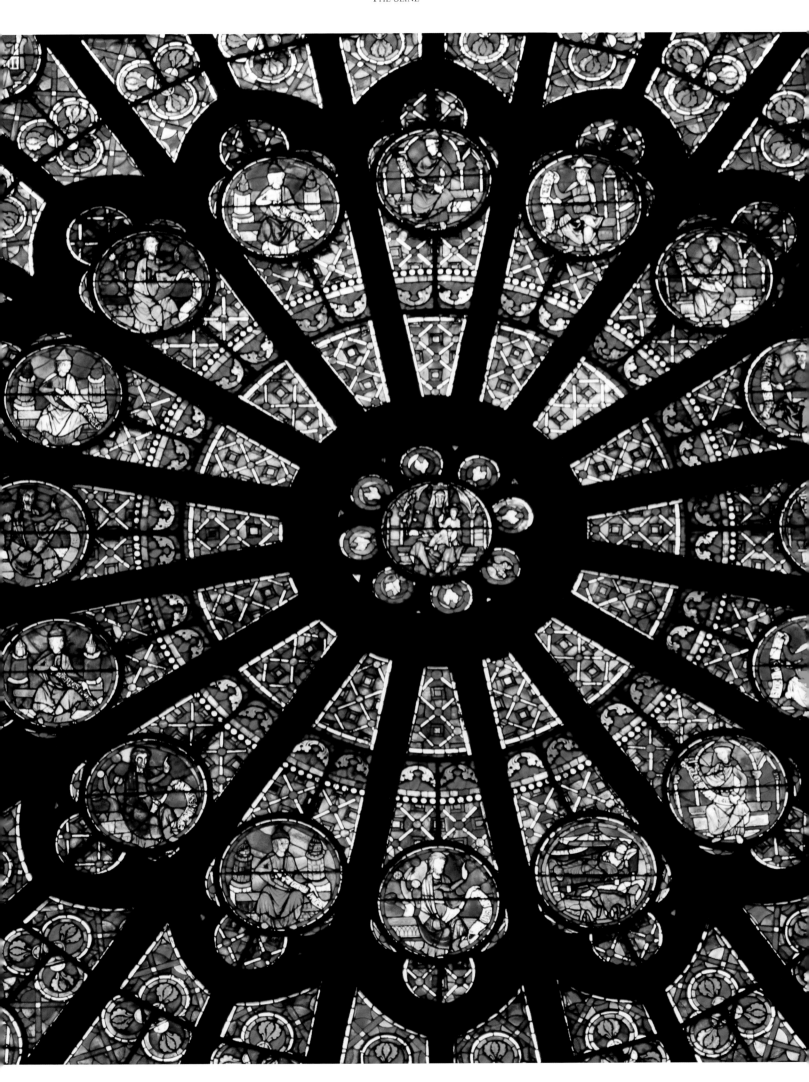

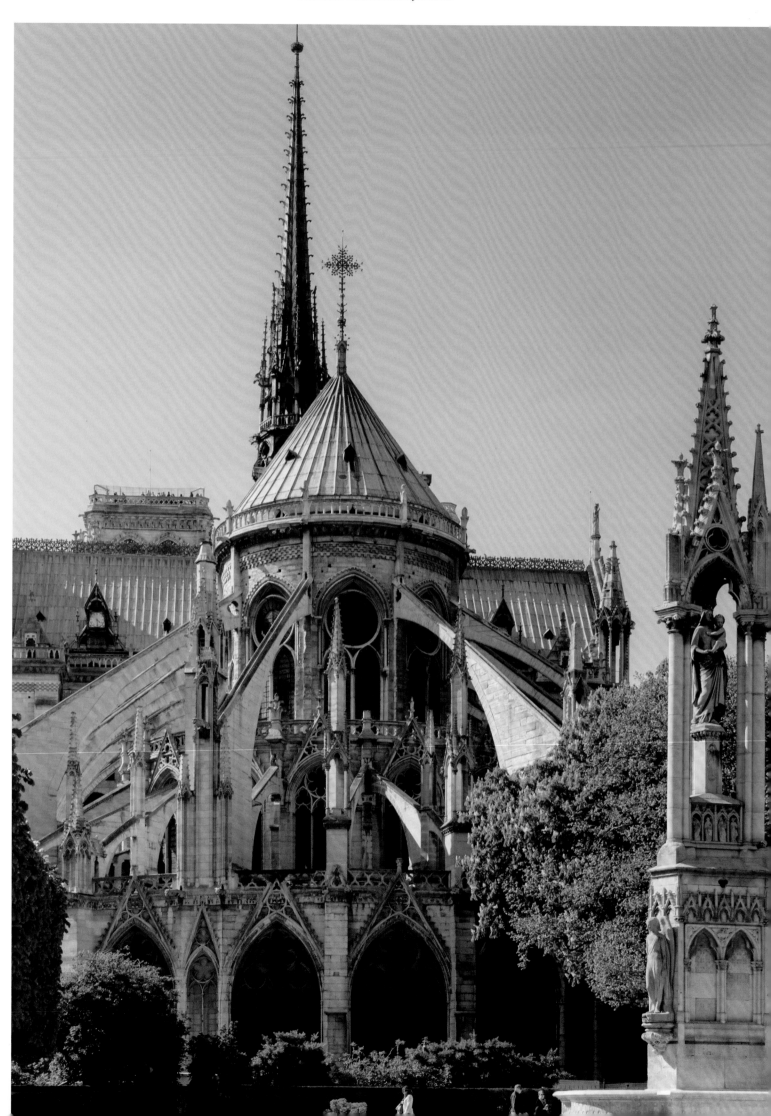

**LEFT:** Looking up at Notre-Dame cathedral from Square Jean XXIII. The tiny garden is named after Pope John XXIII and is a spot for quiet contemplation. It was intended at one stage to place two spires on top of the two towers but the idea was dropped.

**RIGHT:** The cathedral is richly carved with elaborate figures and decorations. The main arched doorway is the Portal of the Last Judgement. In the center is an image of Jesus surrounded by angels and Mary (Notre-Dame) and Saint John. Those souls to his right are rising to heaven while those on his left—next to the devil—are being dragged screaming down to hell.

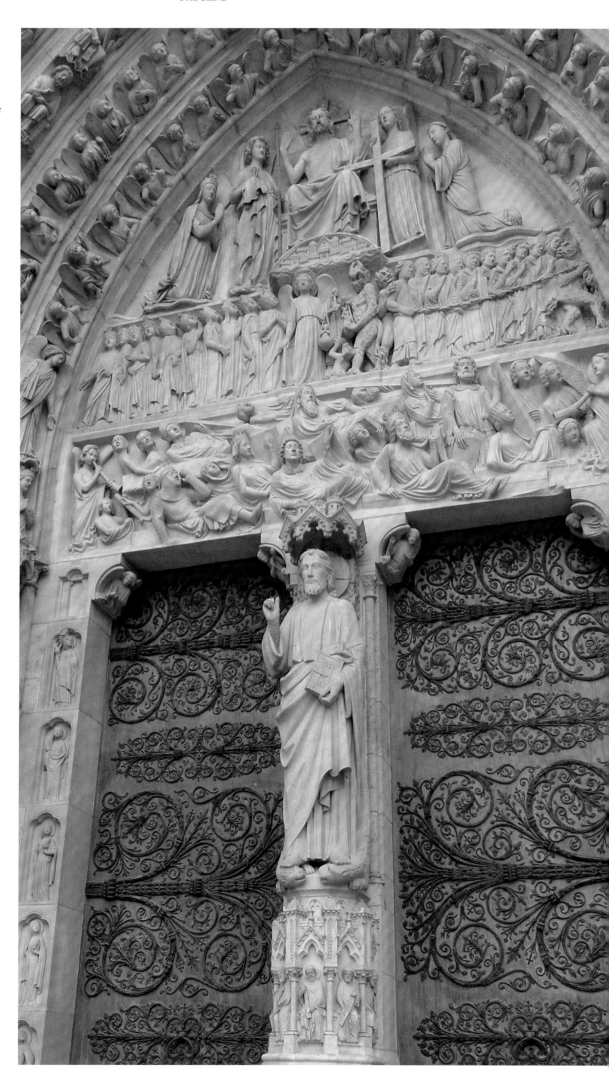

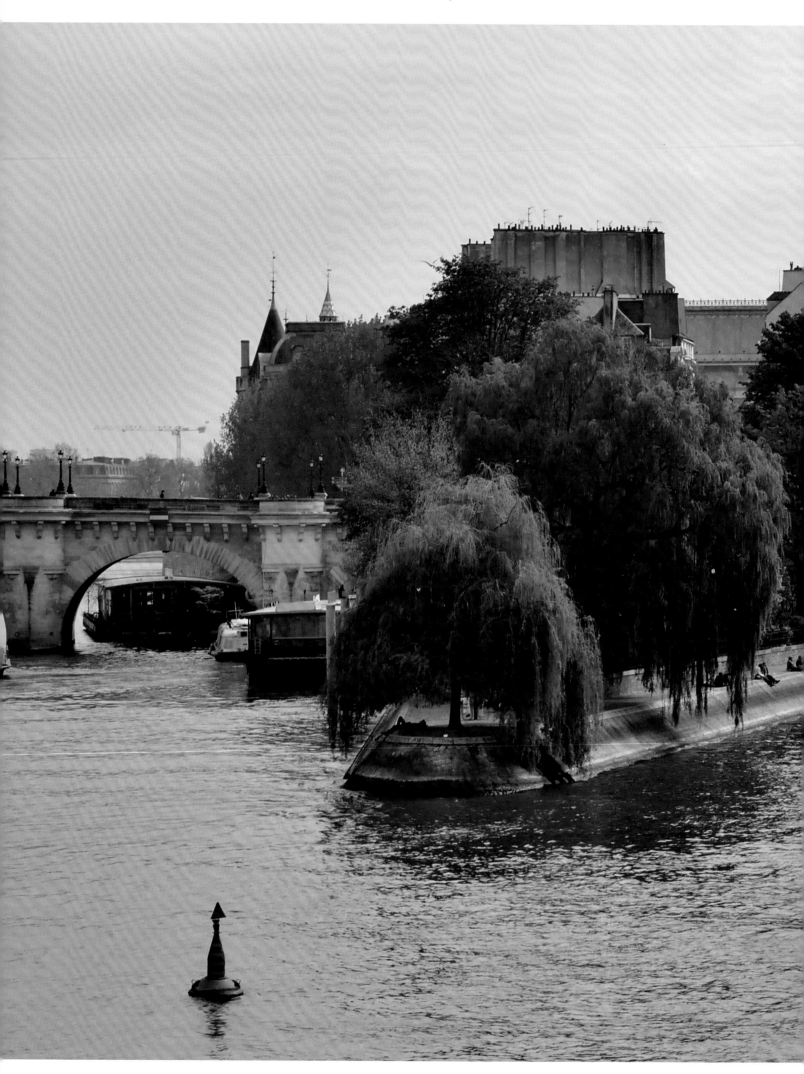

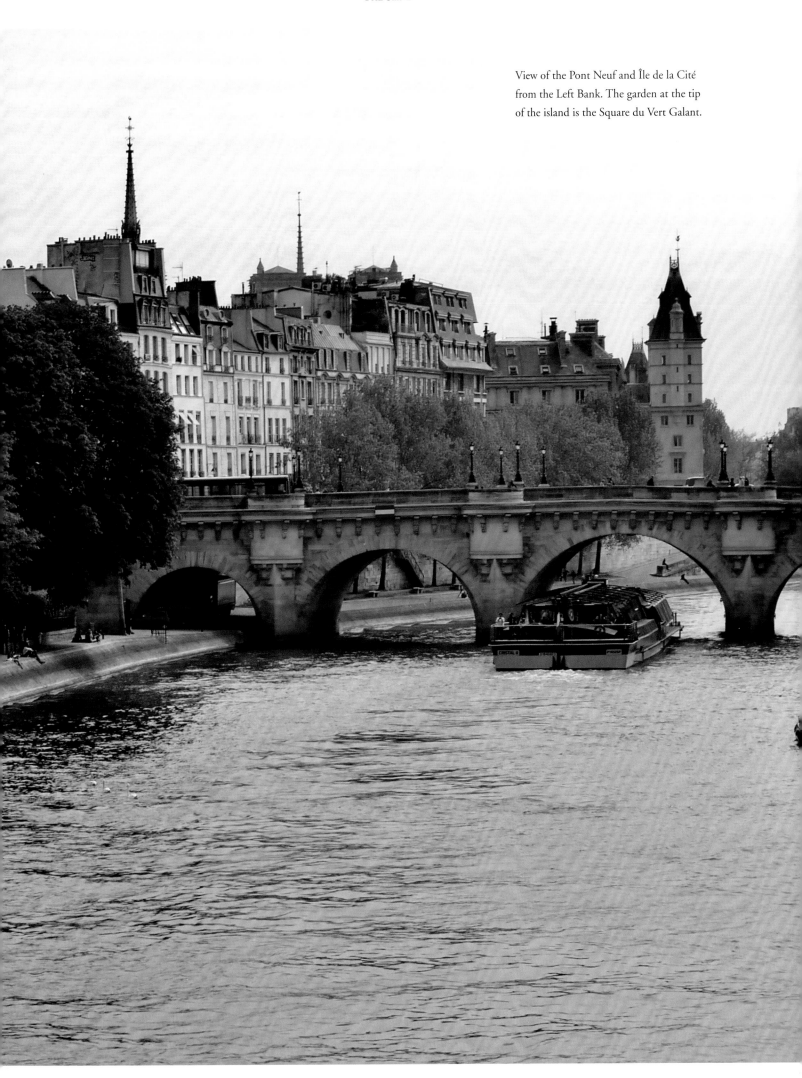

View of the Pont Neuf and Île de la Cité
from the Left Bank. The garden at the tip
of the island is the Square du Vert Galant.

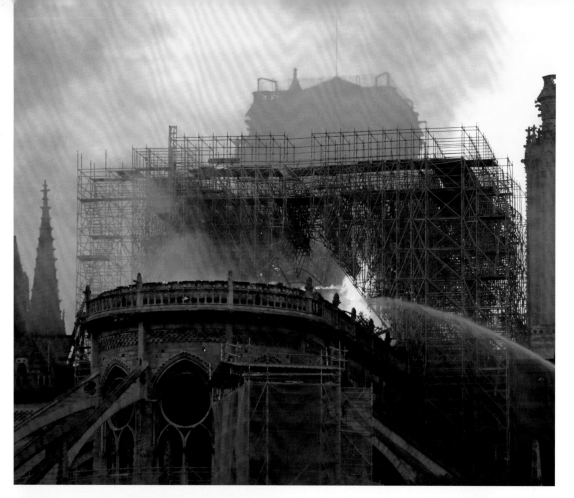

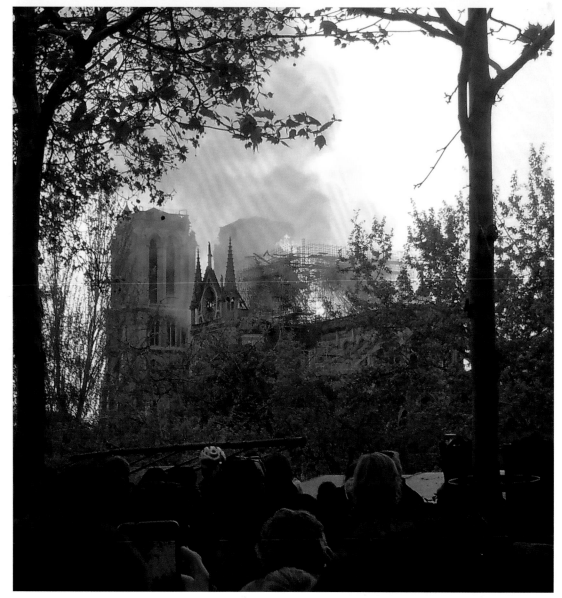

**LEFT AND BELOW LEFT:** The world watched in horror on the night of April 15, 2019, as fire caught hold of the ancient cathedral. For many hours it seemed as if the whole edifice would be destroyed, but the work of over 500 firefighters—and the doughty construction of the stone vaulted ceiling (see page 137)—helped reduce the damage. Most of the irreplaceable art and artifacts contained in the cathedral were removed during the fire. The restoration will take many years once it is decided exactly how it is to be achieved. The many options include direct reconstruction, using materials from the regions that provided the originals, and a more contemporary approach using modern construction techniques.

**RIGHT:** Much of the oak roof of the cathedral's nave and transept was lost along with the spire, its slow fall at around 20:00 on the evening of the 15th punctuating the catastrophe. The spire was a later addition to the cathedral, by Eugène Viollet-le-Duc, the architect who led the restoration of the building in the 1840s.

**PAGE 146:** The carved monsters of Notre-Dame enjoy one of the best views of Paris. These creatures are grotesques, half man half beast. Some, such as those sticking out from the top of the nave, despite their appearance had a practical function—they are actually elaborate drainpipes. Hidden inside each sculpture is a pipe which funnels rainwater from the roof out through a spout in the gargoyle's mouth. The word gargoyle comes from the Latin and means drain or gullet. Some of the gargoyles can be viewed up close by (paying to) climb 387 steps up the north tower. The other figures—as these two—are decorative, showing a strix (**ABOVE**), a bird of ill omen, and a chimera (**BELOW**), a mythical beast.

**PAGE 147:** Evening light on the built-up banks of the Seine.

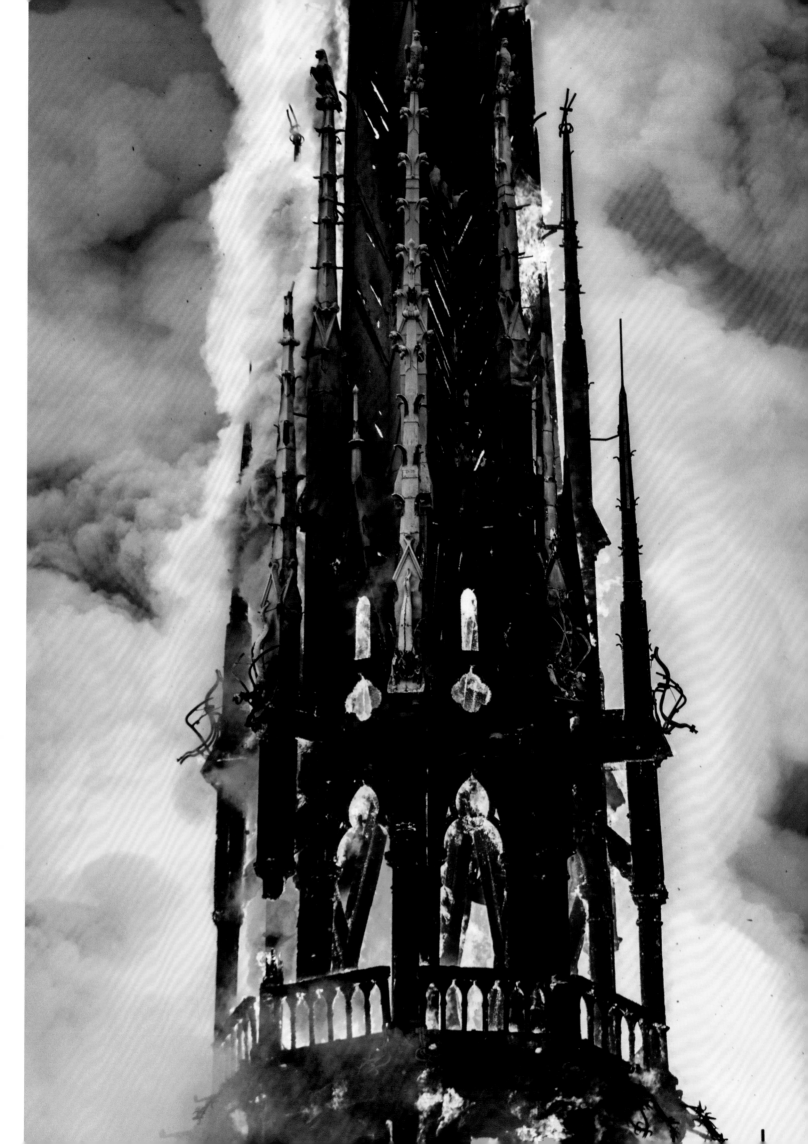

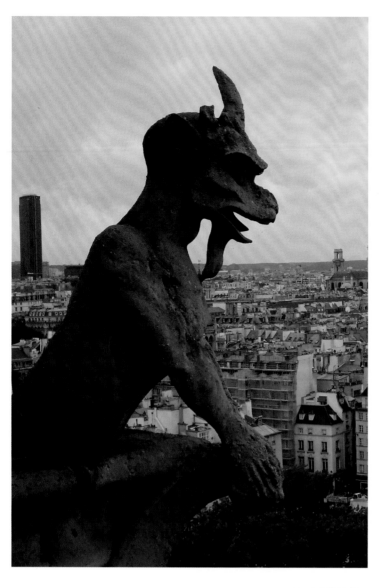

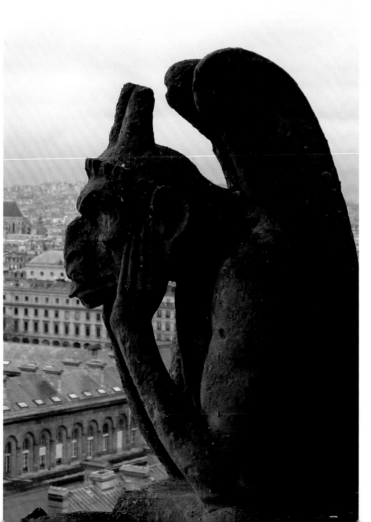

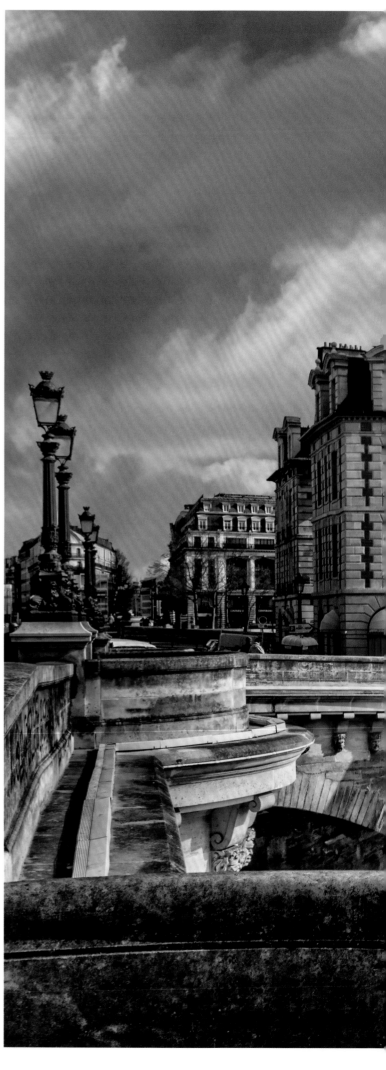

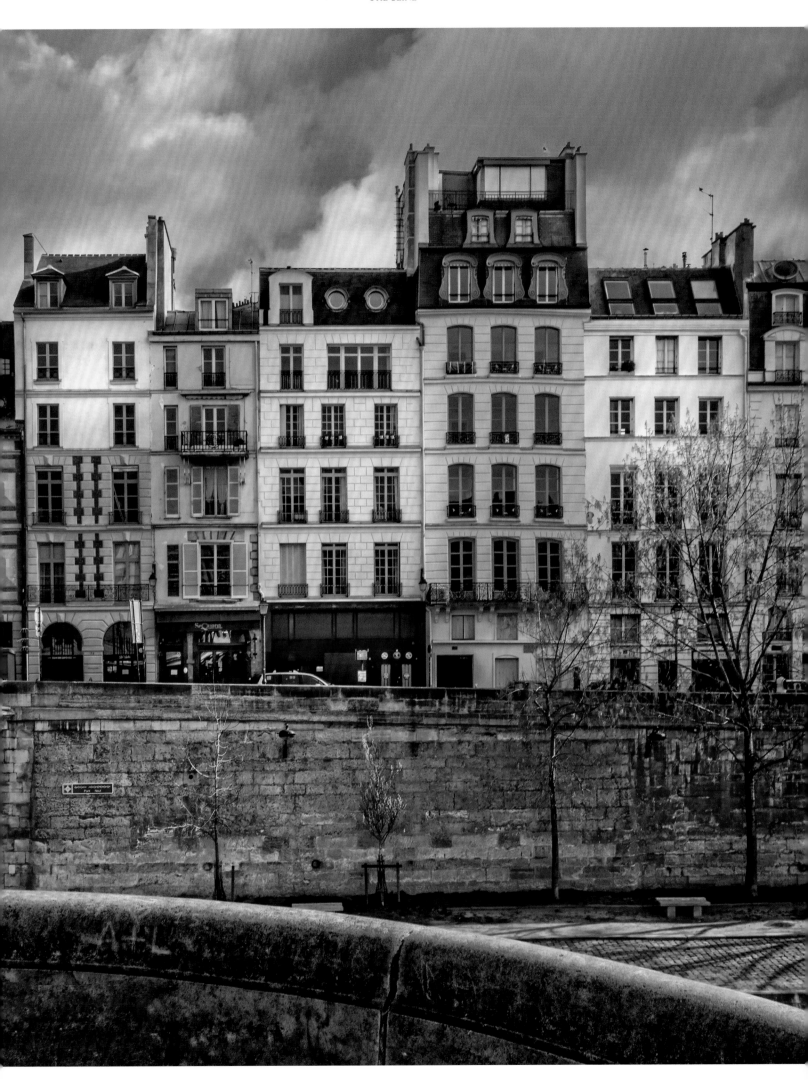

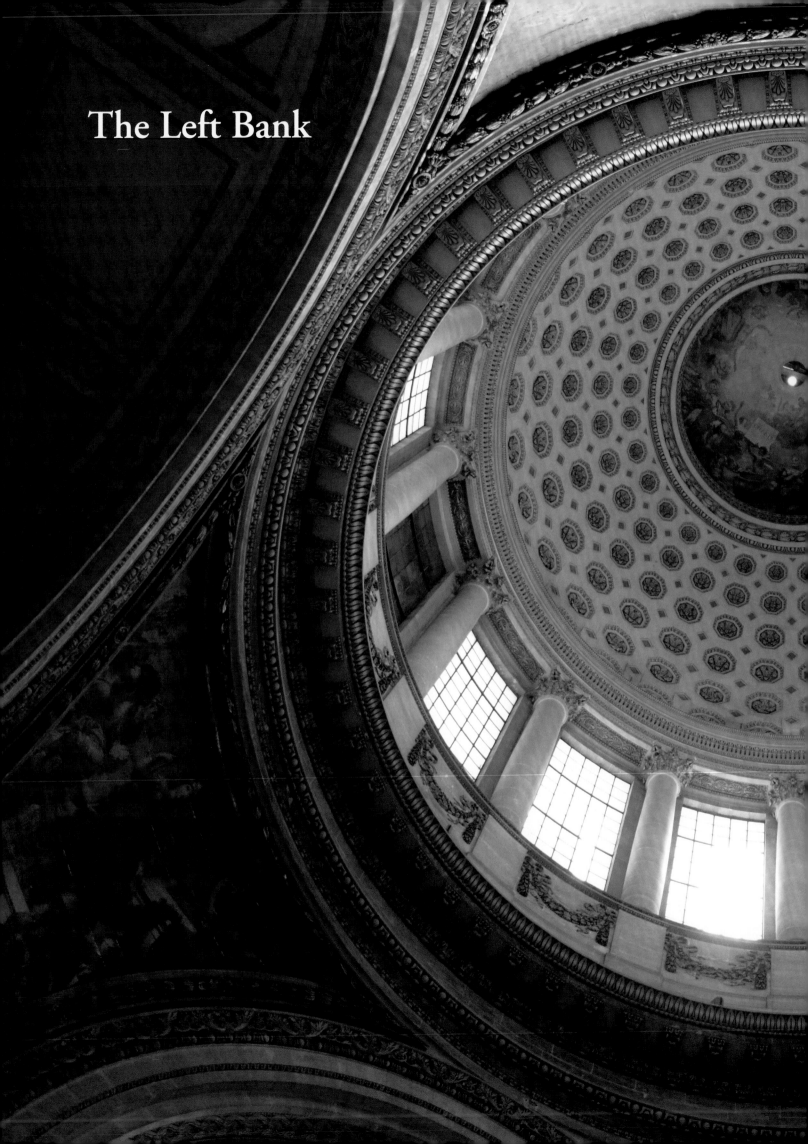

# The Left Bank

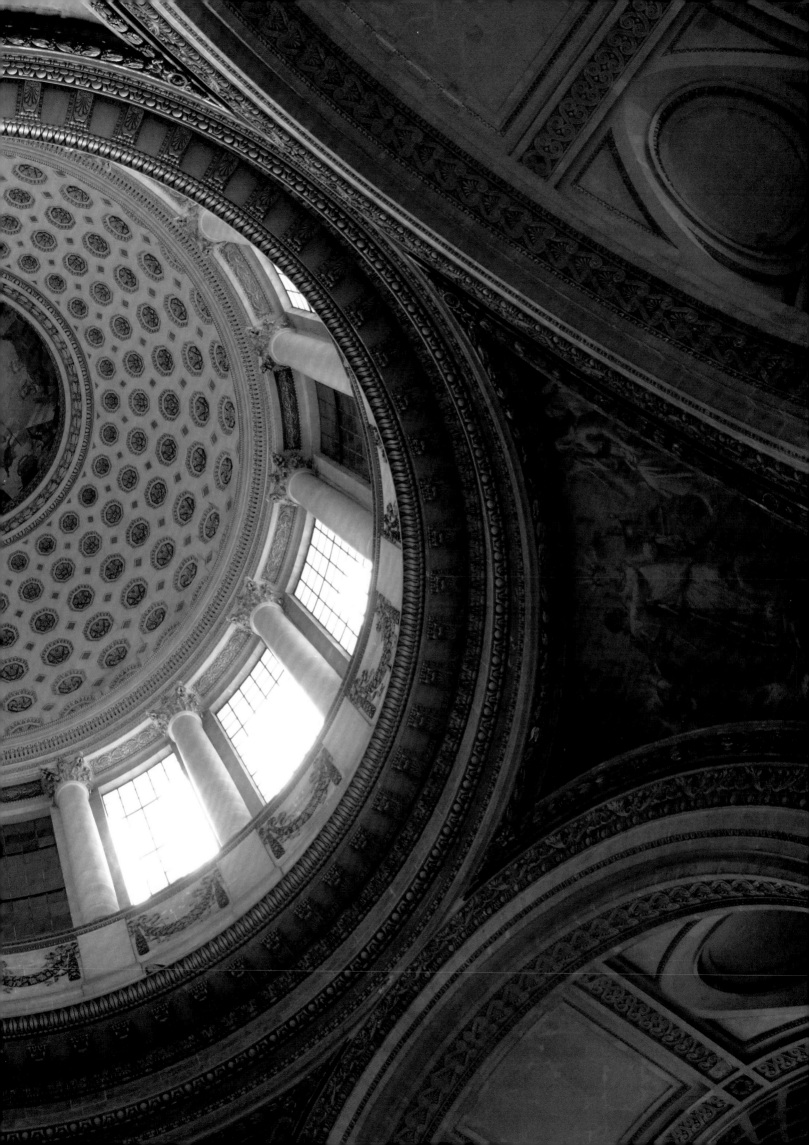

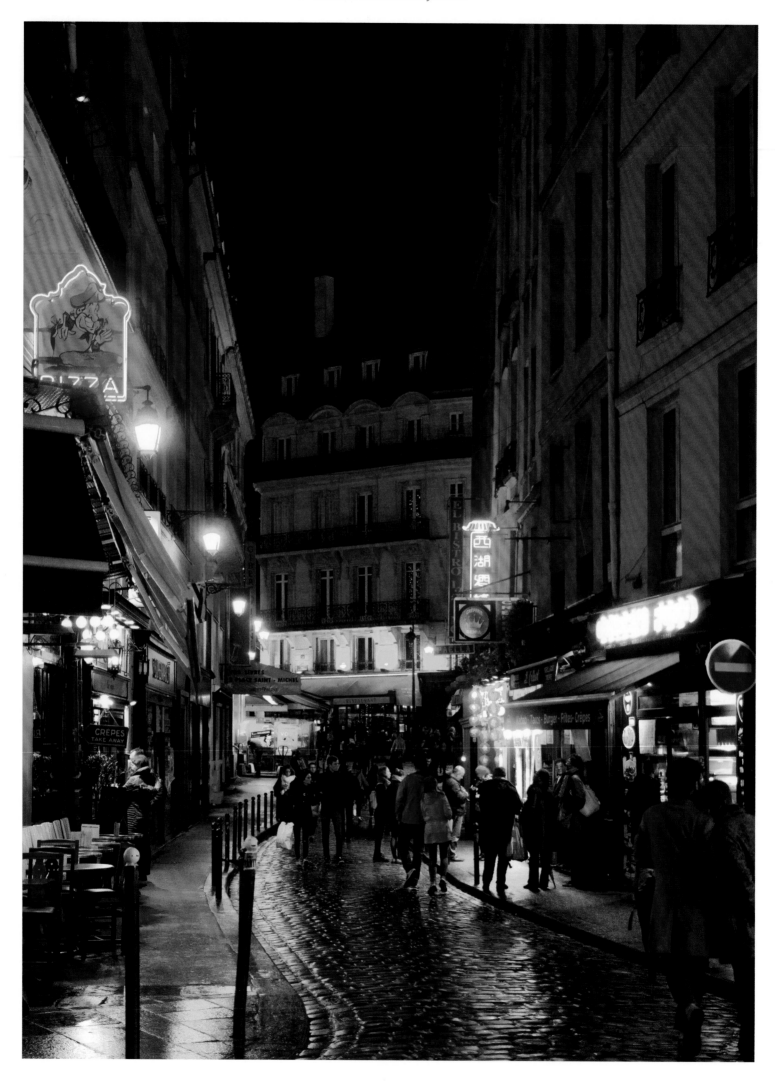

**PAGES 148–149:** The dome of the Panthéon.

**LEFT:** The Latin Quarter is the location for the Sorbonne University on the Boulevard Saint-Michel—so in term time the area is full of students. The quarter gets its name from the fact that in medieval times the students at Paris University spoke Latin to each other (until 1793).

**RIGHT:** One of the most famous cafés in Paris, Les Deux Magots, is in the 6th arrondissement. It has served numerous luminaries including Jean-Paul Sartre, Ernest Hemingway, and Simone de Beauvoir and has attracted writers, poets, and philosophers for decades. The café is named after the two wooden statues of magots (a kind of monkey) that dominate the interior.

**BELOW:** The Latin Quarter is full of coffee shops and restaurants. A popular tourist destination, its center is the Place Saint-Michel.

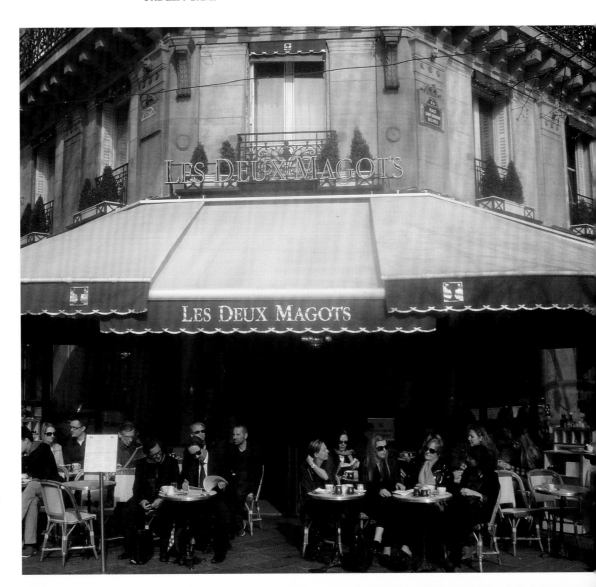

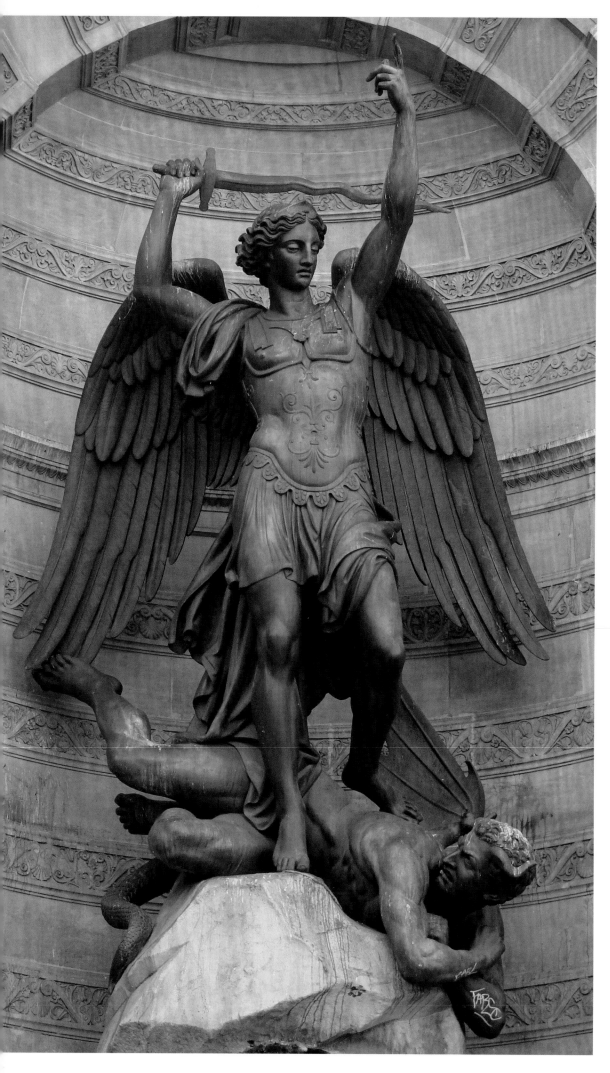

**LEFT:** Even on a wet day there is plenty to see in the Latin Quarter as some of the oldest parts of Paris are here including the Gallo-Roman thermal baths near Cluny from the ancient Roman city of Lutetia, and the Église Saint-Etienne du Mont dedicated to Sainte-Geneviève, the patron saint of Paris. This is the central niche of the fountain that dominates the south end of the Place Saint-Michel. The sword- wielding Archangel Michael has the devil at his feet in Gabriel Davioud's design—but the archangel was third choice: first had been a female statue representing peace; next came Napoleon Bonaparte; finally, in 1858 the current scene was agreed and the fountain was inaugurated in 1860.

**RIGHT:** Saint-Germain-des-Prés is a busy area full students, tourists, writers, and artists all providing the numerous cafés and restaurants with plenty of business. This is the Benedictine Abbey church which was completed in 558. Rebuilt first in stone and then after depredations by Vikings, the current structure was finished in the twelfth century, although the classical doorway seen here was a 1606 replacement of an older portal.

**PAGES 154–155:** Established in October 1795, the Institut de France comprises five academies of which the Académie Française (established 1635) is the best known. The other institutions are the Académie des inscriptions et belles-lettres (1663), Académie des sciences (1666), Académie des beaux-arts (1816), and Académie des sciences morales et politiques (1795). The building was constructed with money bequeathed by Cardinal Mazarin and designed by Le Vau in 1663–1664.

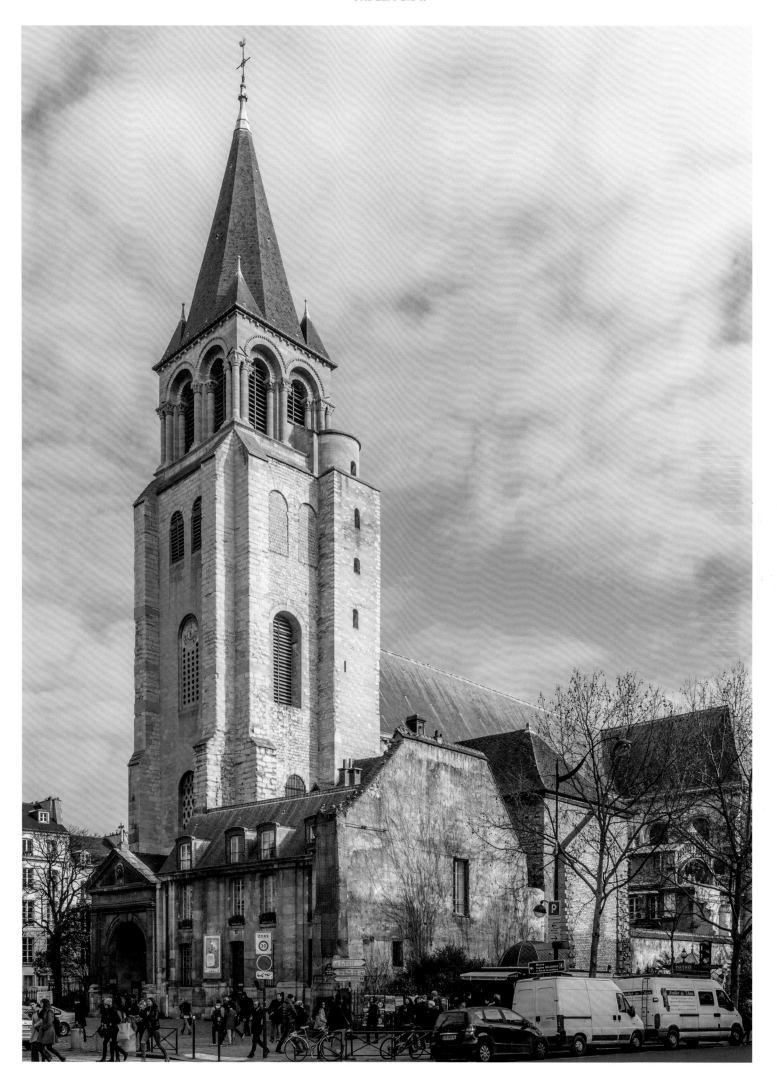

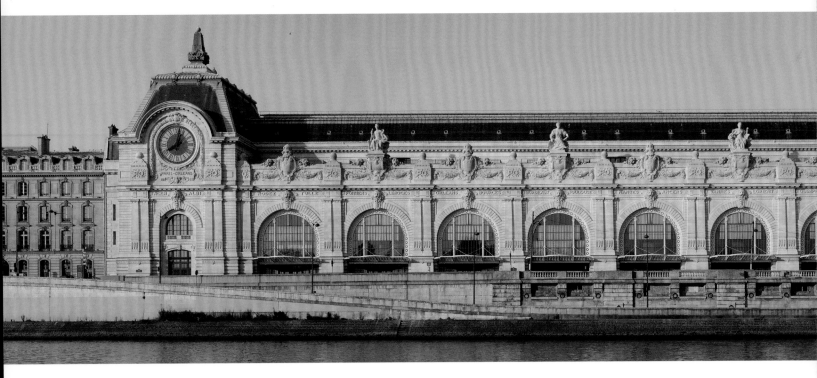

**ABOVE AND BELOW:** The Musée d'Orsay started life as the Gare (railroad station) d'Orsay. Built for the 1900 Universal Exhibition, inside were the most modern amenities of the time. From 1900 until 1939 the station was the terminus for southwestern France, by which time the platforms were too short for long-distance electric trains and so the station became a suburban terminus. It was threatened with demolition but the building was saved as a museum for the arts and opened to the public as the Musée d'Orsay on December 9, 1986. It is the best place in the world to see Impressionist paintings.

**OPPOSITE, ABOVE:** The eye of the Panthéon. There are 267 steps to the colonnade from which there are wonderful views over Paris.

**OPPOSITE, BELOW:** In 1744 King Louis XV fell ill while besieging Metz. He recovered and, in thanks, rebuilt the church of Sainte-Geneviève. The front is modeled on Rome's Pantheon. It was in the Parisian Panthéon in 1851 that French physicist Jean Leon Foucault (1819–1868) demonstrated the rotation of the Earth to the public. Crowds flocked to see the demonstration and the experiment became known as Foucault's Pendulum. On completion the Panthéon became a mausoleum where great French men and women were buried—Voltaire, Rousseau, Hugo, Marie Curie, and two heroines of the French resistance in 2015.

**PAGES 158–159:** One of the most extraordinary places to visit in Paris are the Catacombs at Place Denfert-Rochereau. When the church graveyards of Paris were cleared out in 1785, the bones were carefully collected and transferred to these old quarry pits. The bones are arranged in their parishes and a mass was said as each was completed. A sign indicates which cemetery the bones originally came from, but there are no individual skeletons.

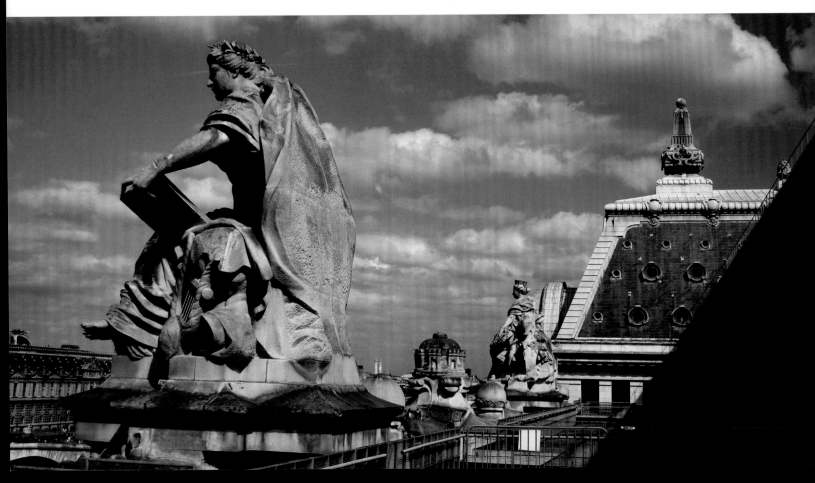

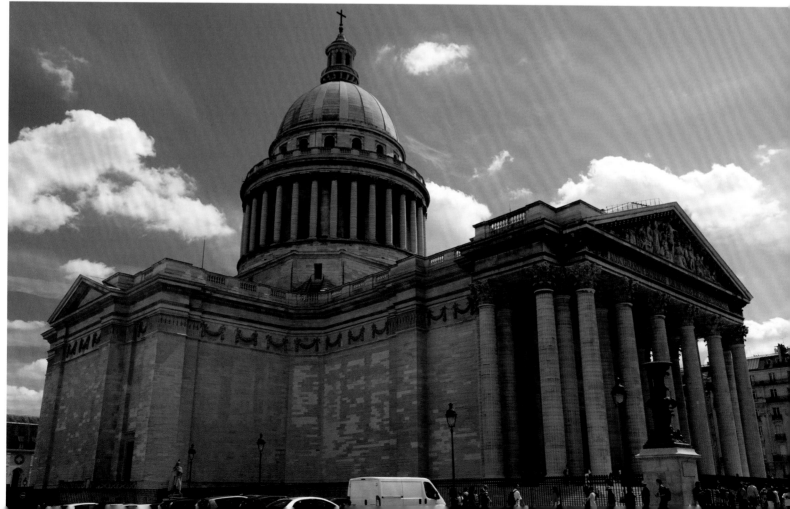

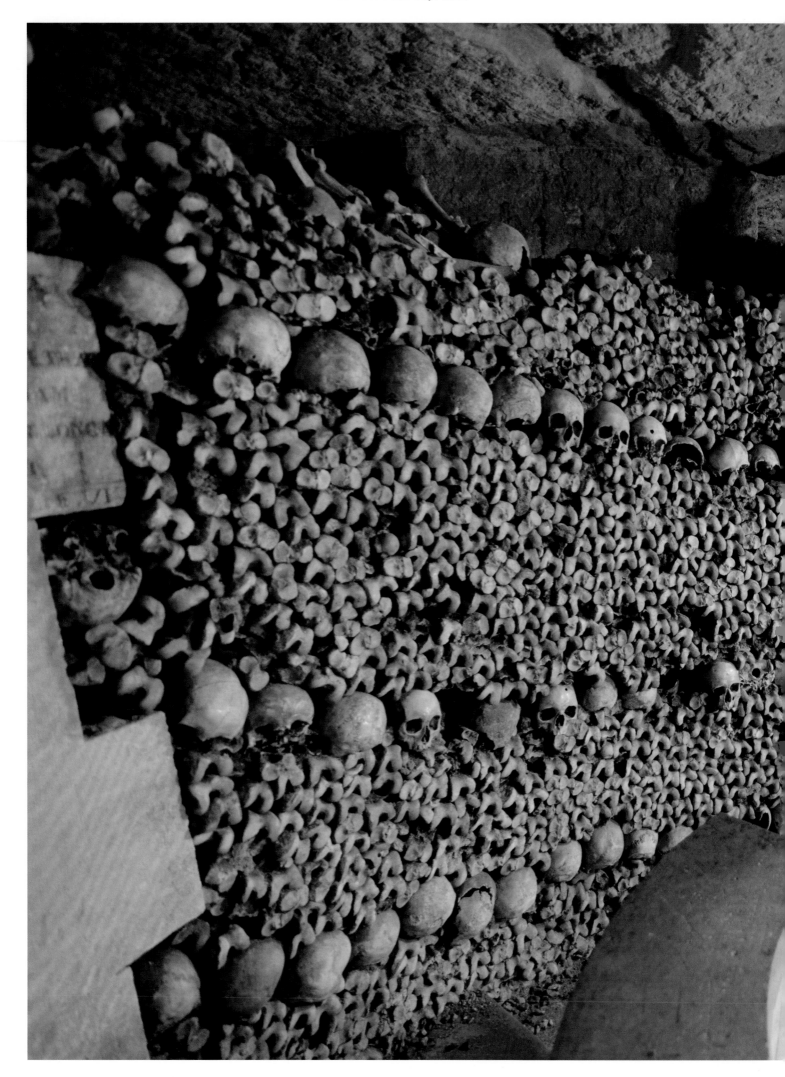

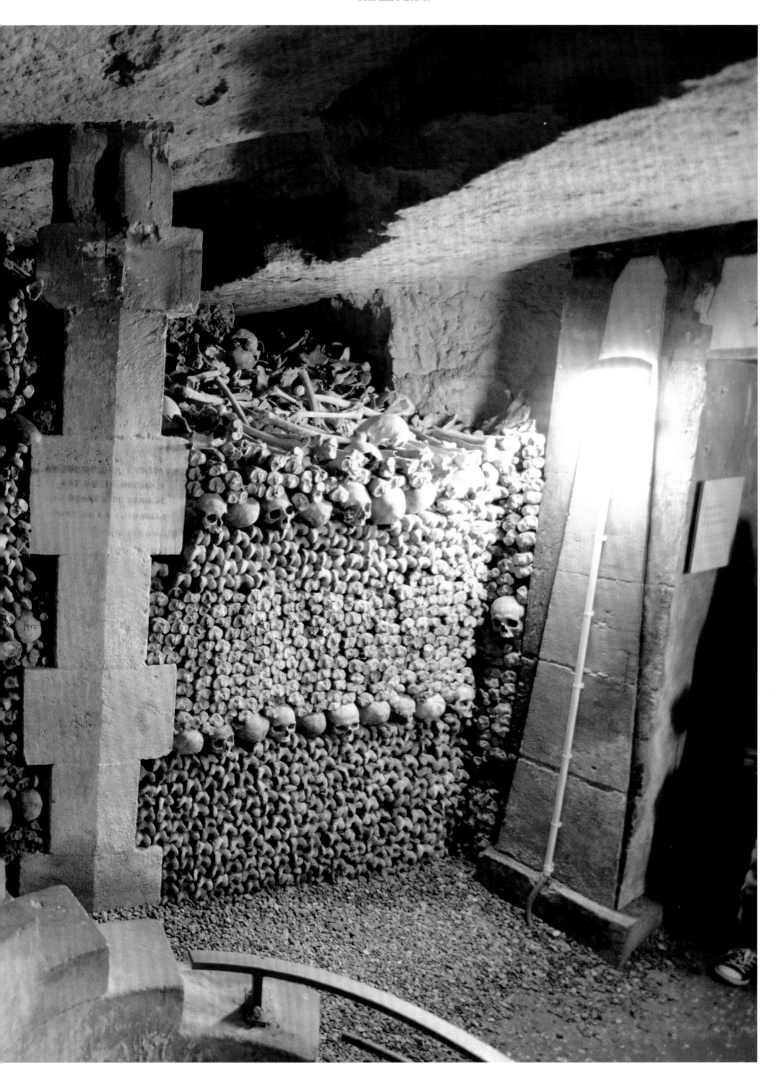

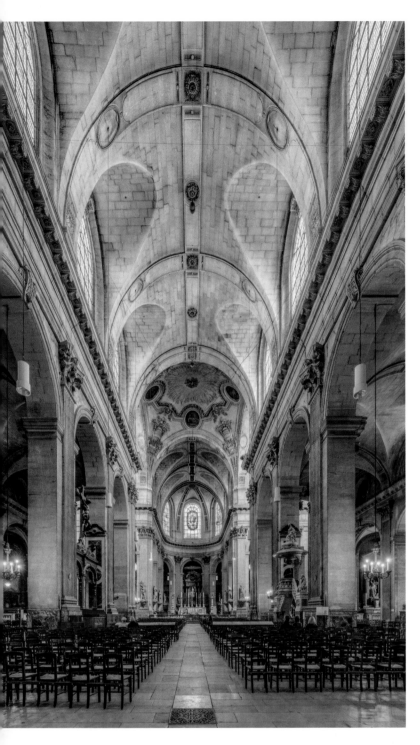

**ABOVE AND RIGHT:** Saint-Sulpice originally dates from the thirteenth century but most of the current church was built in the early seventeenth century starting in 1646. The ground plan is the same size and shape as Notre-Dame. The south tower was never finished and neither was the façade. Inside it is a fine rococo church with a magnificent organ by F. A. Cliquot and an extraordinary pulpit dating from 1788 which seems to be suspended in midair by two sets of stairs. Both the Marquis de Sade and Baudelaire were baptized here, and Victor Hugo was married here. The Paris meridian runs through the middle of the choir and is delineated by a copper line. More recently the church has witnessed a rise in visitor numbers thanks to its involvement in the *Da Vinci Code*.

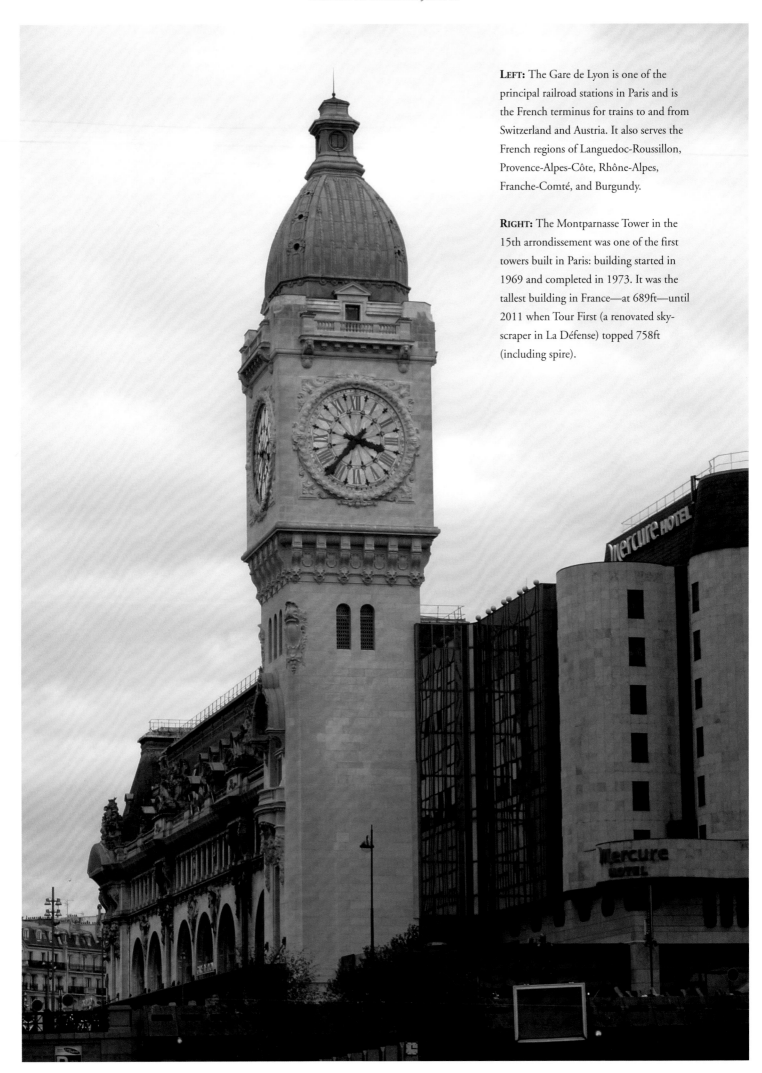

**LEFT:** The Gare de Lyon is one of the principal railroad stations in Paris and is the French terminus for trains to and from Switzerland and Austria. It also serves the French regions of Languedoc-Roussillon, Provence-Alpes-Côte, Rhône-Alpes, Franche-Comté, and Burgundy.

**RIGHT:** The Montparnasse Tower in the 15th arrondissement was one of the first towers built in Paris: building started in 1969 and completed in 1973. It was the tallest building in France—at 689ft—until 2011 when Tour First (a renovated skyscraper in La Défense) topped 758ft (including spire).

**RIGHT AND BELOW RIGHT:** The Palais du Luxembourg was commissioned by Marie de Medicis. Built between 1615 and 1627 architect Salomon de Brosse designed the buildings which are considered by many to be the best example of French seventeenth century classical architecture. Peter Paul Rubens and Eugène Delacroix among others contributed paintings to ensure the interior decoration was as rich as the exterior. The Palais has served many masters during its existence and was even a prison during the Revolution. During the German occupation of Paris in the 1940s the commander-in-chief of the Luftwaffe took the Palais du Luxembourg for his headquarters. It was used for the peace conference of 1946, and now houses the French Senate. The Palais du Luxembourg is surrounded by 62 acres of magnificent parklands and gardens which are filled with fountains, flowers, and statues of many of the queens of France.

**PAGES 166–167:** In the 5th arrondissement is the Jardin des Plantes—botanical gardens—started by Louis XIII as a Royal Medicinal Herb Garden in 1633 for the instruction of medical students. Seven years later it became the first garden in Paris to open its doors to the public. There are two hothouses built in 1834 to contain collections of plants from Australia and Mexico.

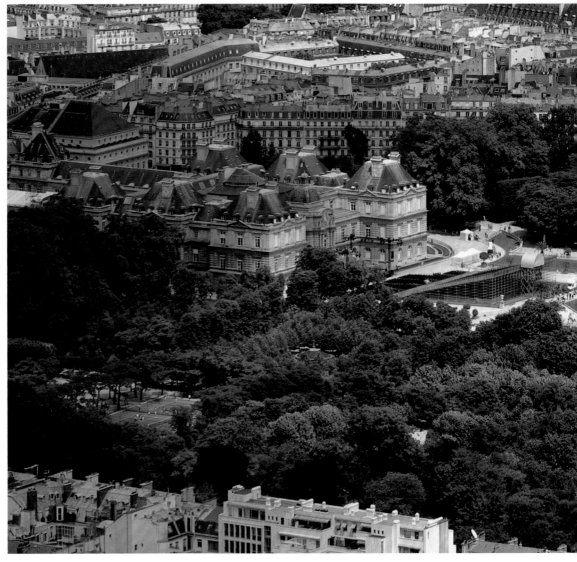

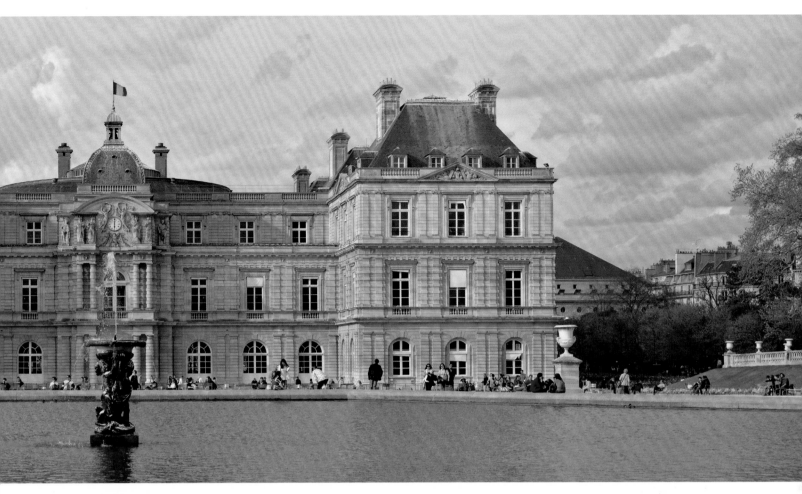

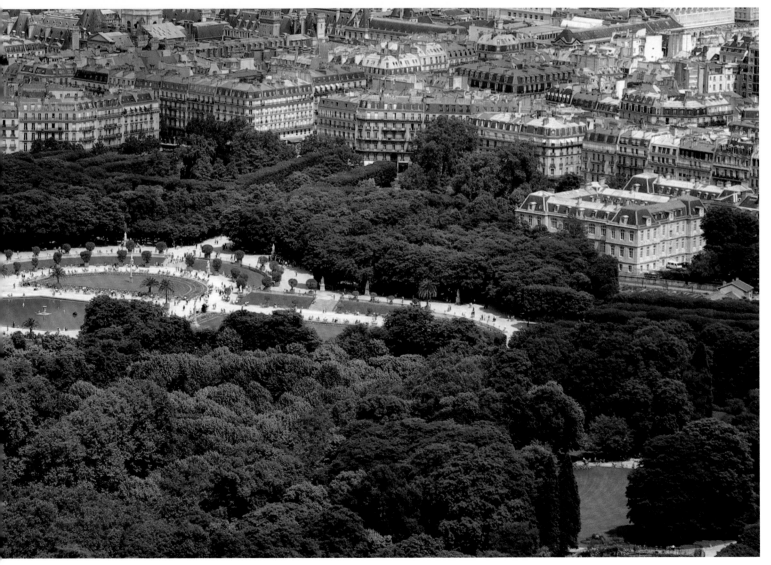

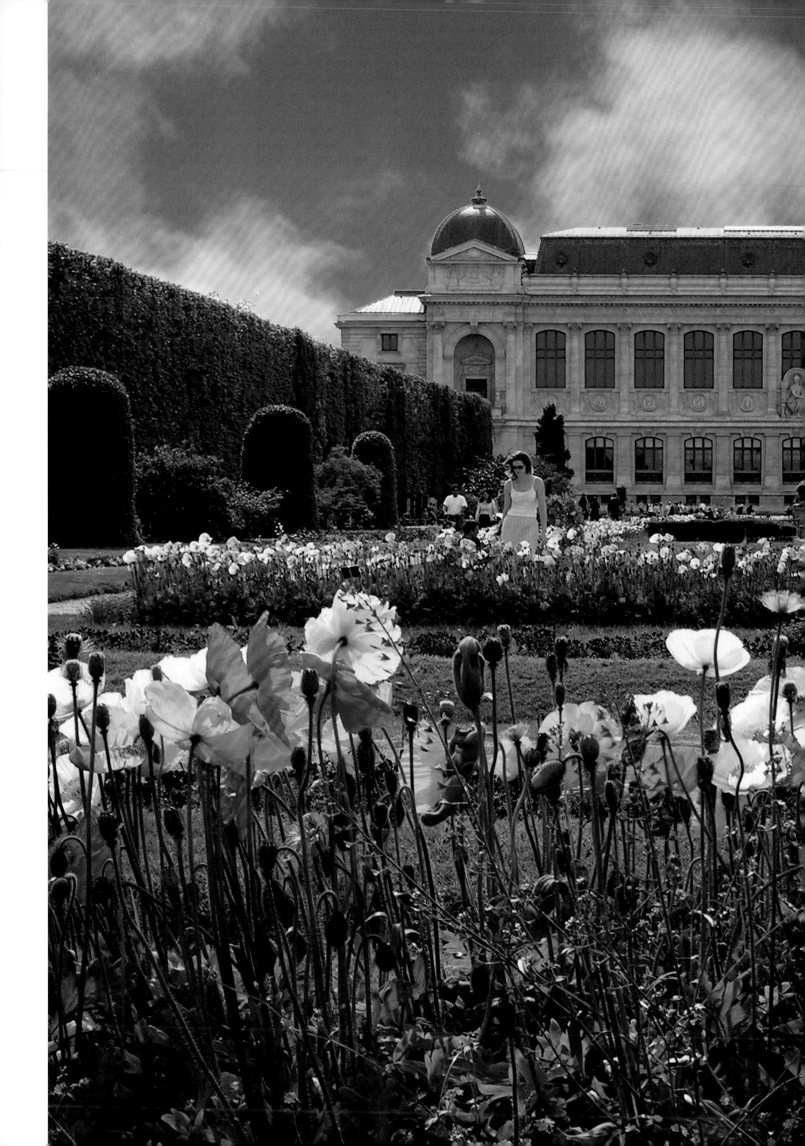

**RIGHT:** The Hôtel des Invalides was built by Louis XIV in 1670 as a hospital for 4,000 old soldiers who had fallen on hard times. The money for the building was funded by a five-year levy on the salaries of soldiers serving in the French army. Inspiration for the buildings was taken from the Escorial in Madrid by the principal architect Libéral Bruant. Work was completed in 1676. On Bastille Day in 1789 the Paris mob stormed Les Invalides, overwhelmed the guards and from the underground rifle storehouse made off with around 28,000 arms which they then took to the Bastille. The hospital has now become a paraplegic center and fewer than 100 old soldiers live here any more.

**BELOW:** A statue of Napoleon stands above the Cour d'Honneur in the heart of Les Invalides.

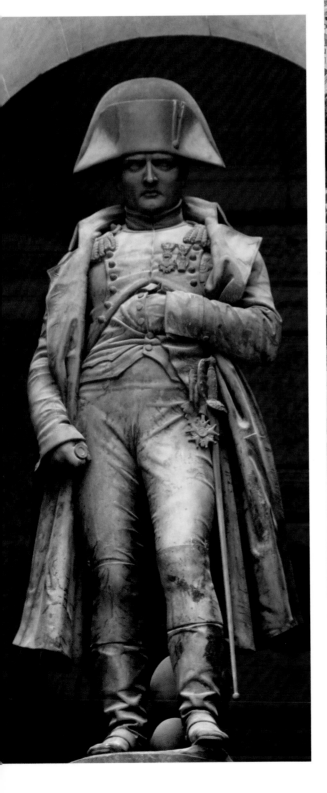

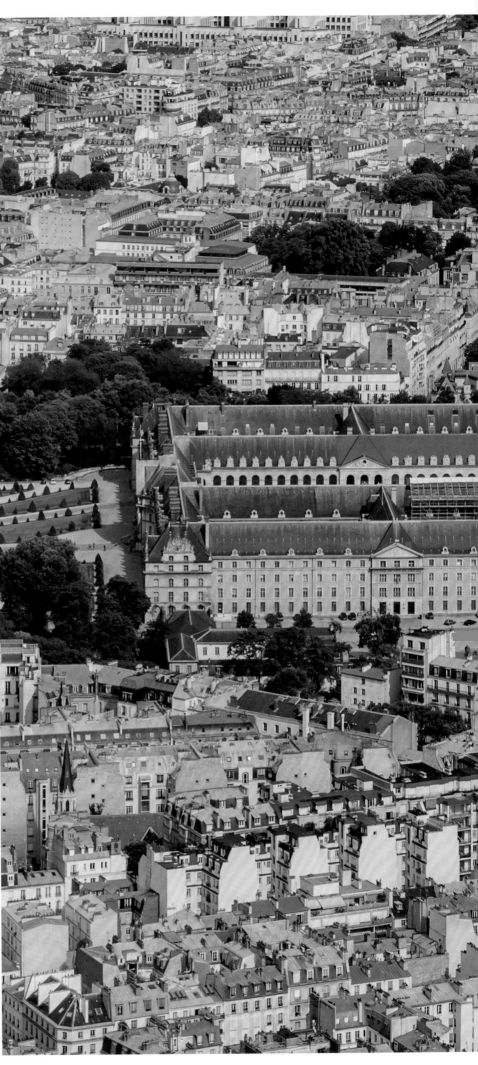

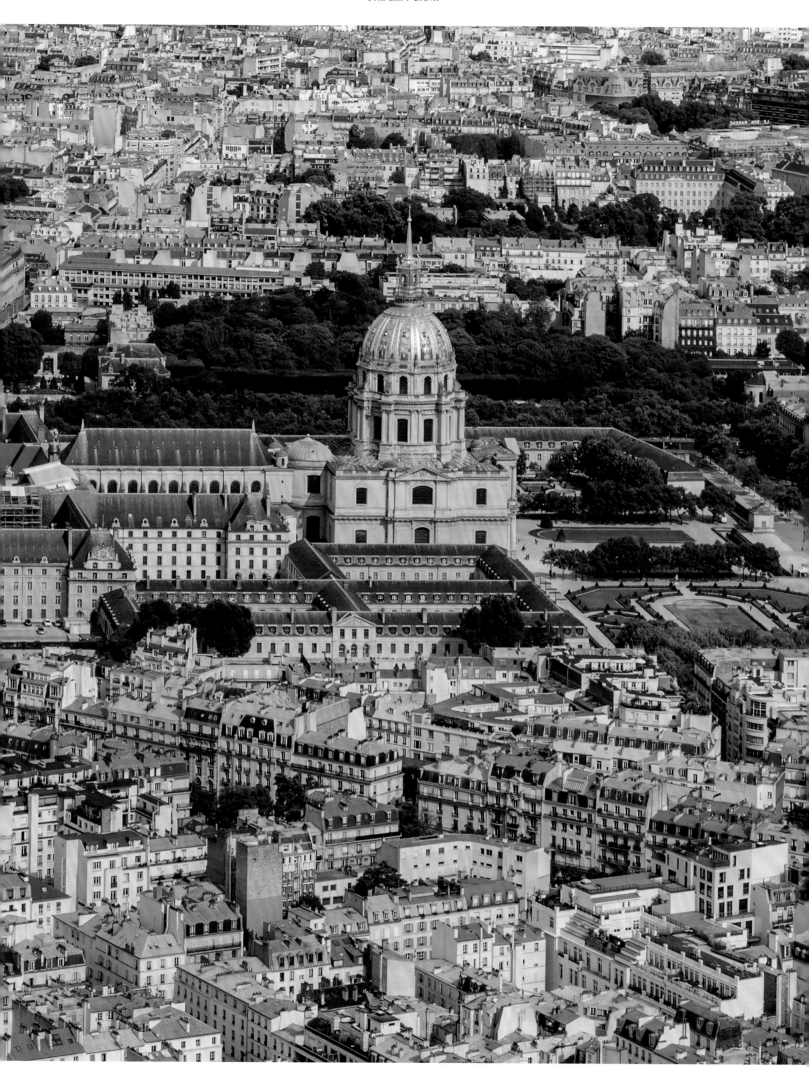

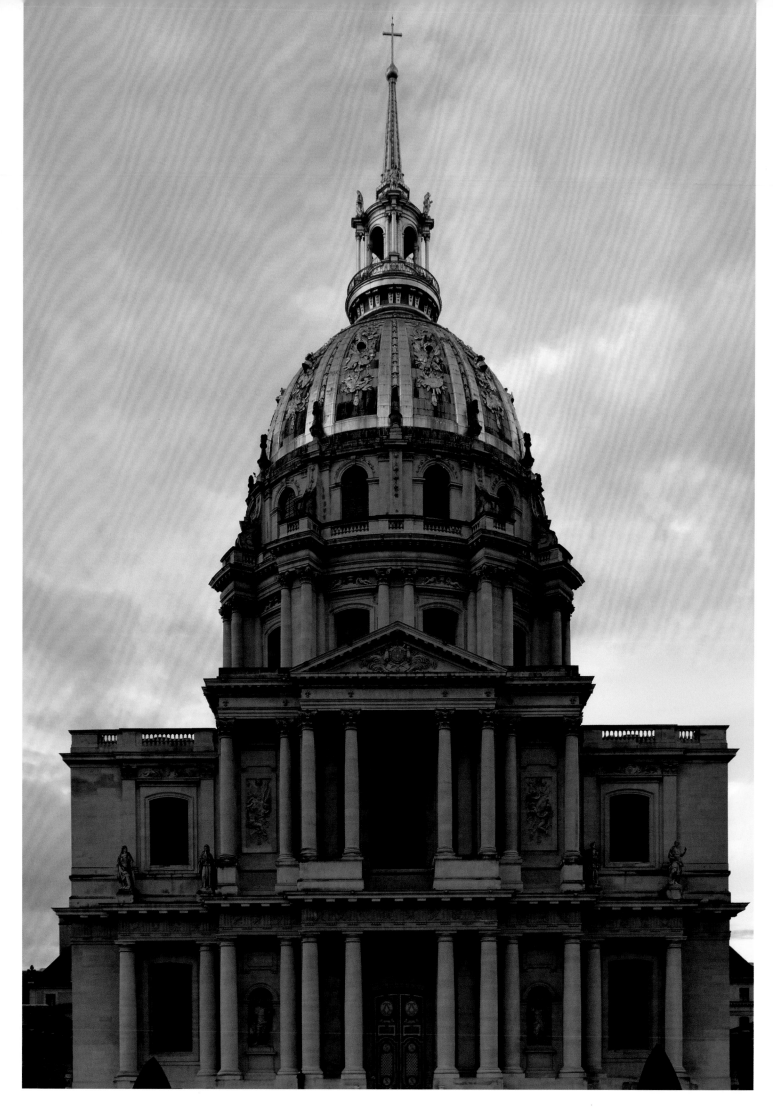

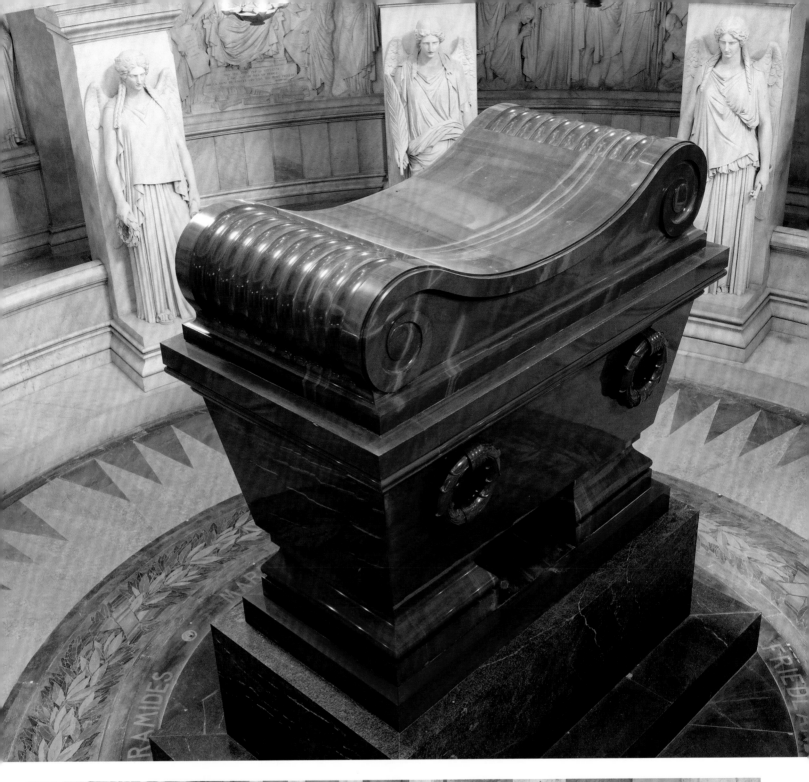

**PAGE 170:** The dome of Les Invalides belongs to the Church of Saint-Louis which was designed by Jules Hardouin-Mansart in a style known as "Jesuit" after the first Jesuit church in Rome. Work started in 1706 and then completed after his death in 1708 by de Cotte. It took 13lb of gold leaf to gild the dome.

**PAGE 171, ABOVE:** Following seven years of hard negotiations with the British government, King Louis-Philippe repatriated Napoleon's body from St. Helena on the frigate *La Belle Poule*. Arriving at Le Havre the coffin was brought up the Seine and landed at Courbevoie. On December 15, 1840, it was taken in state, through a snowstorm, via the Arc de Triomphe, the Champs-Élysées, across the Place de la Concorde to the Esplanade, and brought to rest at Saint-Jerome's Chapel where it stayed until the tomb was completed. Finally, on April 3, 1861, Napoleon was put into his magnificent red porphyry sarcophagus inside six coffins under the dome of Les Invalides. Personal items such as Napoleon's uniforms, medals, and arms are on display at the Musée de l'Armée in the front of Les Invalides.

**PAGE 171, BELOW:** Les Invalides incorporates a number of important monuments and institutions: namely the Musée de l'Armée, the Musée des Plans-Reliefs, the Musée de l'Ordre de la Libération, and L'Eglise de St-Louis-des-Invalides. This line of cannon in the Cour d'Honneur is part of the collection of the Musée de l'Armée—holding over 500,000 artifacts.

**RIGHT:** There are two chapels in Les Invalides including the royal chapel (today's Dôme des Invalides) and the veteran's chapel (the Cathédrale Saint-Louise-des-Invalides).

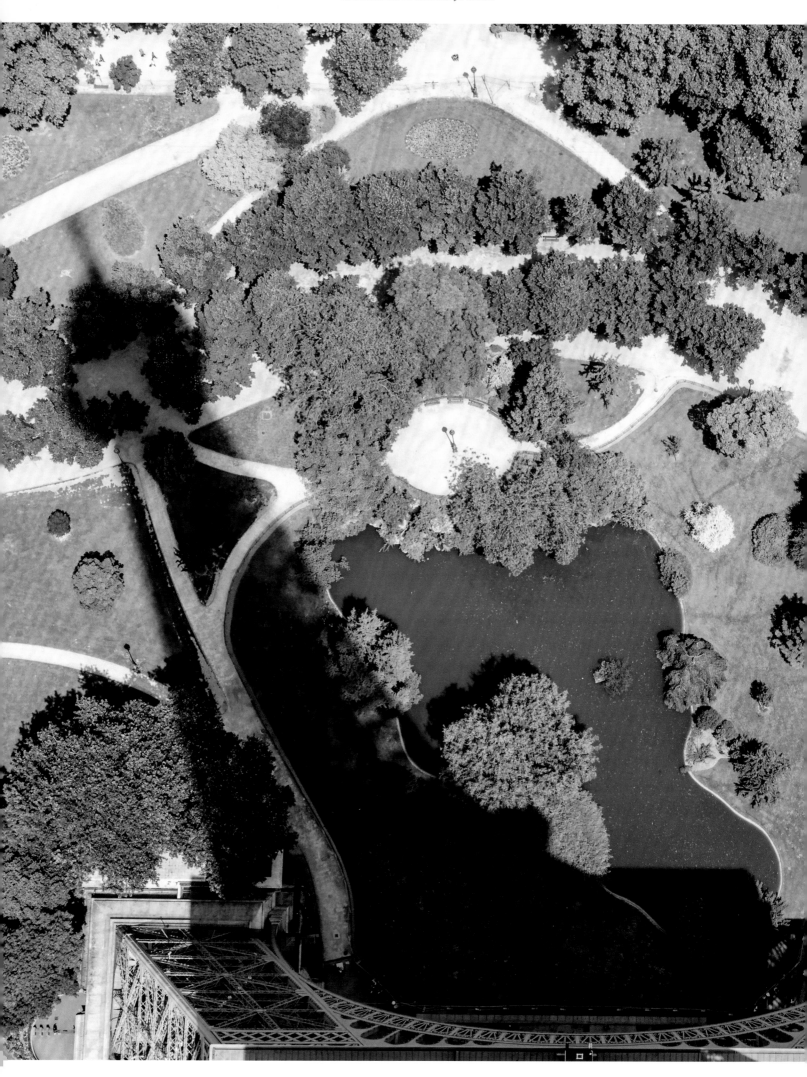

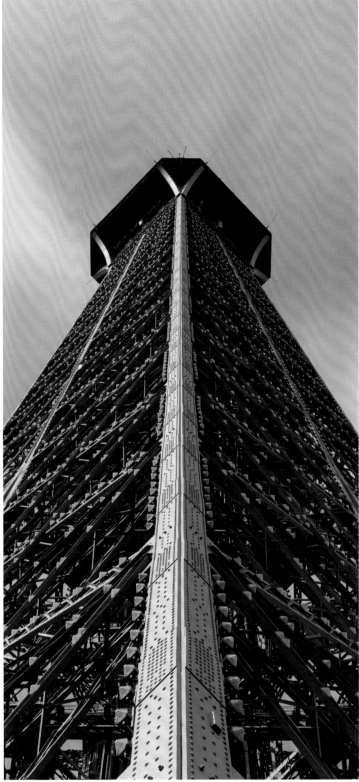

The Eiffel Tower was built to celebrate the centenary of the French Revolution. In particular, it was designed as the centerpiece of the 1889 Universal Exposition. After winning the design competition for the exposition Gustave Eiffel took three years in planning the structure before building could start in 1887 by which point there was not much time to spare before the exposition was due to open. It took 121 men two years, two months, and five days to assemble the 18,038 individual bits.

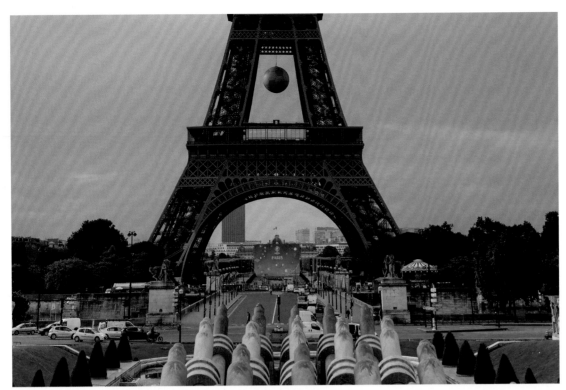

**LEFT:** The view of the Eiffel Tower across the fountains from the Trocadéro—note the football, part of the celebrations for the Euro 2016 soccer tournament played in France.

**BELOW:** The Eiffel Tower in spring.

**RIGHT:** View from the Eiffel Tower toward the Montparnasse Tower across the Champs de Mars and the École Militaire.

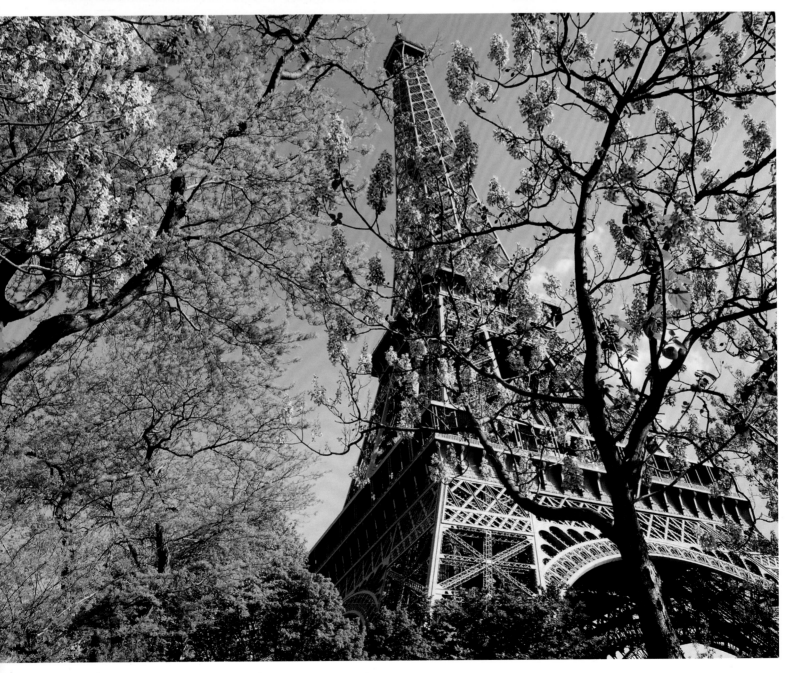

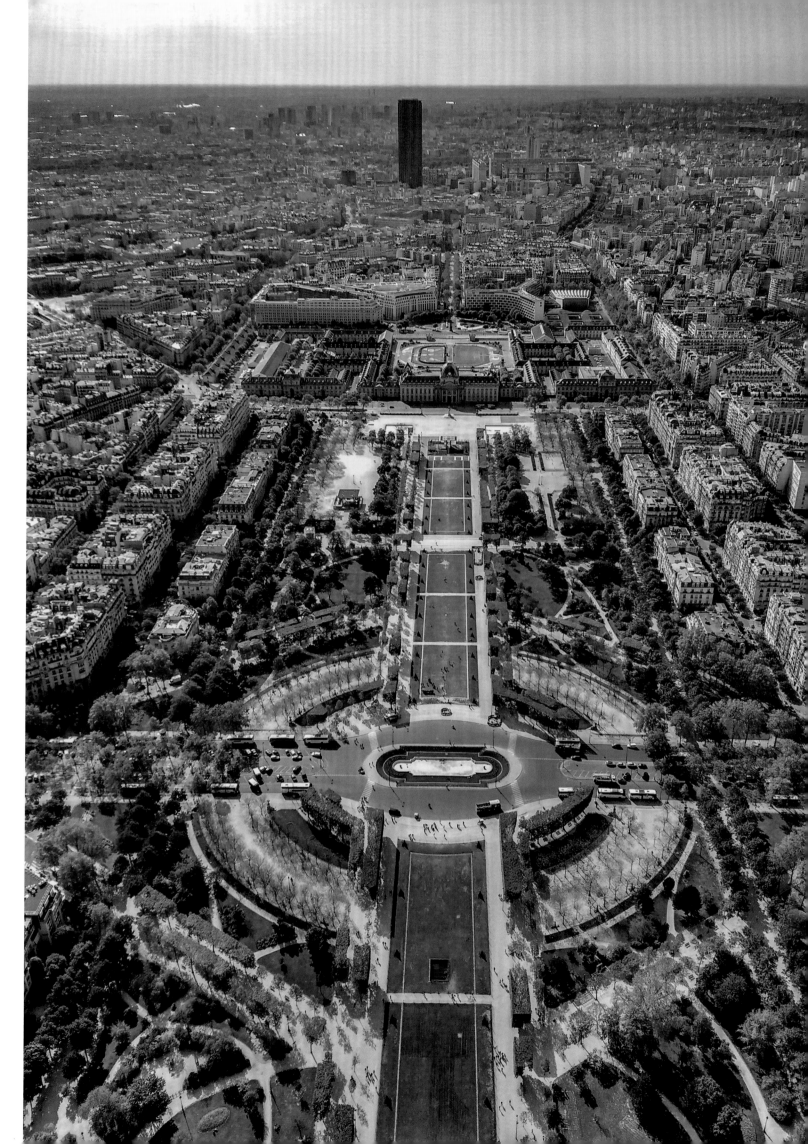

**LEFT AND BELOW:** The tower was completed in 1889, just in time and could boast of being the tallest building in the world—a title it held until the Chrysler Building in New York claimed the record in 1930. The total weight of the tower is 10,000 tons of which 7,300 is the metalwork. It takes 50 tons of paint to cover the metalwork and this has to be renewed every five years. Between 1980 and 1985 the Tower underwent a much needed restoration during which time an amount of unnecessary structure was removed and the remainder strengthened—the tower after all was intended to be temporary although Gustave Eiffel designed it to remain indefinitely. New elevators operating from the second floor to the top were installed, new lights put in place, and new r estaurants were provided.

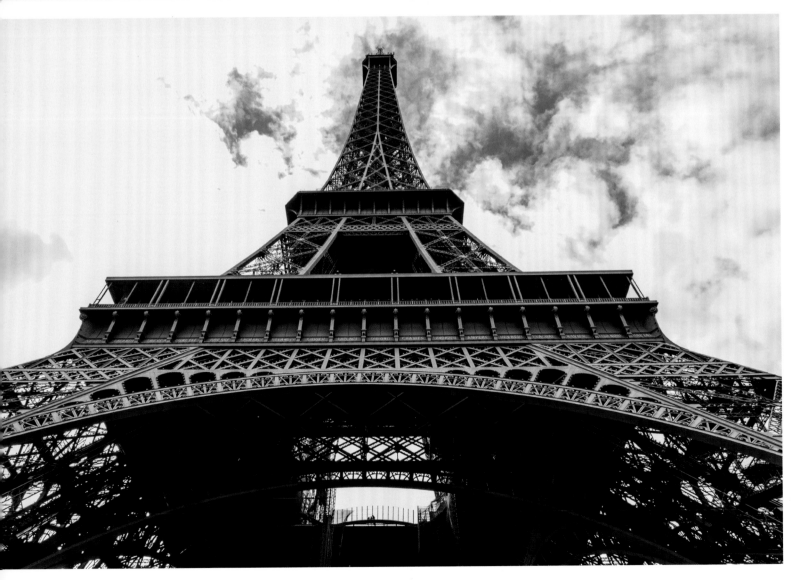

**RIGHT:** Paris throngs with visitors in the summer when in common with all cities it can get very hot. Luckily many of the streets are tree lined providing welcome shade, also the many bars and cafés offer refuge from the exhaustions of shopping and sight-seeing.

**BELOW:** The Paris skyline at dusk— looking from the Montparnasse Tower toward La Défense.

**PAGES 180–181:** Sacré-Coeur from the Eiffel Tower.

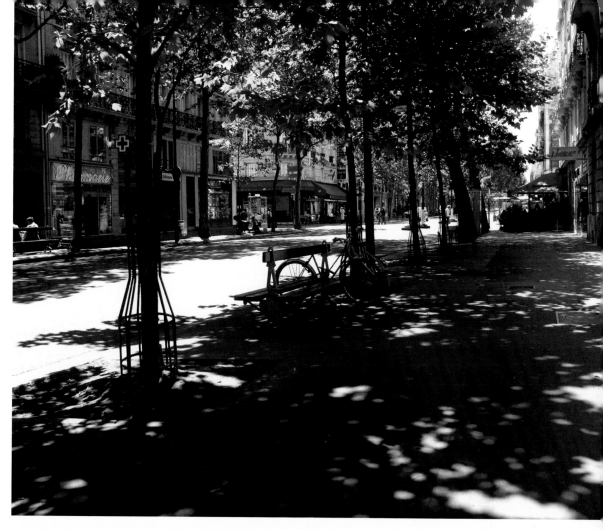

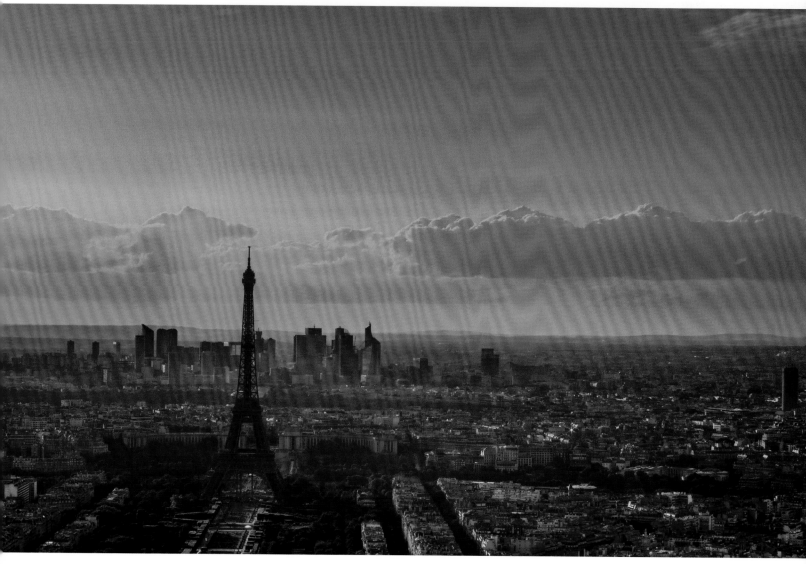

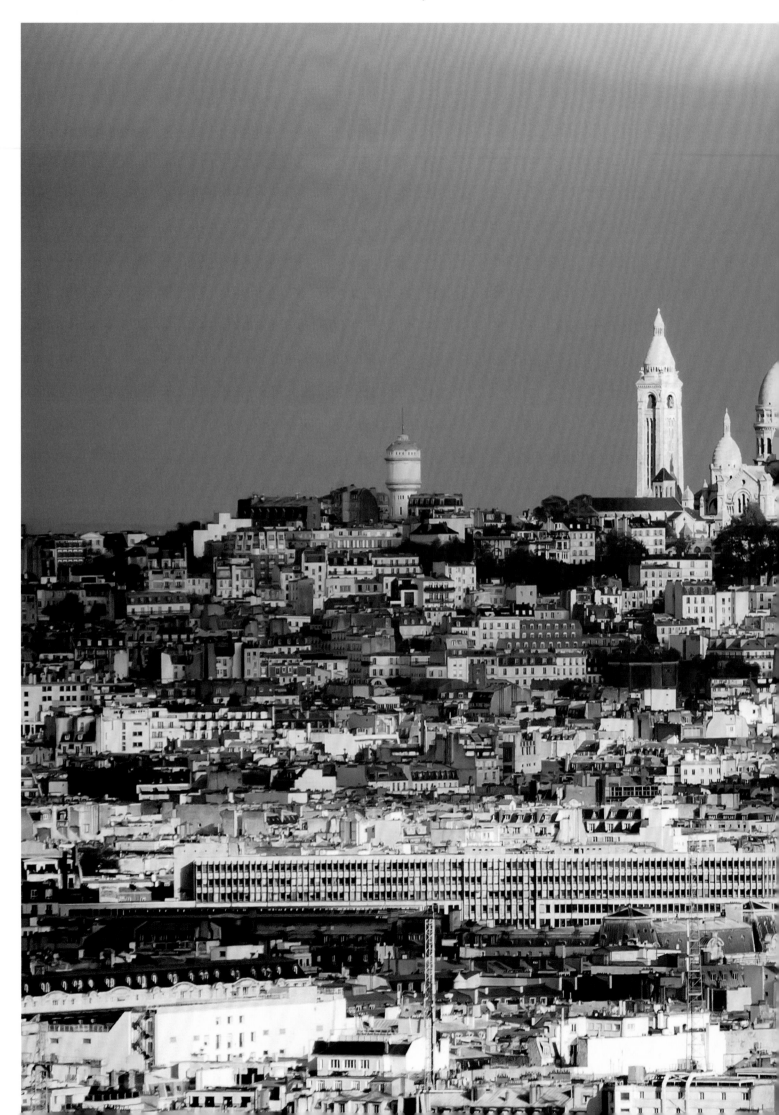

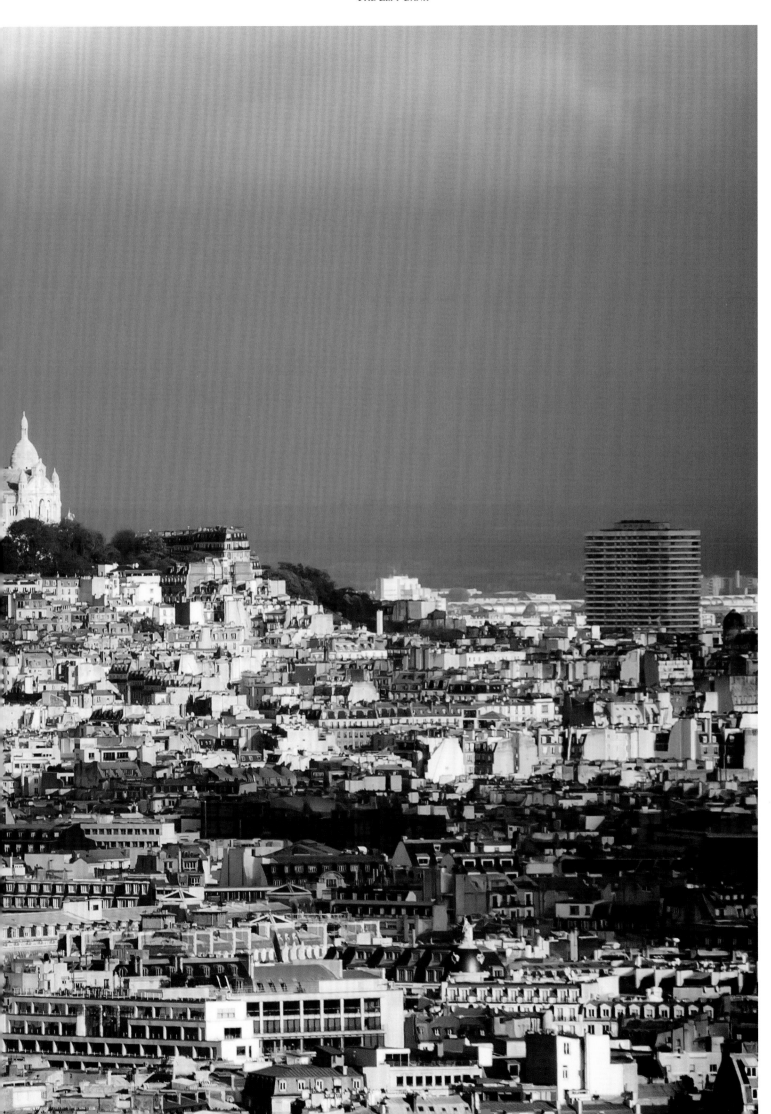

Outside the Péripherique

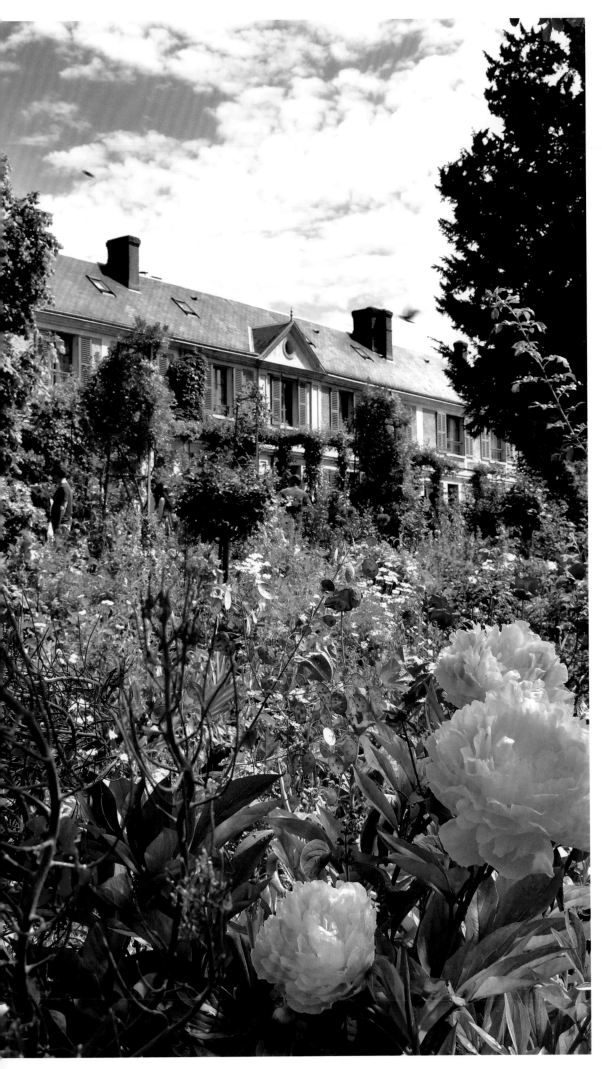

Outside the *Boulevard Circulaire*—better known as the *Péripherique*—lies much of Paris's dormitory area, where high-rise apartments house the many city workers. There are also many beautiful places that attract visitors from the city—particularly Louis XIV's palaces at Versailles and Fontainebleau and Monet's house at Giverny. Also included in this section is the Bois de Vincennes, for administrative purposes part of the 12th arrondissement.

**PAGES 182–183:** Detail of the gilt wrought-iron gates into Versailles. The French crown and the fleur de lys symbolize the French monarchy. These are restored facsimiles, the originals having been destroyed during the French Revolution.

**LEFT AND RIGHT:** Southwest of Paris on the right bank of the tree-lined River Seine lies Giverny. In 1883 Claude Monet rented a large farm-house and moved in his mistress Alice Hoschedé, her six children, and his two sons. In 1890 Monet was able to buy the property and to indulge his unique horticultural vision. As Monet's fame spread, more and more artists moved to Giverny and by 1887 a colony of artists, many of them American, lived nearby, a fact loathed by Monet himself. Monet spent most of his life at Giverny and when he died on December 5, 1926, he was buried in the family vault in Giverny church-yard. Monet's son gave the house and garden to the Académie des Beaux-Arts who administer and look after the property. Monet's garden is a riot of color, with peonies and tulips, (**LEFT**) and nasturtiums, dahlias, and the odd sunflower (**RIGHT**).

**BELOW RIGHT:** Copper pans and blue and white tiles in Monet's kitchen.

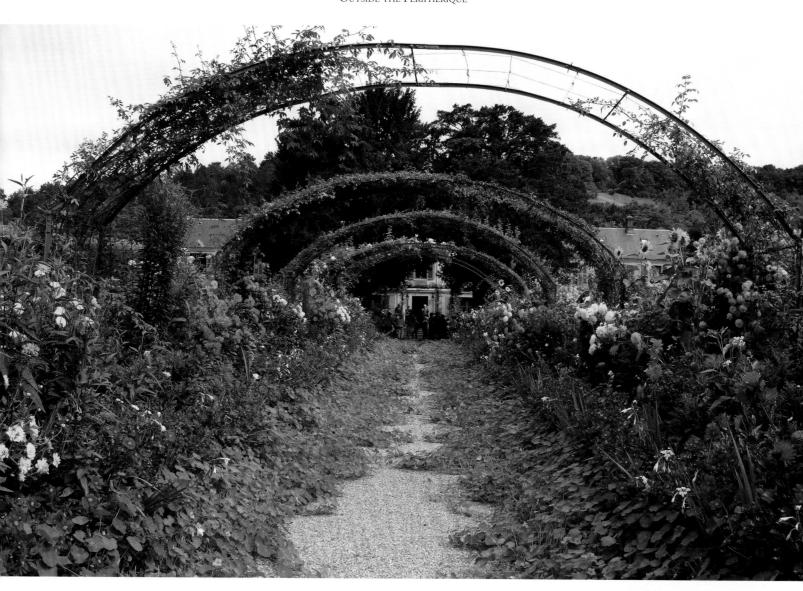

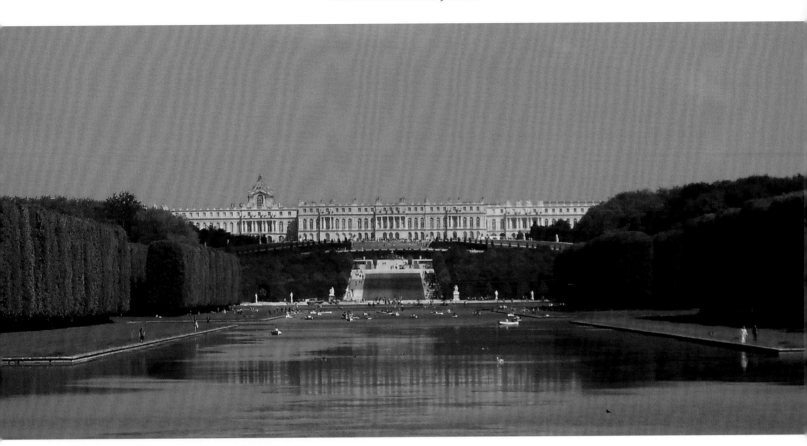

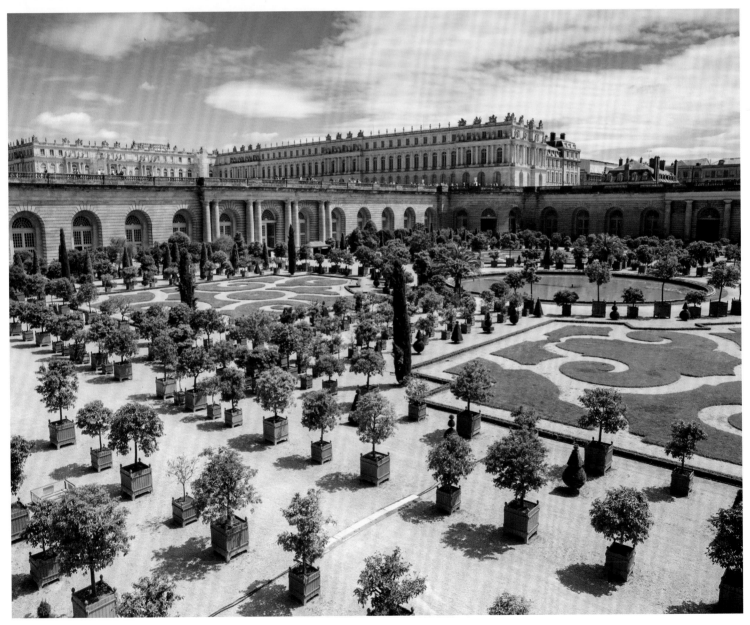

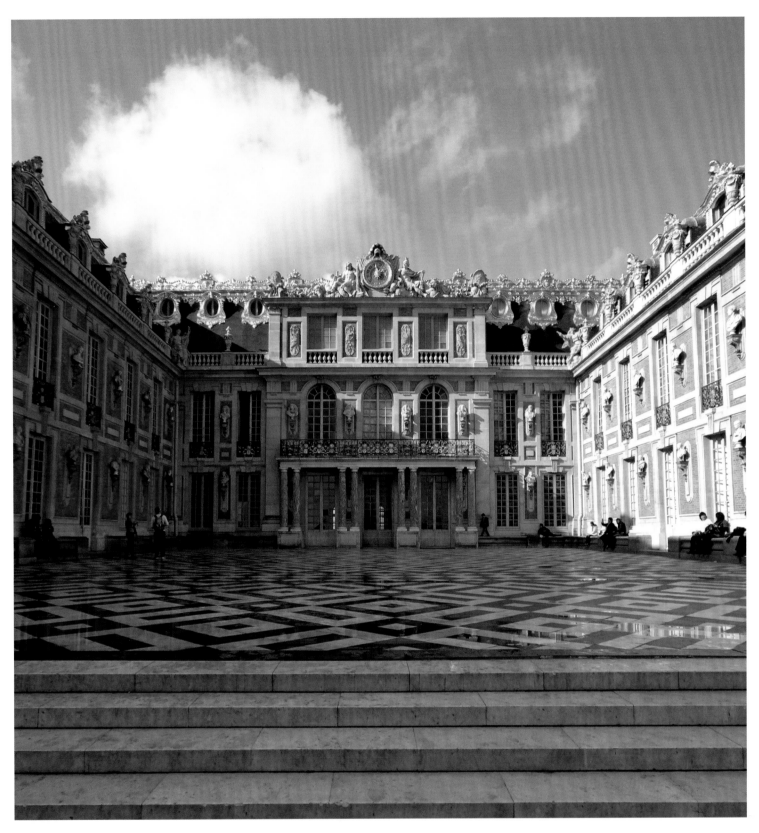

One of the biggest tourist attractions anywhere in the world, the magnificent Baroque palace of Versailles is located just over ten miles southwest of Paris. The complex started as a modest hunting lodge in 1624 for Louis XIII in the heart of the forests. His successor Louis XIV felt unsafe in rowdy and turbulent Paris and gradually transferred the seat of royal power to Versailles. From 1660 to 1685 36,000 workmen were employed building and decorating the palace as plans for the works became ever more ambitious. The principal architects were Jules Hardouin Mansart and Louis Le Vau, whose job was to transform the king's fantastic ambitions into superb buildings. The interiors were decorated by Charles Le Brun and the extensive palace gardens designed by André Le Nôtre. The Château de Versailles is a monument to Louis XIV, the Sun King. Its extravagance and opulence show the king at his most lavish. It is one of the largest palace complexes in the world with over 700 rooms, 67 staircases, 1,250 fireplaces and so on and on—and all set in magnificent formal gardens of over 1,800 acres designed by Le Nôtre. After massively extending his father's original hunting lodge Louis XIV officially moved his royal court to Versailles in 1682, but even then work was not finished. The palace and gardens were badly damaged during the French Revolution. After the restoration of the monarchy, King Louis Philippe in 1837 turned the chateau into a museum dedicated to "all the glories of France" which are told through paintings and sculptures in the largest history museum in the world. The photographs show: the palace seen from the Grand Canal (**ABOVE LEFT**); the Orangery created by Le Vau and expanded by Jules Hardouin-Mansart (**LEFT**); and the Marble Court (**ABOVE**), with its black and white paving, surrounded by Louis XIII's original château.

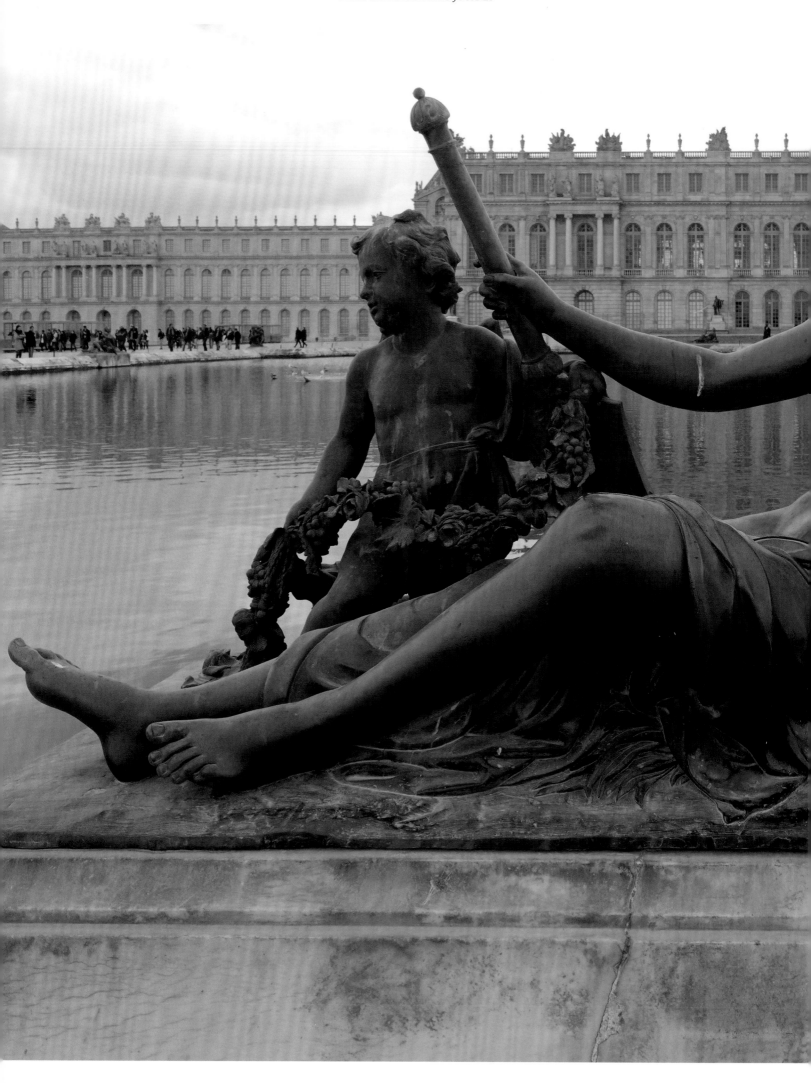

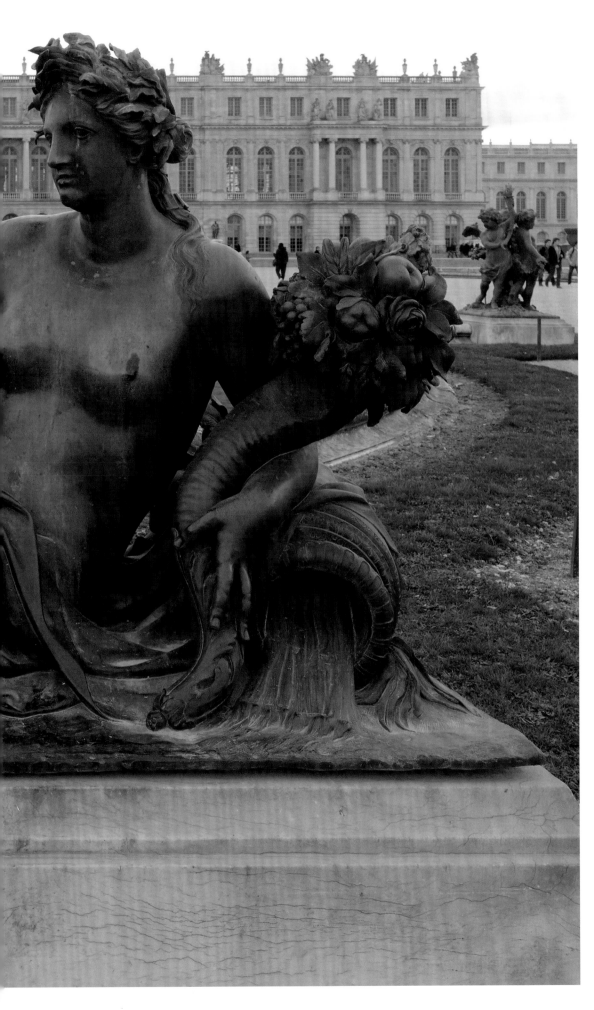

**LEFT:** Some of the great glories of the gardens at Versailles are the fantastic fountains which consume huge volumes of water. To solve the problem a pump was built at Marly to move water from the Seine to Versailles. This alone could not solve the problem, so work started on the Maintenon aqueduct to bring water almost 50 miles from the River Eure, but this ambitious project was never finished. Nevertheless Louis' engineers and mathematicians devised a semi-closed circuit system of pipes and waterways and open-air and underground reservoirs, galleries, and pumps. The Neptune Basin alone has 58 spouts and 147 hydraulic effects. As well as fountains, Versailles is adorned by 386 works of art, including 221 in the garden, most of the latter being sculptures of bronze, lead, and marble. Apollo is a favorite, as are other gods and goddessses of antiquity. In 1683 a water parterre was created, the two pools surrounded by bronze sculptures that represented the rivers of France: Loire and Loiret (Thomas Regnaudin), Rhône and Saône (Jean-Baptiste Tuby), Seine and Marne (Étienne Le Hongre), and Garonne and Dordogne (Antoine Coysevox). This is the Marne created by Le Hongre (1628–1690).

**ABOVE AND RIGHT:** East of Paris, Vincennes was a royal hunting lodge that grew. Originally built for Louis VII in 1150, by the seventeenth century it was a large fortress which also acted as a prison. Within the castle is the Sainte-Chapelle, founded in 1379.

**LEFT:** Vincennes is the home of the Parc Zoologique de Paris—Vincennes Zoo. Its animals include two white rhinos.

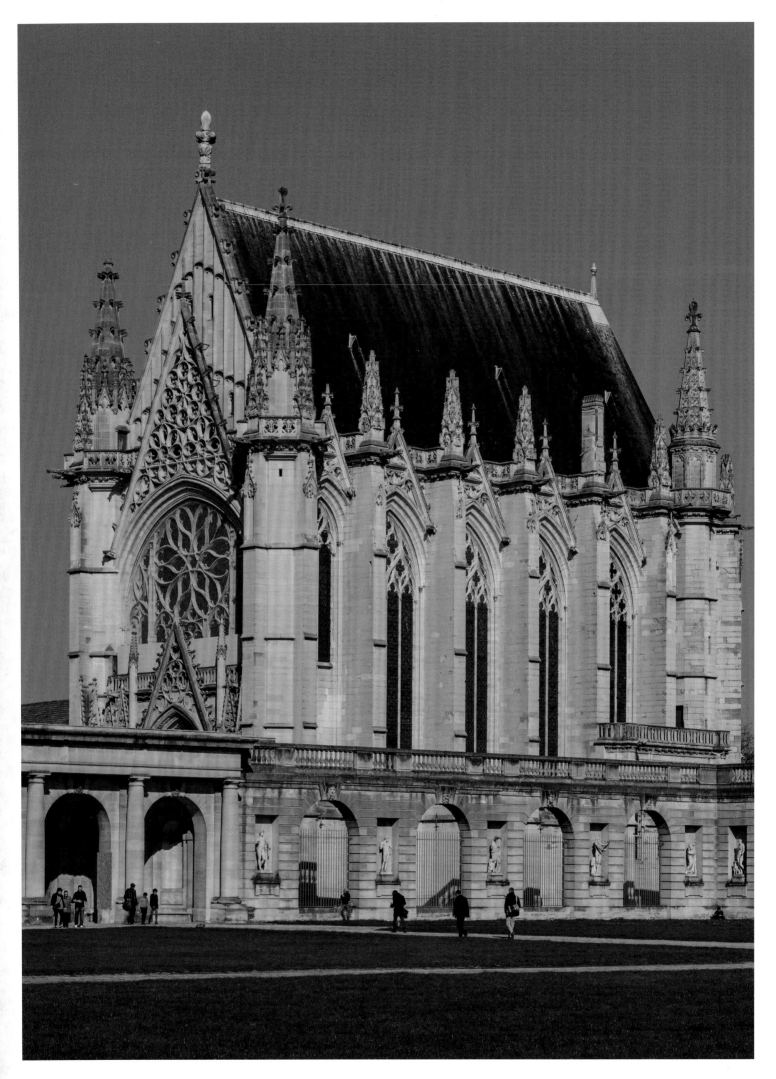

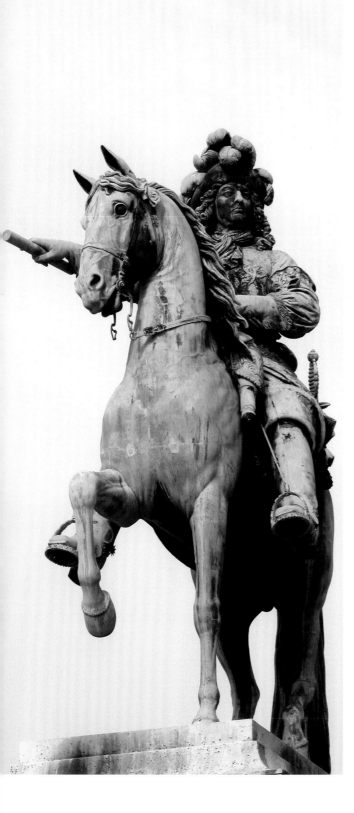

**BELOW:** The equestrian statue of Louis XIV that greets visitors as they enter Versailles is a composite. The horse was sculpted by Pierre Cartellier to be used for a sculpture of Louis XV. The Louis XIV was produced by Louis Petitot, Cartellier's son-in-law and finished in bronze by Crozatier.

# Photo Credits

**Greene Media**
1, 67B, 78 (both), 83T, 87B, 116T

**Fotolibra**
8 (Arnold de Bruin), 12 (Glenys Mary Hart), 14 (Glenys Mary Hart), 16 (Nick Jenkins), 17 (Glenys Mary Hart), 20 Both (Amoret Tanner Collection), 21 All (Amoret Tanner Collection), 22 Both (Amoret Tanner Collection), 57 (Ceri David Jones), 64T ( Ceri David Jones), 65T (Ron Balmforth), 71 (Nick Jenkins), 79 (Ceri David Jones), 81 (Keith Johnson), 102 (Ceri David Jones), 105 (Ron Balmforth), 166–67 (Andrew Millard), 179T (Peter Armstrong), 192 (Tom Coulson)

**Library of Congress**
30, 31, 38–39, 41

**Pixabay**
46 (DorianKrauss), 48 (Gerhard Bögner), 104T (edmondlafoto), 126–27 Wolfgang Moroder), 128–29 (edmondlafoto), 136T (Norbert Oriskó), 136B (Leif Linding), 139 (Ella_87), 146–47 (edmondlafoto), 146T (Bartłomiej Koc), 146B (35069), 182–83 (amelie09996)

**Wikipedia Commons**
2–3 (Stefan Krause), 4–5 (Fred Romero), 6 (dronepicr), 7 (Emily Gould), 10–11 (Alf van Beem), 13 (Guilhem Vellut), 18 (Peter Haas), 23T (Sharon Mollerus), 23B Guilhem Vellut), 24–25 (Pedro J Pacheco), 26 (Guilhem Vellut), 29 (Guilhem Vellut), 32–33 (Marie-Lan Nguyen), 34 (David McSpadden), 37 (Christine Zenino), 40 (Tristan Nitot), 42–43 (0x010C), 45 (Steve Cadman), 49 (Deror avi), 50–51 (Jim Linwood), 52 (Eric Gaba), 54–55 (Guilhem Vellut), 56–57 (Jorge Láscar), 56 (Guilhem Vellut), 58–59 (William Crochot), 60 (Evgenii), 61 (Guilhem Vellut), 62T (Guilhem Vellut), 62B (Pline), 63 (Guilhem Vellut), 64B (Spixey), 65B (Coyau), 66T (Zairon), 66B (IdoZi), 67T (Yann Forget), 68–69 (Didier Boy de la Tour), 70 (Benh Lieu Song), 72–73 (GraphyArchy - Wikipedia 00092, 74 (Guilhem Vellut), 75T (Zairon), 75B (Vassil), 76–77 (Thesupermat), 80 (Gloumouth1), 82–83 (Wolfgang Moroder), 82T (Tim Adams), 84 (Babyaimeesmom), 85 (Daniel Stockman), 86T (Suresh /R), 86B (Joe deSousa), 87T (trolvag), 88–89 (Guilhem Vellut), 90–91 (Francisco Anzola), 90T (Fred Romero), 91T (David McSpadden), 92–93 (Guilhem Vellut), 92T (Patrick Nouhailler), 94–95 (Diliff), 94T (Abderrahman Ait Ali), 95T (Hugh Llewelyn), 96L (Serge Melki), 96–97 (David McSpadden), 97R (Son of Groucho), 98–99 (law_keven), 100 (Chabe01), 101 (Dietmar Rabich), 103T (Yannpassays), 103B (Gerd Eichmann), 104B (Ed Ogle), 106T (Effervescing Elephant), 106B (Laure Coutan), 107 (Antoine Étex), 108 (Pierre-Yves Beaudouin), 109 (Coyau), 110–11 (Guilhem Vellut), 112T (Zairon), 112B (patrick janicek), 113 (Nikolai Karaneschev), 114–15 (Rog01), 116 (Below, stone40), 117 (David Monniaux), 118–19 (Chabe01), 120–21T (Shadowgate), 120–21B (Jorge Láscar), 122–123 (BikerNormand), 122T (Airyyao), 123T (Jebulon), 124T (Dietmar Rabich), 124B (Moonik), 125 (Basili), 130 (Thesupermat), 131T (Eric Pouhier), 131B (David McSpadden), 132–33T (Moonik), 132–33B (Daniel Vorndran), 134–35T (DXR), 134–35B (Benh Lieu Song), 137 (Uoaei1), 138T (Alvesgaspar), 138B (Omar David Sandoval Sida), 140 (Myrabella /CC BY-SA 4.0), 141 (HutheMeow), 142–43 (Zairon), 144T (Cangadoba), 144B (Remi Mathis), 145 (Levrier, Guillaume), 148–49 (Velual), 150 (Hernán Piñera), 151T (DIMSFIKAS), 151B (Britchi Mirela), 152 (watchsmart), 153 (DXR), 154–55 (Guillaume Armantier), 156T (Sanchezn), 156B (Tom Hilton), 157T (Maneck), 157B (Michal Osmenda), 158–59 (Jorge Láscar), 160–61 (Zairon), 160 (Daniel Vorndran), 162 (AHert), 163 (Guilhem Vellut), 164–65T (JLPC), 164–65B (Kirua), 168 (gadgetdude), 168–69 (William Crochot), 170 (Idontfindaoriginalname), 171T (Thesupermat), 171B (Jebulon), 172–73 (Guilhem Vellut), 174–175 (Steve), 175 (William Crochot), 176T (Eutouring), 176B (Jorge Royan), 177 (Udit Kapoor), 178T (William Crochot), 178B (Dietmar Rabich), 179B (Tommie Hansen), 180–81 (SimcaCZE), 184 (La salonniere), 185 both (Schorle), 186T (Wikiwee), 186B (Nono vif), 187 (Dom Crossley), 188–89 (Yves Tennevin), 190T (Daniel Vorndran), 190B (Georges Seguin), 191 (Daniel Vorndran)